Picturing America

Picturing America

teachers resource book
NATIONAL ENDOWMENT FOR THE HUMANITIES

National Endowment for the Humanities
the People

National Endowment for the Humanities 1100 Pennsylvania Avenue, NW Washington, D.C. 20506 www.neh.gov

In cooperation with the American Library Association 50 E. Huron Chicago, IL 60611

Picturing America is a part of *We the People,* the flagship initiative of the National Endowment for the Humanities. *The Teachers Resource Book* accompanies a set of 40 large-scale reproductions of American art, which are awarded as grants to K–12 schools, public libraries, and other entities chosen by the National Endowment for the Humanities, 1100 Pennsylvania Avenue, NW, Washington, D.C. 20506.

CHAIRMAN
Bruce Cole

DEPUTY CHAIRMAN AND
DIRECTOR OF *WE THE PEOPLE*
Thomas Lindsay

PROJECT DIRECTOR
Barbara Bays

PROJECT EDITOR
Carol Peters

DESIGN DIRECTOR
Maria Biernik

WRITERS
Linda Merrill, Lisa Rogers, Linda Simmons (art history),
Kaye Passmore (education)

EDUCATIONAL CONSULTANT
StandardsWork, Washington, D.C.

INTERNS
Samantha Cooper, Mary Conley

PERMISSIONS AND CITATIONS
Carousel Research, Inc.

NEH DIRECTOR OF PUBLICATIONS
David Skinner

NEH ASSISTANT EDITOR OF PUBLICATIONS
Amy Lifson

Printed on Burgo Chorus Art Silk 63 lb. and 130 lb. cover, a Forest Stewardship Council (FSC) certified paper made from 25 percent post-consumer recycled material.

Picturing America is a recognized service mark of the National Endowment for the Humanities.

Cover: Grant Wood (1892–1942), detail, THE MIDNIGHT RIDE OF PAUL REVERE, 1931. Oil on Masonite, 30 x 40 in. (76.2 x 101.6 cm.). The Metropolitan Museum of Art, Arthur Hoppick Hearn Fund, 1950 (50.117). Photograph © Estate of Grant Wood/Licensed by VAGA, New York. See Image 3-A.

Library of Congress Cataloging-in-Publication Data

Picturing America : teachers resource book / [writers, Linda Merrill, Lisa Rogers, Kaye Passmore].
 p. cm.
 "The Teachers guide was designed to accompany the Picturing America project, a part of We the People, the flagship initiative of the National Endowment for the Humanities. It is to be distributed free of charge to participating K-12 schools, public libraries, and other entities chosen by the National Endowment for the Humanities"--T.p. verso.
 Includes bibliographical references and indexes.
 1. Art, American--Study and teaching--United States. 2. Art appreciation--Study and teaching--United States. I. Merrill, Linda, 1959- II. Rogers, Lisa. III. Passmore, Kaye. IV. National Endowment for the Humanities.
 N353.P52 2008
 709.73--dc22

 2008014414

democracy demands wisdom
and vision in its citizens

—from the founding legislation of the
National Foundation on the Arts
and Humanities, signed into law
on September 29, 1965

contents

preface

Chairman Bruce Cole at the National Gallery of Art, Washington, D.C.
—Photograph © DavidHills.net

Picturing America is the newest initiative of the *We the People* program of the National Endowment for the Humanities. Launched in 2002, *We the People* seeks to strengthen the teaching, study, and understanding of America's history and founding principles. To promote this goal, Picturing America brings some of our nation's most significant images into classrooms nationwide. It offers a way to understand the history of America — its diverse people and places, its travails and triumphs — through some of our greatest artistic masterpieces. This exciting new effort in humanities education will expose thousands of citizens to outstanding American art, and it will provide a valuable resource that can help bring the past alive.

In so doing, Picturing America fits squarely within the mission of the NEH. The Endowment's founding legislation declares that "democracy demands wisdom." A nation that does not know where it comes from, why it exists, or what it stands for, cannot be expected to long endure — so each generation of Americans must learn about our nation's founding principles and its rich heritage. Studying the visual arts can help accomplish this. An appreciation of American art takes us beyond the essential facts of our history, and gives us insights into our nation's character, ideals, and aspirations. By using art to help our young people to see better, we can help them to understand better the continuing drama of the American experiment in self-government.

My own experience testifies to art's power to stimulate intellectual awakenings. When I was a young child my parents visited the National Gallery of Art in Washington, and they brought home a souvenir that would alter my life: a portfolio of illustrations from the collections of the National Gallery. As I pondered these great works of art, I had the first glimmerings of what would become a lifelong pursuit: to study and understand the form, history, and meaning of art. This was my gateway to a wider intellectual world. Through that open door, I would delve into history, philosophy, religion, architecture, and literature — the entire universe of the humanities.

I hope that Picturing America will provide a similar intellectual gateway for students across America. This program will help today's young Americans learn about our nation's history. And that, in turn, will make them good citizens — citizens who are motivated by the stirring narrative of our past, and prepared to add their own chapters to America's remarkable story.

Bruce Cole
Chairman
National Endowment for the Humanities

acknowledgements

Picturing America is presented by the National Endowment for the Humanities (NEH), in cooperation with the American Library Association.

NEH also wishes to recognize the following organizations and individuals for their support of the program:

- The Institute of Museum and Library Services
- The Department of Health and Human Services, Office of Head Start
- The National Park Service

Picturing America has also been generously supported by Mr. and Mrs. Robert H. Smith.

NEH wishes to recognize the National Trust for the Humanities. We are also grateful to the History Channel.

The NEH also thanks the U.S. Department of Education and Crayola LLC for promoting Picturing America.

introduction

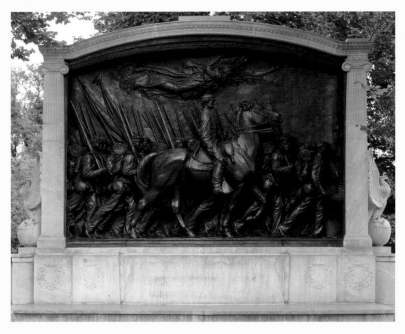

Augustus Saint-Gaudens, _Robert Gould Shaw and the Fifty-fourth Regiment Memorial_, Beacon and Park streets, Boston, Massachusetts, 1884–1897. Bronze, 11 x 14 ft. (3.35 x 4.27 m.). Photograph by Carol M. Highsmith.

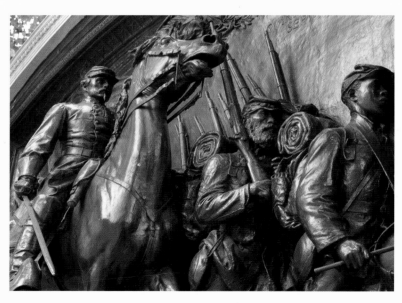

Detail of _Robert Gould Shaw and the Fifty-fourth Regiment Memorial_. Photograph by Carol M. Highsmith.

The stakes could not be higher

as these men march forth to make a desperate attempt to take Fort Wagner, a Confederate stronghold at Charleston, South Carolina. They know the battle will be hard and that the odds are against them; but still, they lean into the advance, united in their resolve. The taut, athletic horse, sensing their mood, jerks back its head, whinnying and snorting against the rumble of feet, metal, and drums. The soldiers do not yet know what we know — how many will die, or that among those will be the steadfast colonel who rides at their side. They will fail to take the fort, but their unflinching heroism will open doors for others. These men are the first regiment of free black soldiers recruited in the North, and they are fighting for more than others dared hope: freedom for their enslaved brethren and the right of African American soldiers to serve in the Union Army. Before the Civil War ends, almost 179,000 more black soldiers will enlist.

Augustus Saint-Gaudens created this bronze monument to honor the memory of the abolitionist Colonel Robert Gould Shaw and the men of the Fifty-fourth Regiment of Massachusetts Volunteer Infantry. The artist could have depicted a more dramatic scene: the attack on the fort, the death of Colonel Shaw, or the saving of the regiment flag from capture. Instead, Saint-Gaudens chose this moving image of human resolve in the face of death. Masterpieces like this help us experience the humanity of history and enhance the teaching and understanding of America's past. Not only are they aesthetic achievements and a pleasure to look at and think about, but they are part of our historical record, as important as any other historical documents.

In order to help young people follow the course of our national story, the Picturing America program, created by the National Endowment for the Humanities in partnership with the American Library Association, is offering reproductions of some of our nation's most remarkable art to school classrooms and public libraries. Materials include a set of twenty large reproductions (24 x 36 in.) printed on both sides with high-quality color images, the Teachers Resource Book, and additional resources on the NEH Picturing America Web site.

THE ARTWORKS

The selection of paintings, sculptures, architecture, and decorative arts represents a broad range of American art, spanning several centuries. The works belong to American collections that are accessible to the public, and were selected for their quality, range of media, and ability to be grouped in ways that expand their educational potential. The narrative qualities of the artworks make them accessible to those untrained in art, and the images are appropriate for children of all grade levels. None are too complicated for a first-grader; none are too simple for a high-school senior. They are large, so that a whole class might view them at the same time, and they are made to last. The images require no special equipment to project or download and can be hung on the wall with pins or even tape.

The collection does not present a comprehensive history of America or its art, nor does it imply a canon of the best or most important examples. A different set of reproductions could work just as well, and we hope that others will expand upon our effort. Our purpose is to show how visual works of art are valuable records for revealing important aspects of our nation's history and culture. Picturing America is a beginning — a flexible sampler that gives students a fresh perspective to approach their core curriculum subjects and offers an effective but uncomplicated way to introduce art into the classroom.

ORGANIZATION OF IMAGES

For ease of use, the reproductions are numbered by side (for example, 1-A and 1-B) and are arranged in roughly chronological order. This was done so that the images that have some historic or thematic relationship appear on one sheet, front and back. For example, if a class is studying pre-colonial America and early Spanish settlement, reproduction side 1-A, which includes pre- and post-contact Hopi pottery, can be turned over to reveal the image of a Spanish mission for a discussion of early Spanish settlement in the Southwest (1-B). Whenever possible,

reproductions that are best seen side by side are placed on separate posters. For example, John S. Copley's *Portrait of Paul Revere* (2-A) can be paired with Grant Wood's *Midnight Ride of Paul Revere* (3-A); and Gilbert Stuart's portrait of George Washington (3-B), which depicts the president in his role as statesman, might be compared to Emanuel Leutze's *Washington Crossing the Delaware* (4-A), which represents his heroism as a military leader.

USING PICTURING AMERICA IN THE CLASSROOM

A teacher whose subject is not art could hang up one of the reproductions and let it remain in place to occasionally catch the eye of a daydreaming student. That in itself would have value; but art can be used to accomplish much more. Not only can it provide a different way to introduce a subject and spark students' interest, it also stimulates the mind to actively work with information. By considering why an artist chose one detail over another, one design over another, students learn to describe, interpret, and draw conclusions from richly layered and nuanced material. As an additional benefit, students will learn to develop an "eye" for how art communicates by looking at and thinking about these images over time. The images gathered here were not created just for scholars or specialists; they were made for everyone, and they communicate in a way that is accessible to anyone who takes the time to enjoy them.

USING THE TEACHERS RESOURCE BOOK

The Teachers Resource Book is intended to help K–12 instructors use the images to teach core curriculum subjects such as American history, social studies, civics, language arts, literature, science, math, geography, and music. The essays are written to give the nonspecialist enough information to lead a discussion of each image. The accompanying teaching activities are organized by elementary-, middle-, and secondary-school levels. At the end of the book, subject indexes arranged by discipline connect topics to specific images, so that teachers can choose which — and how many — images they wish to incorporate into their existing lessons.

PICTURING AMERICA WEB SITE

The NEH Picturing America Web site (PicturingAmerica.neh.gov) makes the information in the Teachers Resource Book free to all. Links to additional resources include relevant lesson plans on the EDSITEment Web site (edsitement.neh.gov), sponsored by NEH in partnership with the National Trust for the Humanities and the Verizon Foundation, as well as material from other Web sources. The links are organized by artwork according to grade level and type of resource.

The National Endowment for the Humanities hopes you will enjoy this collection of the nation's art. America's artistic heritage is varied, inspiring, and great. No student should forgo his or her share.

using picturing america to teach

This book is designed to be a practical tool for teachers. It shows how you can enrich your existing curriculum in a way that will engage your students and add excitement to your classroom. The humanities are an important part of a cross-curricular education because they provide the human focus that gives all learning its meaning and relevance. Picturing America uses the richness of art to develop a panoramic view of American history that spans all of the subjects in the humanities.

Although educators and researchers agree that visual stimulation triggers learning, not enough has been done to help teachers take advantage of the abundant resources art offers to meet the needs of students in core curriculum classes. Learning through art introduces students to subject matter in an immediate and tangible way; students who interact with works of art develop a deeper understanding of history and the shared human experience.

Using the visual arts to teach core subject matter also stimulates creative and analytical thinking. Because an understanding of art begins with sensory perception, which is continually reevaluated and refined as new evidence is discovered, the introduction of artworks into the classroom offers a new, dynamic type of knowledge: one that captures the imagination of students and rewards their sustained inquiry.

In addition, the arts delight and engage the senses, providing educators with a way to reach even the youngest students. When used as part of an American history curriculum that is linked to state standards, the visual arts offer a persuasive and intriguing entry point for studying our nation's past. When integrated into the English language arts curriculum, artworks inspire original thought and stimulate the development of analytical and verbal skills. Teachers can incorporate their students' firsthand experiences or creative narratives into a discussion of works of art, connecting youngsters to the larger world and developing their reasoning and problem-solving skills.

The well-rounded student not only has to meet state standards and demonstrate proficiency in the foundational skills of reading, writing, mathematics, and science, but also has to be able to make interconnections among disparate disciplines. In a culture that rewards students for evaluating and synthesizing increasing amounts of disconnected information, the visual arts encourage the breakdown of walls that separate these disciplines. They offer students the opportunity to explore the subject matter of the standard curriculum through a different lens and to forge links among them.

The sample instructional materials that follow, organized thematically, suggest activities that reach students on multiple levels. They illustrate how teachers of varying grades might incorporate the images into standards-based classrooms. The selection of artwork targets American history and culture by introducing concepts that range across a variety of disciplines. The sample lessons and activities suggested here lay the groundwork for further exploration by both student and teacher. The array of possibilities inherent in this collection will generate thought-provoking conversations in the classroom, provide educators with a useful tool for kindling students' imaginations, encourage interdisciplinary study, reinforce educational goals, and promote critical inquiry. In short, this instructional material should help to instill robust habits of mind that will enable young learners to seek, establish, and test connections.

core curriculum classes

THE REVOLUTIONARY SPIRIT

In the years leading up to the Revolutionary War, the fragile hopes and dreams of patriots were almost extinguished before they could catch fire and spread. A few dedicated individuals tended the revolutionary flame, and the stories of their daring deeds make compelling reading and present an important lesson about the power individuals exercise in history. For elementary-school students, Grant Wood's *The Midnight Ride of Paul Revere* (3-A) offers a captivating bird's-eye portrait of that thrilling ride through a picturesque, toy-like town. Youngsters will find Wood's simplified style, with its colorful, geometric shapes, both pleasing and stimulating; they can see the story unfold and watch as sleepy New Englanders are roused from their beds, light lanterns, and come to their doors to hear the news of the British advance. Through a careful examination of the image, teachers can guide students to extract other information from the painting, such as the time of day and season. Reading aloud the famous Longfellow poem "Paul Revere's Ride" as students view the image, allows teachers to emphasize the interplay between the works, which will help young students develop the ability to discern detail and assemble evidence.

Middle-school students can be led to a more subtle interpretation and a deeper understanding of Wood's painting. For instance, teachers can relate the centrality of the church in the image to the story of Revere's ride as told by Longfellow ("one if by land, two if by sea"), and this could open a discussion on the importance of religion during the Revolutionary era. By highlighting the differences between the historical record and Longfellow's and Wood's artistic interpretations of it, teachers can help middle-school students learn the foundational reading and historical reasoning skills necessary to distinguish between established facts and their interpretations and embellishments. Teachers may also ask students to consider why posterity has neglected the stories of other heroic riders in American colonial history, like Sybil Ludington and Jack Jouett, and the tales that surround their exploits (for example, Scollard's poem, "The Ride of Tench Tilghman"). After learning about the role played by one or more of these patriots, students can create a corresponding picture, poem, or short story that reinvents the tale, and then compose a statement identifying how and why their interpretation differs from the historical facts. Such an assignment would give them the opportunity to create meaning, hone their writing skills, and reinforce several core reading comprehension skills: in sum, it would challenge students to pose questions about the materials they encounter and differentiate the literal from the figurative.

For secondary-school students, John Singleton Copley's realistic portrayal of Paul Revere holding a teapot (2-A), coupled with

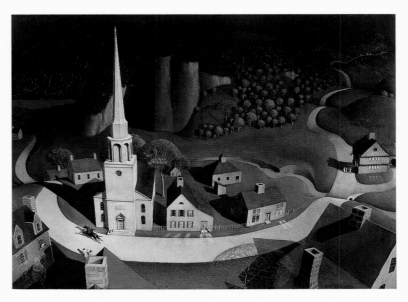

3-A Grant Wood, *The Midnight Ride of Paul Revere*, 1931.

an array of American tea sets (see 2-B), testifies to the endur-
ing symbolism of tea in America. Teachers might begin a
discussion of the painting by alerting students to the date of
its composition — prior to the Boston Tea Party and Revere's
famous ride — and ask students to imagine how Revere might
have been portrayed after these events. They could also draw
students' eyes toward Copley's naturalistic, idealized image —
the spare, smooth, and orderly workbench and Revere's
spotless linen shirt worn without a protective work apron —
and have students compare it to Wood's more abstract and
fanciful interpretation, thus leading to a discussion about the
function and effect of each on the viewer. From a discussion of
the details in Copley's painting, teachers can launch an investi-
gation into the colonial era experience of the artist and his sitter,
which provides a fascinating entry point into the political, social,
and economic forces behind the American Revolution, a main-
stay of social studies at all levels of schooling. By examining the
origins of the revolt in the colonies through the eyes of the rev-
olutionary Revere and the loyalist-leaning Copley, teachers can
involve their classes in a discussion of both men's first-hand
experience with the economic consequences of mercantilism
and the growing tensions caused by the policies of the Crown
toward its colonies. Wood's and Copley's paintings about Paul
Revere also give students the opportunity to interpret past
events and issues within the historical context of the Revolution,
and to reconcile different points of view held by men of strong
conviction during this tumultuous era.

Developing research skills is a crucial part of middle- and
secondary-school language arts and social studies curricula.
Projects that expand on material in the images allow students
to become more familiar with the nuances of historical cause
and effect and to hone their understanding of the scholarly
apparatus that accompanies research, including evaluating,
paraphrasing, and citing primary and secondary sources. This
foray into the multi-faceted history of the colonial era can
therefore prompt students to delve more deeply into a critical
period in our nation's history and research particular historical
events and documents (e.g., the Townsend Acts and Paine's
Common Sense), or even biographies and autobiographies of
other figures who played crucial roles, such as Benjamin
Franklin (see 4-B).

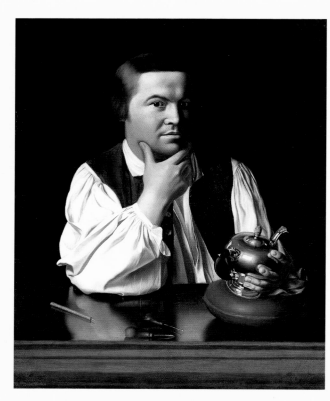

2-A John Singleton Copley, *Paul Revere*, 1768.

AMERICAN VALUES

By the end of the Great War (World War I), the United States had emerged as an international power. However, the stresses of the Great Depression and the threat of another overseas conflict dampened the nation's underlying optimism and self-confidence. The artworks that chronicle these dramatic shifts in the American spirit—from Childe Hassam's *Allies Day, May 1917* and Edward Hopper's *House by the Railroad*, to Dorothea Lange's *Migrant Mother* and Norman Rockwell's *Freedom of Speech (19-A)*—not only represent some of the most intriguing and thought-provoking images from the first half of the twentieth century, but offer a host of opportunities for students to explore the fundamental values that underlie our national character.

Childe Hassam's *Allies Day, May 1917* (12-B) offers visual proof of the American spirit immediately following the nation's entry into World War I and is a harbinger of the increasingly crucial role the United States would come to play in world affairs. The bold colors of the flags instantly communicate the importance of symbols, and teachers can use the natural curiosity of young learners to create age-appropriate activities that explore the role of the flag in America. This might take the form of civics lessons on the ideals contained in songs such as "The Star Spangled Banner" or an examination of another familiar statement of American values, such as the Pledge of Allegiance.

The images permit middle-school students to trace the spirit of the American people from the hope of victory in Europe through the feeling of isolation and hopelessness of the Great Depression, to the re-emergent faith in and enthusiasm for American values on the brink of World War II. As students explore the meaning of Hassam's painting, they are offered a new way to initiate a description and discussion of America's self-image when the nation joined forces with its European allies in World War I. The red, white, and blue flags of the Allies (with that of America at the top), the overall blue-sky tone of the picture, and the brushstrokes that seem to lie on the surface like a crust, create a visual unity that communicates the political solidarity of the countries and can lead to a discussion of the American political outlook at the time the painting was made.

The mood of *Allies Day, May 1917* stands in stark contrast to that expressed in Edward Hopper's *House by the Railroad* (16-A) painted eight years later. Observant students will notice how the structure of Hopper's picture creates the feeling of isolation. The house stands alone near a railroad track with no neighbors (or even trees) close by, and the blank whiteness of the drawn shades points to a growing sense of dislocation caused by the transition to modern life. The story continues with the social upheaval and dislocation caused by the Great Depression, elegantly expressed in the composition of Dorothea Lange's *Migrant Mother* (18-B). By emphasizing

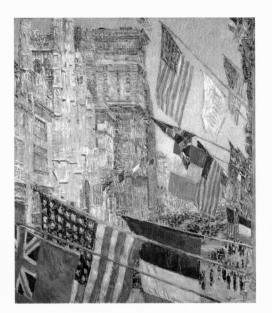

12-B Childe Hassam, *Allies Day, May 1917*, 1917.

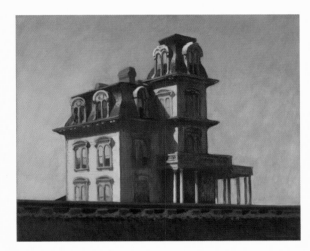

16-A Edward Hopper, *House by the Railroad*, 1925.

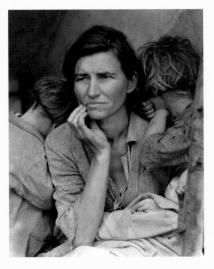

18-B Dorothea Lange, *Migrant Mother*, February 1936.

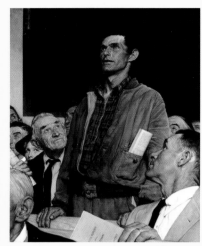

19-A Norman Rockwell, *Freedom of Speech, The Saturday Evening Post*, February 20, 1943.

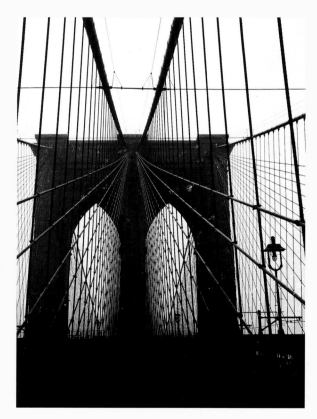

13-A Walker Evans, *Brooklyn Bridge, New York*, 1929, printed c. 1970.

the iconic arrangement of mother and children in Lange's photograph, teachers can lead students in a discussion of how, through the power of visual expression, artists captured the struggles Americans experienced during the inter-war period. Teachers can also turn their students' attention to the endurance of American values — even in the face of hard-ship — by incorporating Norman Rockwell's *Freedom of Speech* (19-A) into lessons on World War II or the Bill of Rights. After examining the painting's symbolic content, teachers can begin a discussion of both the historic and present-day value of free expression and set students on the path to forming a sense of civic consciousness.

Secondary-school students who explore the disjunction and isolation captured in the Hopper and Lange images will be able to more fully understand the disillusionment that gripped the nation after the Great War. Students can compare the details of Hopper's painting — imagining the sound of a train's forlorn whistle as it rolls past — and the bleak strength of Lange's photograph with Rockwell's more optimistic work, and its orderly details of small-town life (the setting, the attire of the citizens, and the expressions on individual faces). Such comparisons also provide an excellent entry into the study of Lost Generation novels from this era such as Hemingway's *A Farewell to Arms* and *The Sun Also Rises*, and Remarque's *All Quiet on the Western Front*. Discussing such literary masterpieces in tandem with these works of art reinforces general reading skills such as identifying setting, symbolism, and imagery, and helps to hone the ability of more advanced students to make inferences about plot devices and historical context.

Great documentary imagery such as Lange's *Migrant Mother*, Walker Evans's photograph of the Brooklyn Bridge (13-A), and paintings that reveal the varied responses to modernity and the Machine Age, such as Edward Hopper's *House by the Railroad* and Charles Sheeler's *American Landscape* (15-A), also dovetail with literature of this era that delves into the experience of ordinary Americans. These artworks can be introduced to students at a variety of grade levels to comple-ment literary works ranging from Steinbeck's touching and moving story *Of Mice and Men* for freshmen, to his complex tale for older readers about the adversity faced by the Joads in *The Grapes of Wrath* or James Agee's *Let Us Now Praise Famous Men*.

All of these visual works of art provide entry points for exploration throughout the K–12 curriculum. Students in lan-guage arts and literature could compare what they've seen in the images with the rich legacy of World War I poetry — from the idealism of Rupert Brooke to the battle-weary lyrics of Wilford Owen and Siegfried Sassoon. Students studying history and civics will discover the many congruencies among the

images included in Picturing America and the historical and ethical issues underlying the Bill of Rights, free speech cases, the Treaty of Versailles, and Roosevelt's First Hundred Days. In sum, the images in Picturing America offer numerous possibilities for teachers of different disciplines to prompt students to further consider what our American heritage implies.

CONNECTING CULTURES

An understanding of the American experience would not be complete without discussions about diverse cultural experiences and interactions among ethnic groups. The artworks gathered here offer teachers a number of avenues for exploring, in particular, the American Indian and African American experience.

Primary students might begin their introduction to American Indian culture with discussions of George Catlin's *Catlin Painting the Portrait of Mah-to-toh-pah — Mandan* (6-B) and Black Hawk's *"Sans Arc Lakota" Ledger Book* (8-B). By learning how to identify the chief, warriors, women, and children, young learners can absorb lessons about the organization of Indian tribes and the expression of individual identity. Teachers can also lead investigations about specific cultural artifacts such as the clothing worn by the Lakota in the *"Sans Arc Lakota" Ledger Book* and the variety of jars, bowls, and baskets illustrated in image 1-A. By studying these objects, primary-school students learn how to build geographic skills such as mapping out the location of different cultures. Students can exercise their interpretive skills by showing how useful, everyday objects from their own daily lives offer clues to modern-day culture.

Young learners can further hone their abilities to describe and interpret what they see by exploring Jacob Lawrence's *Migration Series* (17-A) and Augustus Saint-Gaudens's memorial to Colonel Robert Shaw and his regiment of soldiers (10-A). The portrayal of the backbreaking labor once required for those burdened with the daily wash, shown in the fifty-seventh panel from Lawrence's *Migration Series*, invites students to creatively and empathetically reconstruct the lives of others. The detailed portrayal of ordinary soldiers in Augustus Saint-Gaudens's memorial helps youngsters to envision themselves in the place of individual members of the first African American regiment to fight in the Civil War.

Middle-school students can develop a deeper understanding of the history of North America by examining the interaction between American Indians and white settlers. N. C. Wyeth's portrayal of Uncas (5-B), a character in James Fenimore Cooper's 1826 novel, *The Last of the Mohicans*, is a good introduction to a classroom dialogue about the American Indians' relationship with British and French colonists during the French and Indian War. When discussing the Indian Removal Act and the Trail of Tears, teachers could ask students to consider

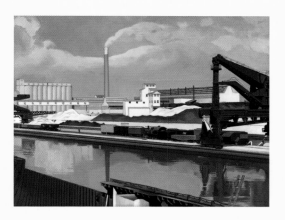

15-A Charles Sheeler, *American Landscape*, 1930.

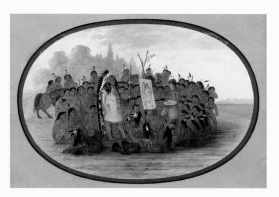

6-B George Catlin, *Catlin Painting the Portrait of Mah-to-toh-pah — Mandan*, 1861/1869.

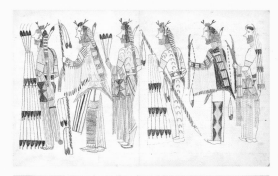

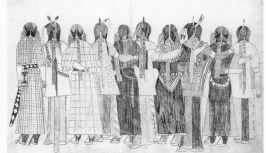

8-B.1–8-B.2. Black Hawk, *"Sans Arc Lakota" Ledger Book* (plates no.18 and 3), 1880–1881.

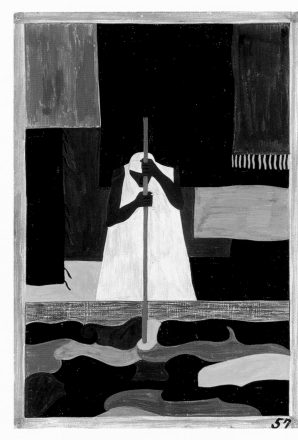

17-A Jacob Lawrence, *The Migration of the Negro Panel no. 57,* 1940–1941.

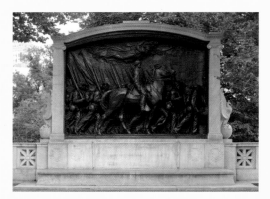

10-A Augustus Saint-Gaudens, *Robert Gould Shaw and the Fifty-fourth Regiment Memorial,* Beacon and Park streets, Boston, Massachusetts, 1884-1897.

the historical context of the *"Sans Arc Lakota" Ledger Book* or the cultural significance of Catlin's physical position relative to that of Mah-to-toh-pah in his portrait of the Mandan chief. By comparing background stories of settlers on the plains (as in Laura Ingalls Wilder's *Little House on the Prairie* books) with the experience of Black Hawk and the Lakota, students will recognize that history is written from multiple perspectives. The study of Saint-Gaudens's *Robert Gould Shaw and the Fifty-Fourth Regiment Memorial* reinforces that lesson. Just as Saint-Gaudens gave each figure individual features and characteristics, various poets have expressed their individual interpretations of the valor displayed at Fort Wagner. Focusing on historical perspective, students can carefully consider works by African American poets Paul Dunbar and Benjamin Brawley and contrast them to Robert Lowell's famous poem "For the Union Dead."

Secondary-school teachers can use these same images to generate a more abstract analysis of art from their students, leading them to a higher-order synthesis and a deeper understanding of the culture under investigation. N. C. Wyeth's cover illustration of Uncas from *The Last of the Mohicans* is a provocative prompt for secondary students studying Enlightenment philosophy. The lone figure in a landscape has been viewed as symbolic of America as a pristine, untamed country waiting to be civilized, which naturally leads to the discussion of Rousseau's concept of the noble savage. In English language arts classes, secondary-school students can explore the power of historical perspective by studying Wyeth's painting in tandem with poetry such as Longfellow's "The Song of Hiawatha." They might juxtapose the figure in the painting with the written description of Cooper's Uncas and/or the portrayal of this loyal Indian in a contemporary film adaptation of the novel. Such comparisons not only can begin a discussion about how the representation of American Indians has changed through the years, but should also test the media skills of students, giving them the opportunity to identify what choices the director has made in adapting the novel for the screen.

By working along with their students, teachers can help them separate the intricate web of meaning embedded in the Shaw Memorial into its distinct parts—from the allegorical angel to the moving inscription by Charles Eliot. They can also use this monument as a lead-in to a discussion of the role Frederick Douglass played in encouraging African Americans to enlist, and the effect that the regiment's stand on equal pay had on Abraham Lincoln. Students might further study Alexander Gardner's photograph of Lincoln (9-B) as they focus on the president's speeches. An exercise that asks students to describe and interpret the president's temperament as revealed in Gardner's portrait could be incorporated into an examination of the Gettysburg Address and the Second Inaugural Address.

Such a project might help secondary-school students better understand the man as they learn to identify and explicate how Lincoln elaborated his thesis and structured his argument. The exercise could serve as an inspirational jumping-off point for speeches that the students themselves might write and deliver.

Lawrence's *The Migration Series* (17-A) and Romare Bearden's *The Dove* (17-B) introduce the Harlem Renaissance and its influence, and can be used to begin a unit on this subject. Students might probe Lawrence's work in order to compare and contrast life in the rural South and the urban North, and examine the impetus behind the Great Migration. An alternative understanding of African Americans' subsequent urban experience can be found by looking at Bearden's *The Dove*. Bearden's use of collage metaphorically reflects the many layers of life for African Americans living in urban centers. This complexity of experience is reflected in the short stories and novels by Harlem Renaissance writers such as Ralph Ellison, Langston Hughes, and Richard Wright. As students study this literature, the nature of Bearden's collage will complement their reading comprehension skills, particularly in terms of figurative language, diverse diction, and plots rich in sensory detail.

The works of art chosen for Picturing America are meant to act as springboards for further research experiences. For history and civics classes, the jars, bowls, and baskets presented in reproduction 1-A are windows into changing economic systems, from the practice of barter and trade to the use of money as a unit of exchange. Exposure to the Civil War through Saint-Gaudens's monument could lead to an assessment of the impact of the Fourteenth and Fifteenth Amendments on African Americans, or the Nineteenth Amendment on women. Investigations like these naturally lead students to question the historical position of other minority groups in America. Teachers can use such opportunities as starting points to introduce further information. For example, the experience of Asian Americans during World War II might be discussed in a history class, or a novel like Cisneros's *House on Mango Street*, which delves into the lives of Mexican Americans in Chicago, could be assigned in a literature class.

These are only a few of the ways that the Picturing America images can help you in the classroom. We hope you enjoy discovering others.

5-B N.C. Wyeth, cover illustration for *The Last of the Mohicans*, 1919.

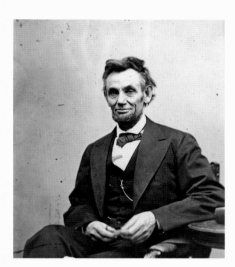

9-B Alexander Gardner, *Abraham Lincoln*, February 5, 1865.

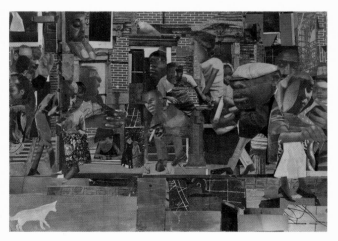

17-B Romare Bearden, *The Dove*, 1964.

artwork, essays, & activities

Anasazi Cylinder Jars, c. 1100

A thousand years ago, American Indians used plants, bone, skin, earth, and stone to fashion the objects needed for daily life: pots for cooking, baskets for storage, or arrowheads for hunting. Many of these objects indicate, in addition to a concern for usefulness, a deep regard for beauty.

The pots and baskets illustrated are indeed beautiful, and also provide a glimpse of the cultures and traditions that produced them. Each object exemplifies a craft and a tradition that were handed down and improved upon through generations. A stylized corn stalk painted on a cooking pot reminded everyone of that crop's central importance in their lives, and a better source of clay meant that new pots lasted longer than the old ones. These cylindrical clay jars, made by potters about eight hundred years ago in the Four Corners region, where the modern-day borders of New Mexico, Arizona, Utah, and Colorado converge, are evidence of a remarkable American Indian culture that flourished there.

The Anasazi people were farmers who not only built homesteads and small villages across the Four Corners region, but also built a great cultural capital in Chaco Canyon in the northwest corner of what is now New Mexico. Between 900 and 1150, they dominated the region. Their engineering feats included towns with multistory apartment buildings and a road network to connect them. The largest of the apartment buildings, or great houses, is Pueblo Bonito in Chaco Canyon.

These six jars were found with about one hundred others in one of the rooms of the Pueblo Bonito great house. To make each pot, circular coils of clay were layered over a flat base and then given a smooth surface by hand or use of a scraper. The smoothed surface was covered with a slip (a thin mixture of clay and water) and painted with a mineral-based color. When the pot was dry, it was fired, or baked, in a kiln to harden it and set the decoration.

We do not know how these jars were used. The cylindrical shape, which is rare in Anasazi pottery, varies slightly with each pot: some are fatter, some are taller, and some are a little tipsy. They have flat bottoms and can stand upright. Small holes or loops near the opening show they could be hung by some kind of cord, perhaps, as some archaeologists think, for use in rituals.

The geometric designs, painted with black lines on a white background, give the pots their individual character. The designs are hand drawn with a relaxed asymmetry. Squares stretch over one jar in a form-fitting grid that seems to reveal every bulge of a squirming body beneath. A crooked line of triangles travels down another, and up and down on a third. The slimmest pot is made to look even thinner by vertical striping, and the two widest pots appear even broader because their designs twist from the vertical and move diagonally across them.

Chaco Canyon's dominance was short-lived. By the end of the thirteenth century, the Anasazi had abandoned the area and migrated south and east to smaller settlements. Their descendants are the Pueblo peoples who now inhabit the region.

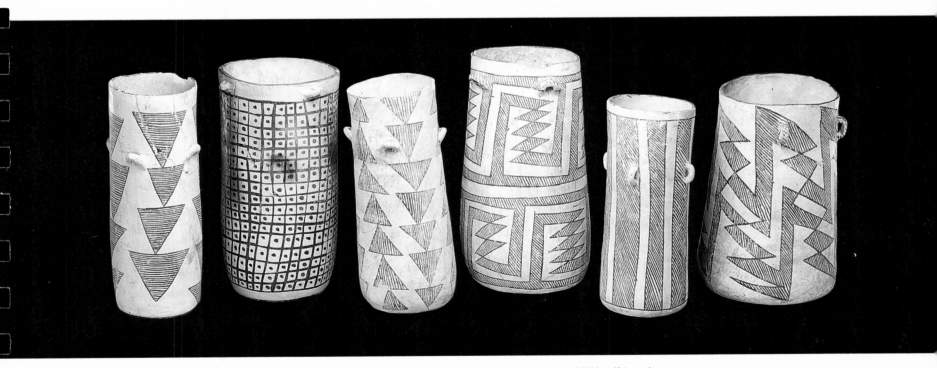

1-A.1 Anasazi pottery, c. 1100, Pueblo Bonito, Chaco Canyon. Jar at left, height 10¼ in. (26 cm.). Photograph by P. Hollembeak. © American Museum of Natural History, New York.

1-A.2 Sikyátki polychrome bowl, c. 1350–1700, height 3⅔ in., diameter 10¾ in. (27.4 x 9.3 cm.). Catalog no. 155479. Department of Anthropology, Smithsonian Institution, Washington, D.C. Photograph by D. E. Hurlbert.

Sikyátki Bowl, c. 1350–1700

By the mid-1300s, Sikyátki potters from the First Mesa area, about 125 miles west of Chaco Canyon, had developed a decorative style that was strikingly different from the symmetry and basic geometric designs of the jars found at Pueblo Bonito. While Anasazi pots have a background of white slip (watery clay), the background of Sikyátki pottery is bare clay and decorated in a wider range of plant- and mineral-based colors. Firing at higher temperature, made possible by the use of coal, also made the pots more durable. Decorations combine abstract geometric shapes with forms derived from nature: rain clouds, stars, the sun, animals, insects, reptiles, and birds (the human form is rarely depicted). The inside of this Sikyátki bowl, made sometime between 1350 and 1700, has geometric decoration on the exterior, but greater attention is focused on the interior, which seems to contain a great reptile that slithers and spins around the inside. The creature is something more than the reptiles that commonly scurry over rocks in this arid land: it wears a three-feather headdress, and its snout and one of its toes stretch to fantastic length.

The Hopi people live in the First Mesa area now. Their traditions recount the destruction of the Sikyátki community by its neighbors even before Spanish explorers arrived about 1583. The meaning of the symbolism of Sikyátki pottery has been forgotten, but the Sikyátki style was given new life at the end of the nineteenth century, when a young Hopi-Tewa potter named Nampeyo (c. 1860–1942) drew inspiration from Sikyátki pottery designs for her own pieces. They found commercial success, thanks in part to the arrival of the railroad in Albuquerque in the 1880s and the popularity of the arts and crafts movement among collectors. Nampeyo's work helped spark a revival in Hopi pottery that continues today.

MARÍA MONTOYA MARTÍNEZ (1887–1980) and JULIAN MARTÍNEZ (1879–1943), Jar, c. 1939

Just as Nampeyo was reviving the Sikyátki style in her community west of Chaco Canyon, another Pueblo potter was reviving an ancient style in her Tewa community, one hundred miles east of Chaco. María Montoya Martínez (1887–1980) worked with her husband, Julian Martínez (1879–1943), to create a new style based on archaeological finds from the areas around San Idelfonso, near Santa Fe, New Mexico. María made pots using the same coiled-clay techniques that native potters had used a thousand years earlier. Julian then painted and fired them.

The couple were contacted by an archaeologist in 1909, who asked them to find a way to reproduce the style of some of the ancient pottery found nearby. Although the local clay was red, the ancient pottery was black. After eight years of experimenting with the firing process, María and Julian discovered how to produce the arresting black-on-black finish of the jar shown here, which they made sometime around 1939. This geometric style with contrasting matte and gloss finishes characterizes their best-known work.

The jar is a study in opposing forces and restraint. The calculated design and natural irregularities combine to give the form a continual undercurrent of energy. Its bottom is slightly rounded and, when set on soft ground, snuggles into the earth. Positioned on a hard surface, however, the form balances on an invisible axis and appears to hover. Its silhouette is a combination of symmetrical and asymmetrical: the area of greatest volume (the pot's belly) is situated exactly at mid-center, but the jar is also wider at the top, and its silhouette is more pronounced in its upper section. Even the black-on-black decoration holds hidden complications, containing a third color—white—wherever the surface reflects bright light. When the light is more subdued, the contrasts are less bold and the effect is more mysterious, as shapes move in and out of the shadows and negative and positive forms trade places. As though to keep all of these potent interactions in check, the abstract designs, refined and sharp as cut paper, form a girdle around the pot's circumference, stretching to a point just below the belly.

1-A.3 María Montoya Martínez and Julian Martínez (San Ildefonso Pueblo, American Indian, c. 1887–1980; 1879–1943), Jar, c. 1939. Blackware, height 11⅛ in., diameter 13 in. (28.26 x 33.02 cm.). National Museum of Women in the Arts, Washington, D.C., Gift of Wallace and Wilhelmina Holladay.

The pottery of María and Julian Martínez gained national recognition and led to a revival of pottery-making in San Idelfonso and towns in the area. Today pottery-making holds an important position in the economies of both areas. It also reflects a wider resurgence of interest in Pueblo history and traditions.

LOUISA KEYSER (c. 1850–1925), *Beacon Lights,* **1904–1905**
About seven hundred miles northwest of Four Corners, another group of American Indians discovered commercial value in some of their creative traditions. The Washoe people and their ancestors had lived as nomads in the area around Lake Tahoe for several thousand years. Their way of life altered suddenly with the 1848 California Gold Rush and the discovery of silver in the Comstock Lode in 1859. Travelers to California were followed by settlers who populated the Washoe area around Virginia City, Nevada. The settlers cut trees, built roads, put up fences, and laid out ranches. Adjusting to the new cash economy, the Washoe abandoned their nomadic life and began to work for wages.

For all its upheavals, the cash-based economy brought a new market for the Washoe's sophisticated basketry. The Washoe weaving tradition had produced baskets fit for hunter-gatherers, to be used as fish traps and cradles for infants. But in 1895, Abe Cohn, a merchant in Carson City, Nevada, hired a young Southern Washoe woman to produce baskets exclusively for sale to non-native buyers.

Louisa Keyser was also known by her Washoe name, Dat So La Lee. During her thirty-year business arrangement with Cohn, Keyser produced scores of decorative baskets, most notably Washoe degikup (ceremonial baskets). She introduced new designs and experimented with shape and size to attract buyers. The basket shown here, a two-color degikup that Keyser made in 1904 or 1905, was constructed by coiling long strips of willow in layers and then connecting the rows with thousands of tiny stitches of thinner pieces of willow. Designs in redbud (a red-brown color) and bracken fern (brown or black) were worked into the weave in a staggered pattern. The basket is shaped like a slightly squashed sphere, and opposing visual forces create a crisp tension. The coil rows make the form seem to swell outward, but the dark pattern checks the expansion by emphasizing the vertical with wiggling lines that appear to inch their way to the opening at the top.

Commercial success encouraged other Washoe basket makers to follow Keyser's lead. Although demand for Washoe baskets declined after 1935, Keyser helped transform the non-native perception of Washoe decorative basketry from utilitarian objects to works of art.

CAESAR JOHNSON (1872–1960),
Gullah Rice Fanner Basket, c. 1960
In coastal South Carolina, an important tradition of basket weaving arrived from West Africa more than two hundred years ago, traveling by ship across the Atlantic with slaves. The descendants of those slaves still live in the long, narrow strip of islands that stretches along the South Carolina and Georgia coasts. Gullah is the name of their culture and their creole language, which is remarkably similar to Sierra Leone's Krio language.

I-A.4 Louisa Keyser (Dat So La Lee, Washoe, c.1850–1925), *Beacon Lights,* 1904–1905. Willow, western redbud, and bracken fern root, height 11¼ in., diameter 16 in. (40.64 x 28.58 cm.), T751. Thaw Collection, Fenimore Art Museum, Cooperstown, N.Y. Photograph by Richard Walker.

1-A.6 Attributed to Caesar Johnson (1872–1960), Gullah rice fanner basket, c. 1960. Rush, height 2½ in., diameter 17½ in. (6.35 x 44.45 cm.). Courtesy of the South Carolina State Museum, Columbia, S.C. Photograph by Susan Dugan.

During the eighteenth and nineteenth centuries in the Sea Islands, rice plantation owners paid a premium for slaves from the rice-growing areas of West Africa, who knew how to manage the crop. The marshy conditions that made the land ideal for rice also led to the isolation that created and then preserved the Gullah culture.

After the Civil War, many Gullah purchased the land they once worked for others. They maintained their sense of separateness from the mainland and continued to make fine baskets. The flat basket illustrated is a rice winnowing tray attributed to Gullah artisan Caesar Johnson.

These trays were used to separate out the chaff (the dry, outer husk) from the grain of rice after it was crushed in a mortar and pestle. Chaff is lighter than grain and when tossed together in a tray, the chaff floats away on the wind. The winnowing tray and other basket types were made of bulrush (a type of marsh grass) and saw palmetto or white oak, all of which grew in the area. The structure of the basket provides its only decoration. Its design evokes the motion of the tray in use: the spiraling coils seem to contract and expand — the center advancing then retreating— while color variations and little diagonal stitches make the disk appear to rotate.

CARL TOOLAK (c. 1885–c. 1945), Baleen Basket, 1940

Although an ancient tradition of birch-bark basketry was practiced among women of the north Alaska coast, a new and unusual basket form was developed in the early twentieth century by male artisans. A non-native whaler, Charles Brower, commissioned a basket from a local man. It was an unusual request because the basket was to be woven of baleen, the stiff, fibrous plates in the mouth of the baleen whale that filter plankton.

The Inupiat have hunted whales for centuries. Whales supplied food, fuel, and construction materials, and the Inupiat wasted none of it, including the baleen, a material that men traditionally worked. Baleen is pliable and resilient, making it ideal for sled runners, bows, rope, even shredded for fishing line. During the era of commercial whale hunting (1858 to around 1914), Westerners used baleen for buggy whips, umbrella ribs, and stays for women's corsets. When petroleum and plastics replaced these whale products, commercial hunting dried up, and with it, jobs for Inupiat workers.

Brower continued to commission baleen baskets to give as presents to his friends. Gradually, the demand broadened and a new tradition was born.

Carl Toolak was among the first of the baleen basket weavers. This basket shows his style from around 1940. Because baleen is too stiff to form the tiny coils that begin the basket at the center bottom, Toolak used a starter plate of ivory. He stitched the first strip of baleen to the edge of the starter plate through holes drilled around its perimeter, and finished the separate starter piece for the lid with a knob.

Baleen occurs naturally in a range of shades from light brown to black. Toolak expanded his color range by adding a decoration of white bird quills to the weave. The body of the container is glossy and is enriched with a pattern of white stitches grouped in twos and threes. The pattern lines up with that of the dome-shaped lid, where trios of white stitches elongate into lines that converge toward the playful centerpiece of the work—a carved ivory seal who looks as though he has just popped his head above icy water.

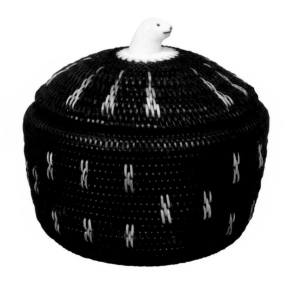

1-A.5 Carl Toolak (c. 1885–c. 1945, Inupiat, Point Barrow, Alaska), baleen basket, 1940. Baleen (whalebone) and ivory, height 3½ in., diameter 3½ in. (9.0 x 8.5 cm.). Catalog no. 1.2E1180. Courtesy of the Burke Museum of Natural History and Culture, Seattle, Wash.

TEACHING ACTIVITIES
E = ELEMENTARY | **M** = MIDDLE | **S** = SECONDARY | **Before beginning the activities below,** encourage students to spend a few moments looking at each of the objects on this poster.

DESCRIBE AND ANALYZE

E|M|S

How are these objects similar? *All are meant to hold something; all are made from natural materials; all are circular; all but one are decorated; all but one were made by American Indians.*

E|M|S

If you could touch these objects, how would each feel? *The clay pots are smooth, possibly cool. The María Martínez pot may feel rough in the design area. The baskets are rough or knobby. The baleen basket has a smooth figure on top.*

E|M|S

What natural materials from their environments did the artists and craftsmen use to create these functional containers? *Clay was used for the Southwestern pots by the Anasazi, Sikyátki, and María Martínez. Animal material—whalebone/baleen and ivory—were used by Toolak. Plant materials—willow, redbud, and fern root—were used by Keyser, and rush was used for the basket by Johnson.*

E|M|S

Why did the Washoe create and use mainly baskets rather than ceramic vessels? *The Washoe moved often and baskets were lighter and easier to carry.*

E|M|S

The María Martínez jar, the Anasazi jars, and the Sikyátki bowl were all made in the American Southwest by the Anasazi or their Pueblo descendants. What features do they have in common? How are ancient jars different from Pueblo pottery? *All the pots were formed with clay coils. They feature geometric decorations, but the designs of the two later pieces also include forms based on nature. The Anasazi jars have a layer of white slip over the clay, but the newer ones have exposed clay.*

E|M|S

What inspired María Martínez and Julian Martínez to create black-on-black ceramics? *The discovery of ancient pottery did.*

E|M|S

Have students create a chart to compare Louisa Keyser's basket to Carl Toolak's basket. Create three columns. Label the first column "Features to Compare." Label the second column "Carl Toolak" and the third column "Louisa Keyser." In the first column, list general features that the baskets share. In the artists' columns, have students compare and contrast how Toolak and Keyser handled each of the general features.

FEATURES TO COMPARE	Carl Toolak	Louisa Keyser
Background value and color	dark; black, brown	light; straw color
Color of the design	white	reddish brown
Top/lid	closed with lid	open with no lid
Body shape	almost straight up and down (like a cylinder)	round or bulbous
Materials (Media)	baleen and ivory (stiff animal material)	willow strips (pliable plant material)

INTERPRET

M|S

Ask students how American tourism in the Southwest influenced American Indian pottery. *Because tourists wanted to buy their pottery, artists began to create more of it and renewed this ancient craft.*

M|S

In the early twentieth century, what did tourists appreciate about Southwest pottery? *They appreciated its design, handmade craft, and the natural beauty of the materials.*

M|S

Why did collectors prefer pottery that was signed by the artist? *The artist's signature shows who made it and that it is an authentic piece of art created by this artist. Often a pot by a known artist is more valuable than an anonymous one.*

CONNECTIONS

Historical Connections: legacy and cultures of major indigenous settlements—Inupiat and other native Alaskan peoples, Cliff Dwellers and Pueblo Indians; slavery and slave trade

Geography: Mesa Verde; American Southwest; Alaska; American Northwest; Southern Coastal Region

Economics: cottage industries; cotton gin and technological advances in agriculture; nomadic, hunter/gatherer, and agricultural economies

Literary Connections and Primary Documents: *The Pot that Juan Built*, Nancy Andrews-Goebel (elementary); *Moby Dick*, Herman Melville

(secondary); *Call of the Wild, White Fang*, Jack London (elementary, middle); *Uncle Tom's Cabin*, Harriet Beecher Stowe (middle, secondary); poetry of Phyllis Wheatley (secondary)

Music: American Indian music, slave spirituals

Mission Nuestra Señora de la Concepción, 1755

This watercolor reconstruction from the 1930s only dimly suggests the dazzle that Mission Concepción offered 250 years ago. The building, now stripped to bare stone, was once covered in white plaster and adorned with painted designs in red, blue, yellow, and black. With a dome glistening against the blue southwestern sky, it must have risen impressively from the surrounding plain.

Built in San Antonio in 1755, the Catholic mission had been founded almost forty years earlier in the Texas-Louisiana border region as one of six Spanish missions that served as a barrier against French expansion from the east. Dominican, Jesuit, and Franciscan missionaries looking for spiritual treasure in the form of converts to Christianity had followed the gold-seeking Spanish, who were using large numbers of

native allies to explore and lay claim to an increasing area of the Americas. The goals of the Church and the Spanish Crown overlapped. Because there weren't enough Spaniards to colonize so vast an area, the plan was to turn the lands over to the new converts who would develop the missions into towns, where they would live as Spanish citizens.

Native peoples came to the missions for diverse reasons: some were coerced; others sought safety from their enemies; and still others responded to the missionary message itself. Nomadic tribes may have found the safety of mission life, with its steady supply of food, a less difficult and precarious existence. It was less appealing for sedentary farming communities like the Hopi, who lived in greater security on high mesas. (In 1680, decades after the Spanish conquest of New Mexico, Pueblo tribes, under the leadership of the Tewa medicine man Popé, forced the Spanish out and destroyed many of their missions.)

Mission Concepción was home to a number of distinct nomadic tribes collectively known as Coahuiltecans. Run by the Franciscan order, it was organized like a small village, with storage buildings, a workshop and a church at its core. The friars lived in cubicles in the convent that flanked the church, and the mission Indians lived in housing built along the inside perimeter wall of the complex. Beyond lay orchards, fields of crops, and ranches for grazing livestock.

The church was designed in the ornate seventeenth-century Spanish Baroque style; it was constructed of adobe and rubble, faced inside and out with stone, and then coated with plaster. Catholic traditions determined the floor plan of the building, which, from a bird's-eye view, takes the form of a cross. A long central hall (nave) leads from the southwestern entrance to the altar at the northeast end and is intersected by a second, horizontal hall (transept). The place where they meet, called the crossing, is crowned by a dome with a cupola to let in light.

The church was adorned on the interior and exterior with frescoes (paintings on plaster) and was further ornamented with statues and relief carvings. On the exterior, borders with geometric and floral designs emphasized the building's architectural parts, outlining windows and creating the fictive columns that frame the openings in the bell towers. The flat expanses of wall on the towers were given an overall pattern that resembled Spanish tile work, with each square containing a floral cross inside a circle.

The mission still contains some fragments of the frescoes that once enlivened the interior with color and religious imagery. The most unusual of these is a sun with rays painted on the ceiling of the library. Although the sun is often used as a symbol of God in Christian art, it is a little surprising here to see the mustachioed face (perhaps of a mestizo, a man with mixed Spanish and American Indian ancestry) peering back at us.

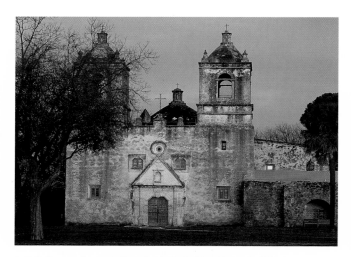

1-B.2 Convento and church at dusk. San Antonio Missions National Historical Park. © George H. H. Huey.

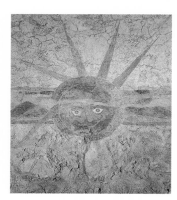

1-B.3 Detail. "Eye of God" decoration on ceiling of the library. San Antonio Missions National Historical Park. © George H. H. Huey.

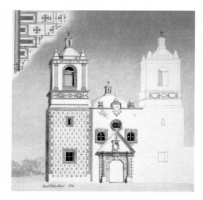

1-B.1 Mission Nuestra Señora de la Concepción de Acuña, San Antonio, Texas, 1755. Ernst F. Schuchard (1893–1972). *Mission Concepción*, fresco details of façade, 1932. Watercolor on paper, 17½ x 17 in. (45 x 44 cm.) in frame. Daughters of the Republic of Texas Library. Ernst F. Schuchard papers, Gift of Mrs. Ernst F. Schuchard and daughters in memory of Ernst F. Schuchard.

TEACHING ACTIVITIES
E = ELEMENTARY | **M** = MIDDLE | **S** = SECONDARY

Allow students to look carefully at these images, briefly pointing out that the detailed views show how the building looked in an earlier state.

DESCRIBE AND ANALYZE

E M
Have students locate the lanterns and the crosses at the top of the towers and dome. Look for slight variances in the symmetry of this building.
A buttress is on the right corner, the mission wall extends to the right, and windows vary slightly in size on each side of the building.

E M
Ask students what the original function of the two towers on the front of the church was.
They were bell towers, used to summon the community.

E M S
Encourage students to compare Mission Concepción's 1755 façade to the way it looks today.
It was originally plastered white with red, blue, yellow, and black patterns. Now it is exposed rock.
Why is it no longer white with painted designs?
The plaster and designs weathered away.

E M S
Ask students why the Spanish built the Texas missions.
They built missions to stop the French from expanding their colonies into Texas and to convert American Indians to Christianity.

INTERPRET

E M S
What was the purpose of this building?
It was used as a place of worship.
In addition to religion, what other important functions did the missions serve?
They raised food, trained American Indian workers and artisans, and produced goods such as leather saddles and cloth.

E M S
Why did American Indians live at the missions?
Some were forced to, others converted to Christianity and wished to be near the church, and others sought safety from their enemies.
What buildings were often parts of a Spanish mission?
The church, granary, workshops, houses for soldiers, and living quarters for friars and Indians formed part of the missions.

E M S
Ask students what the sun detail represents.
It may represent the face of God.
What is unusual about this depiction of God?
This face has a mustache like that of a man of both Spanish and American Indian ancestry.

M S
Ask students why the Spanish and American Indians constructed European–style churches in America.
The Spanish wanted churches like those in Spain.
Show students examples of seventeenth-century Baroque church façades. (The Obradorio façade of the famous Spanish pilgrimage church of Santiago de Compostela in Spain is an excellent example. Images are available on the Internet.)
Discuss why Mission Concepción is much simpler than many of these ornate churches.
This frontier church was constructed with local building materials and artisans. Although some Spanish artists worked on the mission, most of the builders were American Indians who learned European construction techniques from the Spanish.

M S
How does this church design symbolize Christian beliefs?
There are many crosses on it symbolizing Christ's suffering and death. Throughout the design there are references to the number three for the triune God — Father, Son, and Holy Ghost.

S
Find design elements that suggest the number three.
The triangle over the door, the three openings above the door, and the façade, which has three major parts — the center flanked by the two bell towers.

CONNECTIONS

Historical Connections: European colonial settlements in North America; California missions; the Pueblo Revolt; Texas history; the Mexican-American War

Historical Figures: Francisco Vásquez de Coronado; Popé; Andrew Jackson; James K. Polk; Zachary Taylor

Arts: Spanish architecture (amalgam of Moorish, Romanesque, Gothic, and Renaissance influences) modified to meet frontier needs

2a Paul Revere, 1768

John Singleton Copley had emigrated to London by the time Paul Revere made his legendary midnight ride to alert the patriots that the British were coming. He had painted this portrait of Paul Revere some years earlier, when Revere was known as a silversmith with a flourishing Boston trade but not yet as an American hero. Although Revere had been active, even then, in revolutionary politics, Copley prudently kept the portrait free from any hint of controversy. In retrospect, we can see that the portrait captures the qualities that allowed Revere to play an instrumental role in colonial history: physical strength, moral certainty, intelligence, and unequivocal dedication to a cause.

In the American colonies, portraiture was generally considered more of a practical trade than a fine art, and a portrait's success was largely measured by its likeness to the person portrayed. Because John Singleton Copley had an extraordinary talent for recording the physical characteristics of his subjects, he became the first American artist to achieve material success in his own country. Copley's portraits endure as works of art because they transcend pure documentation to reveal clues to a sitter's personality, profession, and social position.

Most of the colonial citizens Copley depicted were clergymen, merchants, and their wives—the aristocracy of early America—but *Paul Revere* is the picture of an artisan who, like Copley himself, took pride in the work of his hands. The portrait captures a critical moment in the silversmith's work: he appears poised to engrave the gleaming surface of a teapot (presumably one he fashioned himself) using tools that rest on the table before him. But would a working craftsman have worn such a spotless linen shirt or a woolen waistcoat (even if left casually unfastened) with buttons made of gold? And could that highly polished, unscratched table possibly be a workbench? Apart from the engraving tools, the setting is free from a craftsman's clutter or any other indication of an active workshop, which tells us that these are props to signify Revere's profession.

The fine mahogany table that distances Revere from the viewer and gives the workman in shirtsleeves an air of authority also serves an important compositional purpose. It forms the base of a pyramid, with the sitter's brightly illuminated head at the apex. The triangular shape is echoed in the arched brow of Revere's right eye, which commands attention with its steady, knowing gaze; his left eye remains in shadow. Copley may have chosen the pyramidal pose in allusion to Paul Revere's association with Freemasonry, an esoteric fraternal society based upon a shared set of moral and metaphysical ideals and a declared belief in a single god, or Supreme Being. As Copley would have known, Revere made engravings for the Masons featuring an omniscient eye emanating rays of light to symbolize God's creative power; that emblem was sometimes framed by a triangle or a pyramid. (The emblem, which can be found on the back of a dollar bill, was adopted in 1782 as part of the Great Seal of the United States.) This portrait, an idealized view of labor consistent with the democratic ideals of the New World, not only offers a record of Revere's powerful physical presence but suggests his moral dignity and spiritual illumination.

Revere's portrait remained in the family in an attic until the end of the nineteenth century, when Henry Wadsworth Longfellow's famous poem, "Paul Revere's Ride," finally brought the patriot's story back into the light. In 1930, Revere's descendants donated Copley's likeness of their famous ancestor to the Museum of Fine Arts, Boston.

2-A John Singleton Copley (1738–1815), *Paul Revere,* 1768. Oil on canvas, 35⅛ x 28½ in. (89.22 x 72.39 cm.). Museum of Fine Arts, Boston, Gift of Joseph W. Revere, William B. Revere, and Edward H. R. Revere, 30.781. Photograph © 2008 Museum of Fine Arts, Boston.

TEACHING ACTIVITIES

E = ELEMENTARY | M = MIDDLE | S = SECONDARY

Allow students to look closely at the figure in this portrait, his environment, and what he is doing.

DESCRIBE AND ANALYZE

E|M|S

What is Paul Revere holding?
He is holding a teapot in his left hand and his chin in his right.

E|M|S

Find the three engraving tools on the table. Why do you think Copley included these tools and the teapot in this portrait?
They suggest that Revere was a silversmith.

M|S

How has Copley drawn our attention to Revere's face?
He placed Revere against a plain, dark background to contrast with his light face and shirt. The hand under his chin leads to the face.
What part of the face did Copley make the most important?
He made the eye on the left — Revere's right eye — the most important.
How did he do this?
He accomplished this by slightly turning Revere to the viewer and shining a light on that part of Revere's face.

M|S

Why did he emphasize the eye?
Students can speculate on this. Perhaps he emphasized the eye to get the viewers' attention and draw them into the painting, or perhaps to remind viewers that the eye is an important part of the artist's skills and a sign of talent (as in "having an eye for" something), etc.

INTERPRET

E|M|S

We know that some artists (such as Leonardo da Vinci) were left-handed. Ask students if they can prove whether Paul Revere worked with his right or left hand according to clues in the painting.
If he is left-handed, why are the engraving tools to his right?
He is not working.
If he is right-handed, why does he hold the pot in the left?
He rests the pot on the leather pad in order to engrave on it.

M|S

By placing Revere's hand under his chin, what does Copley suggest about Revere's personality?
This pose usually indicates a thoughtful person.

M|S

What might the combination of these three things tell us about Paul Revere as an artist: the pot he made and prominently holds, the thoughtful gesture of the hand on chin, and the emphasis on his right eye?
His work is a combination of handiwork, thought, and artistic vision.

S

Paul Revere was a craftsman in a busy studio. How has Copley idealized the setting for this portrait?
If this were truly an artist's workbench, it would probably be littered with tools and bits of metal.

S

Some writers on art see a connection between Copley's portrait of Revere and the symbol on the dollar bill. Compare Revere's portrait with the eye on the back of a dollar bill. How are they alike?
1) On the dollar bill, the eye is highlighted and set at the apex of a triangle; in the painting, Revere's arms and the table form a triangle with his head at the top.
2) The eye on the dollar bill is a Freemason symbol, and Revere, like many revolutionary leaders, was a Mason.
Encourage students to debate this connection. Do they think the similarity between these two images is deliberate?

CONNECTIONS

History: Sons of Liberty; famous ride and ensuing battles in Lexington and Concord (American Revolution)

Historical Figures: Paul Revere; King George III; Patrick Henry; John Adams; Samuel Adams; Crispus Attucks

Civics: Whigs v. Tories

Geography: Massachusetts Bay; Charles River; Coastal Lowlands

Literary Connections and Primary Documents: *Common Sense*, Thomas Paine (secondary); *Rip Van Winkle* and *The Legend of Sleepy Hollow*,

Washington Irving (elementary); "Paul Revere's Ride," Henry Wadsworth Longfellow (elementary)

Arts: portraiture; American colonial art

During the seventeenth century, tea imported from east Asia changed the drinking habits of Europe and, before long, the American colonies. The caffeine it contained was stimulating, but without the negative effects of the beer or ale Europeans and the colonists normally drank (even for breakfast), and — because it was made with water purified by boiling — it was healthier than plain water.

For European and colonist alike, tea was expensive, and drinking it was often a social event. A distinct etiquette developed around its consumption, and special utensils were designed for preparing and serving it. Teapots made of silver were the choice of the well-to-do. The metal retained heat and could be fashioned to make vessels of subtle sophistication and beauty. Its smooth surface was ideal for etching designs indicating ownership or commemorating events.

The teapots sparkled when moved and handled. When not in use, they were displayed, infusing light into dark corners of colonial interiors. They were not only a symbol of the owner's social standing and prosperity; silver vessels had monetary value as well, and were a form of cash reserve that could be melted and used as currency.

Boston was one of the main centers of colonial silver craft, and Paul Revere was one of the city's leading silversmiths before and after the Revolution. The dramatically angled pot made by Revere in 1796, shown here, is radically different in style from the curvaceous prerevolutionary pot he holds in the 1768 painting by Copley (see 2-A).

Following the Revolutionary War, many American architects built in the Neoclassical style in honor of the new nation's political foundations, based on the ideals of ancient Greece and Rome. Some examples are Thomas Jefferson's Virginia State Capitol, Charles Bulfinch's Boston State House, and Benjamin Latrobe's designs for the U.S. Capitol. Paul Revere's teapot is in the Federalist style, an American version of Neoclassicism that developed in New England.

Seen from the side, Revere's teapot looks like a section of a fluted (grooved) classical column, but when viewed from the top, the vessel is oval and appears much lighter in mass. Its oval footprint has the advantage of allowing most of the pot's surface

2-B.1 Paul Revere Jr. (1734–1818), *Teapot*, 1796. Silver, overall 6⁵⁄₁₆ x 11⅝ in., 668.7 grams (15.4 x 29.5 cm., 21.499 troy ounces); base 5¹¹⁄₁₆ x 3¾ in. (14.4 x 9.5 cm.). The Metropolitan Museum of Art, Bequest of Alphonso T. Clearwater, 1933 (33.120.543). Image © 1986 The Metropolitan Museum of Art.

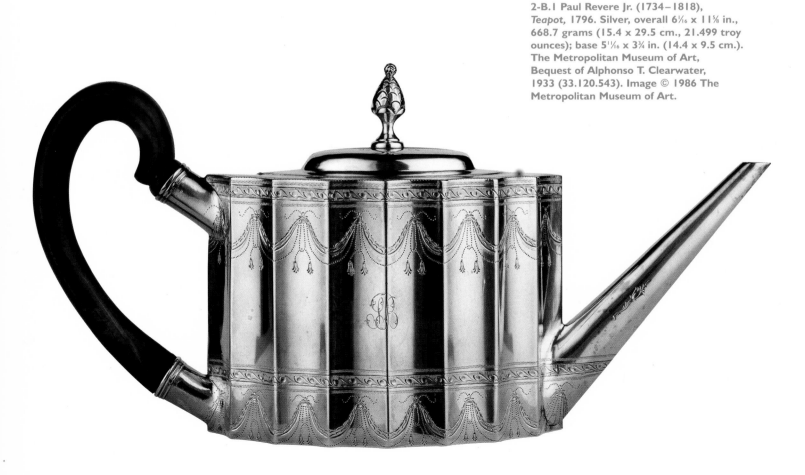

2-B.2 Thomas William Brown (Wilmington, North Carolina), tea service. Silver, c. 1840–1850. © North Carolina Museum of History. Courtesy of the North Carolina Museum of History, Raleigh, N.C.

to be visible from the side when it is set on a shallow shelf. Etched garlands, as delicate as spider lace, loop in swags around its top and bottom. Their lightness adds grace to the teapot's form without disturbing its strength.

Revere was an energetic entrepreneur who understood the wisdom of diversifying. The market for his silver work was not limited to the wealthy, and he earned as much from many small jobs for people of more limited income as he did for the more expensive pieces made for the elite. He cast bells and cannon in bronze, and established the country's copper industry. He also developed a copper-rolling machine and supplied protective copper sheathing for hulls of ships and copper bolts and spikes for the USS *Constitution*.

Silver continued to be the metal of choice when Thomas William Brown designed this tea service around 1840–1850 for Edward Kidder, a prominent businessman in Wilmington, North Carolina, where Brown also lived.

The pieces were crafted in much the same way Revere's were a half century earlier. Each vessel began with a lump of silver that was hammered or rolled through a flatting press to form

a sheet. It was then shaped into a three-dimensional form by pounding it against a stake to bend it bit by bit. Revere's 1796 teapot has a soldered and riveted seam along the side with the handle, but a bowl shape could be hammered from a single sheet of silver without the need of soldering. Some parts, like finials (lid knobs) and feet (added to the pot to protect the surface of wooden tea tables from heat damage) were usually cast as solid pieces and attached by soldering.

After the pot was smoothed and polished, it was ready for engraving. The vessel was filled with pitch to support the metal and keep it from denting when the silversmith pressed the engraving tool into the surface. The work required a steady hand and a stable surface, so the pot was rested against a leather pad filled with sand (see the leather pad in Copley's portrait of Paul Revere, 2-A).

In contrast to Revere's compact forms, Brown's vessels are tall and stately. His tea service includes a lidded sugar bowl, a pitcher for cream, and a waste bowl (slop) to hold the dregs and unused tea when a new pot is to be brewed. Its owner was involved in several businesses and served on the board of directors of banks, community services, and charitable

2-B.3 Gene Theobald (active 1920s–1930s), *"Diament"* teapot, 1928. Wilcox Silver Plate Company, American, (active 1867–1961), division of International Silver Company, American, founded 1898. Silverplate and plastic, overall 7½ x 6⅝ x 3⅝ in. (19.05 x 16.828 x 9.208 cm.). Location: Meriden, Connecticut. Dallas Museum of Art, Dallas, Tex., The Jewel Stern American Silver Collection, Gift of Jewel Stern.

organizations, and he may have entertained with some frequency. The set was designed to serve tea with ease and grace. Lids are attached, so there is no need to set them down where they might leave a ring, and the rim of the waste bowl is broad enough to catch a splash before it reaches the table. Because heat from the pot might be transferred to the handle, teapots sometimes were given wood handles, as, for example, with Revere's teapot. The delicately scrolled silver handles on Brown's service arc away from the heated pot and are inlaid with precious ivory.

The opening of silver mines in the West, beginning with the discovery of the Comstock Lode in Nevada in 1859, and the development of new technologies like electroplating (applying a layer of silver over a cheaper base metal) made silver wares more widely available. In the economic boom that followed the Civil War, the taste for silver grew. Most homes of respectable means aspired to set a fine table, and homes of the elite desired ever more numerous and specialized silver utensils and containers.

Silver production transformed from a small shop business, where almost everything was done by hand by a few craftsmen, to a large-scale industry with machine manufacturing. Large silver companies like Gorham, Reed & Barton, and Tiffany were founded in the nineteenth century, and America's silver industry became the largest in the world. An exhibition in Paris in 1925 exhibited a new style that celebrated the sleek sophistication

of the modern era, a style that became known as Art Deco. Art Deco taste favored the sleek efficiency of the modern machine age. (See 15-A for another example of the style.)

Designer Gene Theobald and product stylist Virginia Hamill developed a type of tea service called the dinette set, whose components fit closely together in a carrying tray. The set could be moved easily as a unit and took up less space in the chic apartments of the urban sophisticates for whom they were designed. The tongue-in-cheek humor of Theobald's *Diament Dinette Set* of 1928 makes it look less like a tea service than an ocean liner steaming across the table or a miniature version of the skyline glimpsed from an apartment window.

Inventive design was more important than the value of the raw material, and the set is plated rather than solid silver. A new machine-age material—a type of plastic developed between 1907 and 1909—was used for the knobs on the lids. The flat planes and straight lines of the silver reflect images and light differently than Revere's or Brown's pots. The earlier pots distort reflections, which glide over the surface and accent their curving shapes. The planes of the *Diament Dinette Set* create mirror-like images, which sometimes makes the plane look solid and other times makes it look transparent. The reflective play of surface and depth gives the tea set a lively and sparkling appearance, a feature impossible to capture in a static photograph.

TEACHING ACTIVITIES

E = ELEMENTARY | M = MIDDLE | S = SECONDARY

Encourage students to look closely at these teapots and services.

DESCRIBE AND ANALYZE

E

Have students compare the form and texture of the three teapots on this poster. Ask students how they are alike.
They are all shiny metal with spouts, handles, and lids with knobs.
Which is most angular? *Theobald's is.*
Which has the most rounded form? *Brown's has.*
Which includes both straight and rounded forms? *Revere's does.*
Which teapots seem most vertical? *Brown's and Theobald's do.*
Which has an engraved design? *Revere's teapot does.*
Which teapot reflects light like a smooth, flat mirror? *Theobald's does; the other two would create distorted reflections.*
Which teapot looks like a machine made it? *Theobald's does.*

E | M | S

Ask students why Revere's teapot has a wooden handle.
The silver became hot when filled with boiling water. With a wooden handle, the users wouldn't burn their hands as they poured tea.

M | S

Have students compare Revere's 1796 teapot to the prerevolutionary teapot he holds in Copley's portrait of him in 2-A.
The prerevolutionary teapot is much more rounded than the later one.
How is Revere's 1796 teapot like classical architecture?
Its body is fluted like a classical column.
After the American Revolution why did this Neoclassical style appeal to Americans?
Neoclassical designs were based on Roman and Greek architecture, which reminded viewers that their new country's government was based on ancient Greek and Roman ideals.

INTERPRET

E | M

Host a tea party by serving the class hot tea. Because you'll probably use tea bags and disposable cups, explain to students how different this experience is from how tea was served in the eighteenth century, when tea leaves were carefully brewed in silver teapots and tea was served in fine china cups.

E | M | S

Ask students why drinking tea was a social event in the seventeenth century.
Because tea leaves were imported and expensive, an elaborate ritual for brewing and drinking it developed.
Why was drinking tea healthier than water? *Boiling water to brew tea purified the water.*

E | M | S

Have students describe the function of each of the pieces in Brown's tea service.
Left to right: *The sugar bowl held sugar; the teapot brewed and served tea; the creamer held and served cream; and the waste bowl or slop caught the remains of cold tea and used tea leaves before more tea was served.*

E | M | S

Ask students why seventeenth- and eighteenth-century teapots were made of silver.
The silver would hold the heat necessary for brewing tea, and silver teapots are beautiful.

M | S

In addition to their functionality and beauty, why did colonial Americans want to own teapots?
They indicated wealth, and because they could be engraved with the owner's identification, they were considered a safer financial investment than silver coins that could be stolen. If necessary, silver teapots could be melted and used as money.

M | S

Ask students what developments made teapots such as Theobald's more affordable than Revere's and Brown's teapots.
Silver was discovered in Nevada and electroplating or applying silver over a cheaper base metal was invented. Also, the introduction of industrialization meant that machines rather than individual craftsmen made teapots.

E | M | S

Ask students which teapot they would rather use — and why.

CONNECTIONS

Historical Connections: Boston Tea Party; Intolerable Acts

Historical Figures: Paul Revere; King George III; Patrick Henry; John Adams; Samuel Adams

Economics: trade and mercantilism between mother country and the colonies; connection between economic issues and political upheaval

The Midnight Ride of Paul Revere, 1931

3a

In *The Midnight Ride of Paul Revere,* the Midwestern painter Grant Wood casts a magical spell on a familiar American story. As scholar Wanda Corn has recounted, as a child, Wood had been captivated by the tale of Revere's journey through the night from Boston to Lexington (the site of the opening skirmish of the Revolutionary War) to warn the patriots of the British advance. The precise details of this historical event would have been indistinct, or perhaps unknown, to Wood since, like most Americans of his day, he had learned the legend from a poem by Henry Wadsworth Longfellow, published in 1863:

> Listen my children and you shall hear
> Of the midnight ride of Paul Revere.
> On the eighteenth of April in Seventy-five
> Hardly a man is now alive
> Who remembers that famous day and year.

Wood was enchanted by the notion of a local hero bearing urgent news, raising the alarm, and consequently attaining immortality. He liked to imagine himself on just such a mission in his home state of Iowa, galloping from farm to farm to warn his neighbors of an impending tornado—"and being handsomely praised when the storm was over and everyone had been saved." Wood never had the opportunity to become that sort of hero, but he did become immortal through his famous work *American Gothic* (1930)—painted just a year before he completed *The Midnight Ride*—which dignifies a homely country couple on an ordinary Iowa farm.

Although he had trained as an artist, Wood was a self-consciously "primitive" painter who emulated the unpretentious, unschooled manner of American folk artists. This straightforward approach rejects any detail or artifice that might divert attention from the principal subject. *The Midnight Ride of Paul Revere* goes one step further to capture a child's point of view. A bird's-eye perspective (like the view from an airplane) allows us to survey a vast sweep of countryside and gives the New England village the ordered clarity of a town made of toys: the country church and surrounding houses are simple geometric shapes, as though constructed of building blocks; the trees are crowned with perfect green spheres, like those a child would try to draw. Wood makes no attempt to be either historically correct—the windows of the houses, for instance, are far too bright to be lit by candles—or scientifically accurate: the moonlight illuminating the foreground scene is preternaturally brilliant, casting long, deep shadows on the road like a spotlight focused on the main event. The rolling landscape beyond is left sleeping in a darkness that is broken only by tiny glimmers from faraway windows. To complete this evocation of a childhood dream, Wood whimsically portrays Paul Revere's trusty steed—"flying fearless and fleet," in Longfellow's words—as a rocking horse.

Wanda Corn points out that some who saw this playful painting assumed Wood was making fun of a beloved American legend, when in fact his intention was just the opposite. His aim, he said, was to save those "bits of American folklore that are too good to lose." This preservationist tendency was part of his greater scheme to forge a national identity, which he believed could be created through art as well as history. Wood's conviction is supported by the longevity of the legend preserved in Longfellow's lines:

> Through all our history, to the last,
> In the hour of darkness and peril and need,
> The people will waken and listen to hear
> The hurrying hoof-beats of that steed,
> And the midnight message of Paul Revere.

Wood's mission took on added urgency during the Great Depression, when *The Midnight Ride of Paul Revere* was painted. The image of the United States as a young and vibrant nation was beginning to lose its luster; at the same time, American art was losing its traditional association with ordinary life as younger artists exchanged regional subjects and traditions for the more cosmopolitan, largely abstract styles emerging from Paris and New York. Grant Wood struggled against that tide, committed to his dream of a truly American art that would link the present to the past and preserve all the stories that made up the American heritage.

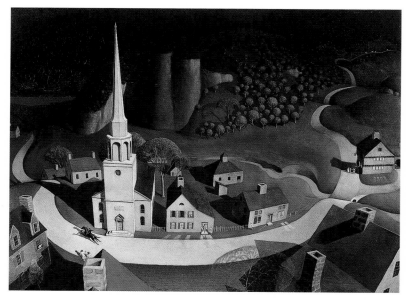

3-A Grant Wood (1892–1942), *The Midnight Ride of Paul Revere*, 1931. Oil on Masonite, 30 x 40 in. (76.2 x 101.6 cm.). The Metropolitan Museum of Art, Arthur Hoppock Hearn Fund, 1950 (50.117). Photograph © 1988 The Metropolitan Museum of Art. Art © Estate of Grant Wood / Licensed by VAGA, New York.

TEACHING ACTIVITIES
E = ELEMENTARY | **M** = MIDDLE | **S** = SECONDARY

Encourage students to look closely at this painting and observe its many details.

DESCRIBE AND ANALYZE

E | M | S

Have each student write a list of at least five different objects they see in the painting. Let them point out what they see to their classmates.

E | M | S

Have students locate Paul Revere on the horse. Ask where he seems to be going and where he has been.

E | M | S

How did the artist show that Revere was on an urgent mission?
He leans forward as his horse's tail and legs stretch out in a gallop.

E | M | S

Have students look at the painting with their eyes squinted. What do they see first? *They probably will see the church.*
How did the artist emphasize the church? *It is large and its brightness contrasts with the dark background.*

M | S

Ask students to describe how Wood guides them through the story in this picture. Have them follow the road through the scene beginning from the distant lights in the upper right.

INTERPRET

E | M

Encourage students to guess what time of night this might be. What clues has Wood given us? *The dark sky, deep shadows, muted background colors, lights in the houses, and people in white night clothes suggest that it is late at night.*

E | M

Ask what the biggest light source in this scene is. *They will probably say "the moon."*
Where is it in the sky? *It is located a little to the right.*
Why do students think this? *The shadows are on the left of objects.*

E | M | S

Ask students if they have ever seen moonlight this bright. Does it seem natural? Why or why not? What other light in this painting seems unusual for an eighteenth-century village?
The house lights are a little too bright for candlelight, and more like yet-to-be-invented electric lights.

E | M | S

Encourage students to guess what some of the buildings are. *One example is the small building that might be an outhouse (this was before indoor plumbing) that is in front of a schoolhouse topped with a cupola.*

M | S

If students have studied New England, ask them how this scene is typical of a New England village.
The land is hilly with a river near the town. Houses with chimneys cluster around a white church with a tall steeple.

M | S

Ask students where someone might stand to view this scene from this angle.
Most likely one would take a position above the town, maybe on a high hill or even on a tall building.
Discuss what Wood implies about this scene by painting it from this angle.
He suggests that it is a story with a feeling of fantasy. We're looking down on the scene as though we were flying over it in a dream or as though it were a toy village.

M | S

What else makes this village seem not quite real — more like a stage set?
Students might notice that the lighting seems like a spotlight. Some may notice the lack of details; everything is simplified or slightly stylized to look like a perfect village — even most of the trees are round with smooth edges.

S

Have students explain why they think this is or is not an appropriate way to depict this important American legend.

CONNECTIONS

Historical Connections: Revolutionary War; importance of Boston in colonial and Revolutionary times

Historical Figures: Paul Revere; King George III; Patrick Henry; John Adams; Samuel Adams

Geography: colonial America

Literary Connections and Primary Documents: "Paul Revere's Ride," Henry Wadsworth Longfellow (elementary); "The Ride of Tench Tilghman," Clinton Scollard (middle, secondary); "The Concord Hymn," Ralph Waldo Emerson (middle, secondary)

Arts: perspective; Regionalism

THE MIDNIGHT RIDE OF PAUL REVERE, 1931, GRANT WOOD [1892-1942]

3b George Washington (Lansdowne Portrait), 1796

Although George Washington sat for the most prominent artists of his day, Gilbert Stuart's images of the first president and hero of the American Revolution have been so widely reproduced that it is almost impossible for Americans to conceive of Washington in any other way. Less than a quarter-century after his death, the writer John Neal had already proclaimed, "The only idea we now have of George Washington is associated with Stuart's Washington."

Stuart was born in Newport, Rhode Island, to an immigrant Scotsman who made his living grinding tobacco snuff, an important commodity in colonial America. Apprenticed to a limner—an artisan painter without formal training—his innate talent soon brought him commissions from prominent clients. On the eve of the Revolution, he sailed for England to learn art in the European tradition. During his eighteen years abroad, Stuart achieved reknown as a portrait painter who worked best from the living model, laying down his colors carefully one over the other— "not mixed," he explained, "but shining through each other, like blood through natural skin."

His ability to charm clients and set them at ease allowed him to capture their inner character, which (following a popular theory called physiognomy) he believed was reflected in their physical features. For Stuart, Washington's features indicated a man of great passions. The painter's daughter, interviewed in 1867, recalled that her father had mentioned this to a mutual friend of Washington, adding however, that the president kept his temper under wonderful control. When the same friend related the remark to the Washingtons, Martha was taken aback, but the president simply smiled and said, "He is right."

When Gilbert Stuart returned to his native land in 1793, he soon set out for Philadelphia, the largest city and the temporary capital of the new nation, with the intention of seeking a commission to paint the president. A portrait of such a revered individual would bring the artist fame and more sitters. Before the age of mass reproduction, a painter could make hefty sums through copies of original works, either by his own hand or through engravings to which he would hold copyright. Stuart knew that people, both in America and abroad, desired to have a portrait of George Washington.

By 1795, Stuart had the first of three portraits of the president completed. It was immediately successful. Washington sat for Stuart at least once more, in April 1796; and the president and his wife visited the artist in 1797, perhaps in reference to an unfinished bust-length portrait now at the Boston Athenaeum. An engraved version of the Athenaeum portrait is the one people see every time they pull a dollar bill out of their pockets.

The full-length Lansdowne portrait reproduced here summarizes Washington's role as leader and father of his country and is one of Stuart's most impressive works. It was painted in 1796 for William Petty, the first marquis of Lansdowne, a great admirer of Washington. The work is conceived in the grand European manner used to depict nobility: The president stands in the classical pose of an orator before a background of draperies, columns, and a glimpse of landscape. Yet the details are distinctly American. Washington wears the black velvet suit he used for formal occasions. On the table, volumes of the *Federalist* and the *Journal of Congress* refer to the foundations of government and Washington's role as head of state. The medallion emblazoned with the Stars and Stripes on the back of the chair is part of the Great Seal of the United States. When the portrait was displayed in New York City two years later, an advertisement noted that Stuart had painted Washington, "surrounded with allegorical elements of his public life in the service of his country, which are highly illustrative of the great and tremendous storms which have frequently prevailed. These storms have abated and the appearance of the rainbow is introduced in the background as a sign."

Many anecdotes relate the difficulty Stuart had in breaking through Washington's public manner. It took all of the painter's considerable conversational talents to draw out the inner man. He was apparently successful, for Washington's grandson noted that the Lansdowne portrait was "the best likeness of the chief in his latter days."

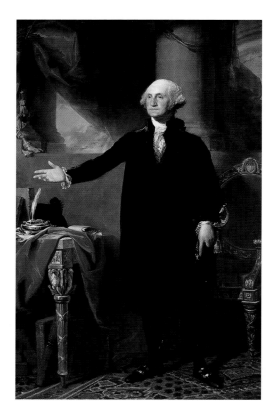

3-B Gilbert Stuart (1755–1828), *George Washington,* 1796. Oil on canvas, 97½ x 62½ in. (247.6 x 158.7 cm.). National Portrait Gallery, Smithsonian Institution, Washington, D.C.; acquired as a gift to the nation through the generosity of the Donald W. Reynolds Foundation. © 2008 Smithsonian Institution. Courtesy of the National Portrait Gallery.

TEACHING ACTIVITIES
E = ELEMENTARY | M = MIDDLE | S = SECONDARY

| **Encourage students to look closely at this painting** and observe its many details.

DESCRIBE AND ANALYZE

E

Ask students to describe Washington's facial features, hairstyle, and clothes.
He has rosy cheeks; a large, straight nose; a closed, thin mouth; a strong jaw; and dark eyes. His wavy hair is powdered; it is pulled back into a ponytail. He wears a black velvet suit, white ruffled shirt, black stockings, and black shoes with silver buckles.

E | M | S

How old do students think Washington appears in this painting? Why? *Explain that he was in his sixties.*

E | M | S

Gilbert Stuart wanted to reflect his sitters' inner character through their faces and outward appearance. From this portrait how would you describe Washington's inner character?
Students may suggest terms such as serene, intelligent, dignified, or calm.
Stuart saw great passion in Washington's features. Ask students if they also see this. Why or why not?

E | M | S

Ask students to find these objects and tell what they might represent.
Rainbow: *Located in the top right corner; it may signify the promise of better times.*
Medallion with stars and stripes: *The medallion, located on the top of the chair, is part of the Great Seal of the United States.*
Ink stand with quill: *Found on the table and engraved with Washington's family coat of arms, it was used for writing—possibly signing papers such as bills passed by Congress.*
Books (on and below the table): *They concern the government and founding of the United States.*
Saber: *During the Revolution, Washington commanded the American army, and as president, he was commander in chief of the military.*

E | M | S

Compare this portrait to the one on a dollar bill.
They are very similar, but do not face the same direction.
(Explain that the dollar-bill image was engraved—the portrait engraved on the metal faced the same direction as in the painting—but when the inked plate was pressed on paper, the image was reversed.)

M | S

Encourage students to notice the details of the background: the drapery, columns on a plain wall, clouds in the sky, and the rainbow. Explain that this type of background was often used in European portraits of nobles and that Gilbert Stuart had studied painting in Europe.

INTERPRET

M | S

Ask students why they think Stuart painted Washington with his arm outstretched.
This pose was oratorical and used by people making speeches.

S

Ask students how Washington's appearance reflects how he wanted people to see him. Remind them that contemporary European rulers wore ornate wigs and brightly colored clothes.
Washington wears a plain black suit and no wig. He showed that the United States president was a citizen, not a king. This emphasized his belief that all men are created equal.

S

Ask students why Stuart made copies of this painting. Why did so many people want portraits of George Washington?
Americans respected Washington as their great leader. They wanted portraits of him in civic buildings as well as in their own homes. Even an English nobleman who had supported the American cause wanted Washington's portrait.

CONNECTIONS

Historical Connections: French and Indian War; U.S. presidents; Constitutional Convention

Historical Figures: George Washington; John Jay; Alexander Hamilton; the Marquis de Lafayette

Civics: U.S. Constitution; powers and duties of the three branches of government

Geography: cities of colonial and Revolutionary America (Boston, Philadelphia, etc.)

Literary Connections and Primary Documents: *George Washington's Birthday: Wondering,* Bobbie Katz (elementary); "Occasioned by General Washington's Arrival in Philadelphia, On His Way to His Residence in Virginia," Phillip Freneau (middle, secondary); Washington's Farewell Address (1796); *Federalist Papers* (1787–1788); Virginia Declaration of Rights (1776); Massachusetts Body of Liberties (1641); Mayflower Compact (1620); John Locke's *Treatise of Civil Government* (1690); English Bill of Rights (1689)

Arts: portraiture; Roman Republican and Iroquois images (eagle and clutched arrows)

4a Washington Crossing the Delaware, 1851

In Emanuel Leutze's painting, the commander of the Continental Army against Great Britain stands boldly near the prow of a crowded boat and navigates the treacherous Delaware River on Christmas night, 1776. The Declaration of Independence had been signed earlier that year in the summer heat of Philadelphia, and through the sobering autumn months General Washington led an army of dwindling numbers, with defeats mounting and morale sinking.

Soundly beaten in New York, Washington was pursued through New Jersey into Pennsylvania by British General William Howe, who fully expected to take Philadelphia, the seat of the Continental Congress. However, in his retreat across the Delaware River, Washington shrewdly seized all the available boats to ferry his men from the New Jersey banks to the Pennsylvania side. A confident General Howe, certain the war was all but won, had already returned to New York in mid-December, leaving his British and Hessian mercenary troops in the Trenton area. The commanders left in charge plotted a river crossing as soon as the Delaware iced over. Washington acted immediately when his spies uncovered the plan. With the same boats used to flee the British, he and his men recrossed the river at Trenton, found the enemy, killed several officers, and captured more than nine hundred prisoners. The surprise attack not only checked the British advance but helped restore morale to the rebels. The victory confirmed Washington's leadership and the brilliance of his military strategy, both vital to reinvigorating the American cause.

Leutze grew up sharing the democratic ideals of the American Revolution and frequently represented them in his historical and literary paintings. The December battle at Trenton, a turning point in the war, appealed to the German-born painter, who had immigrated to the United States as a child decades after the Revolution. His works are combinations of carefully researched information presented in a meticulously rendered dramatic style. Leutze's theatrical interpretations of historic events brought him private and government commissions.

The sheer size of Leutze's canvas, twelve by twenty-one feet, pulls anyone standing before it into the scene. The viewer is nearly the same size as the painted figures and the action seems only a few feet away. Washington stands fast in the lead boat as his men struggle to navigate the craft through the choppy, ice-filled waters. Other boats follow, crowded with soldiers and jittery horses. We feel Washington's resolve and courage in facing the battle ahead as he leans forward into the blustering wind. As his men strain to pull the oars through the water, one deflects the ice while another at the back of the boat uses a paddle like a rudder to steer the course. Dawn glimmers below the troubled sky, and the American flag, blown and knotted by the wind, rises to a peak behind the General.

The Continental Congress did not officially adopt the flag shown in the painting until June 14, 1777, but according to tradition, Betsy Ross is said to have completed one of this design in late May or early June of 1776 at the request of George Washington and two other members of the Congress. The thirteen colonies represented in the flag's ring of stars are also symbolized in the painting by the thirteen men accompanying Washington in his boat, each in clothing representative of his colonial region. Leutze, a passionate abolitionist, included an African American as the third boatman from the front.

Hoping for a government commission, Leutze put the painting on public exhibit in New York in 1851. Within four months, fifty thousand people had paid to see it. Not long after, a private collector bought the work for ten thousand dollars, a stupendous sum at the time. Engraved reproductions, popular in nineteenth-century American homes, expanded the fame of the work even further. The attention and high praise Leutze received helped the artist obtain the commission for his mural *Westward the Course of Empire Takes Its Way*, which now occupies a stairway in the U.S. Capitol.

Originally, Leutze's painting was held in a carved and gilded wooden frame. Along the top of the work's original frame was a twelve-foot carved eagle holding a banner with the famous words from George Washington's eulogy, "First in war, first in peace, and first in the hearts of his countrymen."

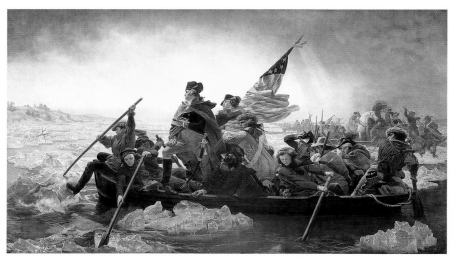

4-A Emanuel Leutze (1816–1868), *Washington Crossing the Delaware*, 1851. Oil on canvas, 149 x 255 in. (378.5 x 647.7 cm.). The Metropolitan Museum of Art, Gift of John Stewart Kennedy, 1897 (97.34). Photograph © 1992 The Metropolitan Museum of Art.

TEACHING ACTIVITIES
E = ELEMENTARY | M = MIDDLE | S = SECONDARY

Encourage students to let their eyes travel around and into the background of this painting.

DESCRIBE AND ANALYZE

E M S

Ask the students to compare the size of this twelve by twenty-one foot painting with something in the classroom, such as a wall. Explain that the figures in this painting are almost life-size.

E

Ask students to find these items.
Washington's white horse: *It is in the boat behind Washington's.*
A man wearing eyeglasses: *It is the man holding the flag.*
A branch floating in the water: *It is on the left.*

E M

Have students describe the men's clothing. Explain that they wear a variety of hats and shirts representative of their regions.

E M S

Ask students how Leutze emphasized Washington and the American flag.
He surrounds their upper bodies with white light, almost like a spotlight or halo.
Most of the colors in this painting are muted blues, grays, and browns. What bright color did Leutze include?
He included the color red.
In what part of the picture is this red located? *It is found only in Washington's boat.*
Why do you think he used red only in Washington's boat? *Red is a bright color and helps to lead our eye to Washington.*

E M S

Ask students to describe how Leutze created an illusion of great distance in this painting.
The distant men and land are smaller, lighter, bluer, and less detailed than those in the foreground.

E M S

Ask students who and what are moving in this scene. Who is standing still?
Only Washington and the distant land seem to stand still in the midst of moving water, ice, wind, and men struggling to control the boat.
How are they controlling the boat? *They are rowing the boat across the Delaware River, pushing ice floes away from the boat with their feet and oars, and trying to steer around the ice.*
How do you think they felt when they reached the opposite bank? *They were cold, tired, and wet.*

INTERPRET

E M S

Have students describe the weather and water conditions. Why isn't it an ideal day for boating?
A powerful storm is approaching from the right, creating a strong, bitter-cold wind. Floating ice clogs the swift, rough river.
Why would anyone want to cross the Delaware River in this weather?
Washington believed that the British were planning to attack his army as soon as the river froze. Washington knew the British would not expect an attack during this storm.

E M S

Ask students to describe the flag. Even though it is knotted and wrinkled by the wind, ask them to find symbols that appear on today's flag.
In the pictured flag, a circle rather than rows of stars are on an upper blue field, while red and white stripes fill the lower part of the flag.

S

Ask students if Washington's boat seems stable to them.
The boat is dangerously overloaded with this many men. The actual boats used by the army were larger but crowded with thirty to forty men.
Why do you think Leutze shows a smaller boat in this painting?
He is more interested in showing Washington and his brave men than the boat.

CONNECTIONS

Historical Connections:
Revolutionary War; Battle of Trenton

Historical Figures: George Washington; Nathanael Greene; Hessian soldiers; General Cornwallis; Abigail Adams; Mary Otis Warren

Civics: Founding Fathers; American flag; Declaration of Independence

Geography: rivers

Literary Connections and Primary Documents: *Crossing the Delaware: A History in Many Voices*, Louise Peacock (elementary); *The Secret Soldier: The Story of Deborah Sampson*, Ann McGovern (elementary); *Poems of Phillip Freneau, Poet of the American Revolution* (middle, secondary)

Arts: compare to works of Delacroix, Géricault, and other Romantic painters

4b Benjamin Franklin, 1862

At age fifty-three, Hiram Powers was the best-known sculptor in the United States when he contracted to produce this full-length, larger-than-life-size marble portrait of Benjamin Franklin for the U.S. Senate. As a young man, his naturalistic portrait bust of President Andrew Jackson (1835) had initiated a brilliant career. Largely self-taught, Powers was particularly noted for his ability to create the illusion of skin in marble; his nude female figure, the *Greek Slave* of 1843—described by the artist as not flesh but "spirit that stands exposed"—was an international sensation that permitted his Victorian audience to be simultaneously uplifted and titillated. Powers was constantly looking for lucrative and prestigious venues for his works, and no client was more desirable than the U.S. government, which was in the process of embellishing the Capitol at mid-century. In 1858, the government offered Powers a commission of twenty thousand dollars to sculpt the Senate's Benjamin Franklin and a full-length statue of Thomas Jefferson for the House.

Powers conveniently had an almost-completed plaster model of Franklin in his workshop in Florence, Italy, which he had begun about a decade earlier with the hope of using it for a government commission. Like other first-generation American sculptors such as Horatio Greenough and Thomas Crawford, Powers had paradoxically emigrated abroad in order to further his career at home. Powers could have shipped the fine Tuscan Severazza marble that he preferred (and from which this sculpture is carved) to America for the same price he paid to ship it to his Florentine studio. But Italy also supplied things readily and cheaply that America could not: experienced workshop assistants, free lectures on anatomy and dissection at the universities, and young females willing to pose in the nude. Furthermore, Italy abounded in great examples of the classical art that inspired Neoclassical sculptors such as Powers.

Many of Powers's contemporaries, such as the writer Nathaniel Hawthorne who visited him in Florence, objected to portraying historical figures in contemporary dress (rather than classical robes), fearing that future generations might find such garments odd or quaint. Powers disagreed in the case of full-length portraits. Although he did employ classically inspired devices in this work (a tree as stabilizing prop, the philosophical pose of head resting on fist, and the bent and relaxed leg stance called *contrapposto*), Powers's rendition of the most senior of the Founding Fathers is historically accurate in detail as well as highly naturalistic in style. The sculpture's attire is based on actual items from Franklin's mid-eighteenth-century wardrobe that the sculptor had imported from America. Powers captured the sense of weight and bulk of the heavy frock coat and the loose fit of the cotton hose, which crease around Franklin's ankles. His tricorne hat, with its soft, smooth folds, contrasts with the intricate play of lines in Franklin's middle-aged features.

The head, the sculpture's most important aspect, was based on the famous portrait bust of Franklin by his eighteenth-century contemporary, the French sculptor Jean-Antoine Houdon. Powers had made several earlier busts of Franklin based on Houdon's rendition; however, for the full-length figure, he appears to have also been inspired by a painting of Franklin made by Scottish artist David Martin in about 1776, in which the American sage is depicted as a contemplative man of science, with elbow resting on his desk and thumb beneath his chin. Franklin was internationally known for his book *Experiments and Observations on Electricity* of 1751, and the sculptor acknowledges this by having the standing Franklin rest his elbow on a tree trunk scored by lightning. Powers ingeniously employed a record of the electric charge to give a sense of Franklin's intellectual prowess. The slight curve of that vertical mark balances the figure's relaxed outer leg, and allows the eye to travel up through the curve of Franklin's right arm to his bowed, pensive expression.

The statue of Franklin, probably crated in one of the sculptor's personally designed cases in August of 1862, arrived at the Capitol that November, and was placed at the foot of the east staircase of the Senate wing, where it still stands.

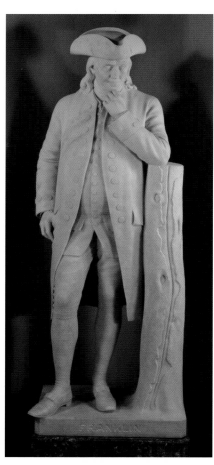

4-B Hiram Powers (1805–1873), *Benjamin Franklin*, 1862. Marble, height 97½ in., width 34⅞ in., depth 21⅝ in. (247.7 x 88.6 x 54.9 cm.). U.S. Senate Collection.

TEACHING ACTIVITIES

E = ELEMENTARY | **M** = MIDDLE | **S** = SECONDARY

Encourage students to look carefully at Franklin's dress, pose, and face in this statue.

DESCRIBE AND ANALYZE

E M S

Have students stand like Franklin with their weight resting on one leg and with the other leg bent. Notice how this is more relaxed than stiffly standing on two feet. Explain that this is a classical *contrapposto* pose. Students might view ancient Greek and Roman sculptures in this pose such as the nude *Doryphoros* (Spear-Bearer) of Polykleitos.

E M S

Describe Franklin's hair, hat, vest, coat, and shoes.
His long hair hangs in waves to his shoulders. He wears a three-cornered or tricorne hat, knee-length buttoned coat, long buttoned vest, and buttoned shoes.
What is Franklin wearing on his legs? How can you tell?
Wrinkles at his ankles suggest cotton stockings.
Encourage students to imagine how warm the typical clothes worn in 1776 would feel in Philadelphia's winters and summers.

M S

Even though Powers lived later than Franklin, he created a realistic portrait of him. Ask students how Powers learned about Franklin's clothes and face.
Powers studied pieces of Franklin's clothing imported from America, Houdon's bust of Franklin, and Martin's bust-length painting of Franklin. (Students may view Houdon's bust and Martin's portrait on the Internet.)

M S

Have students compare Franklin's pose to that of Gilbert Stuart's George Washington in 3-B.
Washington stands squarely on two feet while Franklin rests most of his weight on one foot. Washington holds one arm out like a gesture in a speech while Franklin's arms are close to his body with his chin resting thoughtfully on his fist.
Why is Franklin dressed so casually? *Franklin is dressed like an everyday citizen, in his role as an inventor.*
Explain that both Washington and Franklin wanted others to think of them as ordinary American citizens. When Franklin was at the French court seeking aid for the American Revolution, he also dressed in plain clothing rather than the silks and brocades of French nobility.

M S

Ask students why Powers included the tree stump in this statue.
The tree stump helps stabilize Franklin's body. Secondary students may know that classical Roman sculptures often had similar supports.
This classical art device suggests a classical sculpture. Also, the line in the center of the tree trunk shows that it was struck by lightning. Franklin was famous for his experiments with electricity, such as dangerously flying a kite in an electrical storm.

INTERPRET

M S

Ask students why the United States government wanted a statue of Benjamin Franklin in the U.S. Capitol.
Franklin was a member of the convention that framed the U.S. Constitution, which created the Senate. Students may read Franklin's speech supporting the adoption of the Constitution on the Internet.

S

Nineteenth-century sculptors often depicted leaders in classical Greek or Roman robes, reminding viewers that American government had its roots in ancient Greece. Remind students of the Statue of Liberty's robes. Powers was criticized for showing Franklin in contemporary clothing. Ask students why Powers chose to show Franklin in mid-eighteenth-century clothing rather than a Roman toga.
He wanted viewers to see and understand Franklin as a real person and to know how he actually looked.

CONNECTIONS

Historical Connections: Pennsylvania history; history of American diplomacy; Age of Enlightenment

Historical Figures: Benjamin Franklin; Thomas Paine

Civics: Founding Fathers; Constitutional Conventions

Science: electricity; other experiments and inventions

Literary Connections and Primary Documents: *Benjamin Franklin*, Ingri D'Aulaire (elementary); *B. Franklin, Printer*, David A. Adler (elementary); *Autobiography of Ben Franklin* (also known as *The Private Life of the Late Benjamin Franklin*) (secondary); *Poor Richards Almanack*, Benjamin Franklin (elementary, middle)

Arts: Neoclassical sculpture; idealism

5a View from Mount Holyoke (The Oxbow), 1836

"The imagination can scarcely conceive Arcadian vales more lovely or more peaceful than the valley of the Connecticut," wrote the artist Thomas Cole in his "Essay on American Scenery." "Its villages are rural places where trees overspread every dwelling, and the fields upon its margin have the richest verdure." This idealized view of rural America was already starting to collapse when Cole painted *View from Mount Holyoke, Massachusetts,* also known as *The Oxbow.* By the 1830s, Mount Holyoke had become one of the most popular tourist destinations in the United States, surpassed only by Niagara Falls, and the influx of sightseers was bound to disrupt its pastoral atmosphere. In selecting this corner of the country to preserve in a monumental painting, Cole produced an enduring visual record of a vanishing way of life.

Landscape was a popular and profitable type of painting in the early decades of the nineteenth century, when a growing population of urban dwellers looked on rural life as a remedy for the problems of industrialization. If they were too caught up in business to make weekend trips to the country, these affluent people could at least turn their gaze on a peaceful picture of the life they'd left behind. Cole's decision to portray the famous view from Mount Holyoke was initially commercial: he took advantage of the American taste for identifiable native scenery to paint what he hoped would be a marketable painting.

Intent on producing a crowd-pleaser, Cole adopted a trick from the panorama, a theatrical display in which an enormous picture is revealed to the spectator one section at a time. On a canvas nearly six feet wide, Cole painted the view from the top of the mountain as though it were experienced over time, with a dramatic storm thundering through the landscape. On the right side of the picture lies the Arcadia that Cole described in his essay — an idyllic place with tidy farms, a respectable number of shade trees, and a meandering river to enrich the soil. The distinctive feature of this peaceful place is the river's graceful bend into a U-shape that recalls an oxbow, itself an emblem of human control over nature. The scene is set just after the storm, when the skies are clearing and filled with a golden light.

In contrast, the left side of the picture shows the mountain wilderness still in the grip of the thunderstorm. The landscape is dark, with heavy skies and an ominous flash of lightning. The blasted trunks of the primitive forest appear unrelated to the useful trees scattered across the valley below. The two realms are linked by a small but significant detail: the red-and-white umbrella leaning diagonally from the mountainside to make a visual bridge across the river. Below it lies an artist's sketching gear, including a portfolio bearing the signature of Thomas Cole. The artist himself appears a few yards away, a tiny figure in a flat-crowned hat nestled with his easel into the rocks and trees. Even though the neatly divided farmland implies a human population, Cole is the only visible actor in this sweeping panorama, and he has planted his sunshade like a flag to claim the wilderness as his own territory.

It's difficult to know what Cole believed. He admired a landscape tamed and cultivated by human hands, but he also recognized that the "wildness" of the American landscape, a sphere of moral significance for Americans, was threatened by the arrival of civilization. On the hillside beyond the oxbow, Cole left a hidden message: the word *Noah* is roughly incised in Hebrew letters, a code that read upside down spells out *Shaddai,* the Almighty. Is Cole suggesting that the landscape be read as a holy text that reveals the word of God? If so, wouldn't any human intrusion be a sacrilege? On the other hand, the artist's careful division of the landscape implies that civilization drives out the danger and chaos inherent in the natural world. Perhaps the painting itself embodies Cole's ambivalence. It was produced, after all, expressly for public exhibition in the expectation of material gain — an artful exploitation of the nation's natural beauty.

5-A Thomas Cole (1801–1848), *View from Mount Holyoke, Northampton, Massachusetts, after a Thunderstorm — The Oxbow,* **1836. Oil on canvas, 51½ x 76 in. (130.8 x 193 cm.). The Metropolitan Museum of Art, Gift of Mrs. Russell Sage, 1908 (08.228). Image © The Metropolitan Museum of Art.**

TEACHING ACTIVITIES

E = ELEMENTARY | M = MIDDLE | S = SECONDARY

Encourage students to look closely at this painting; its left and right halves, and its foreground and background.

DESCRIBE AND ANALYZE

E | M | S

Explain to students that an oxbow is a U-shaped piece of wood that fits under and around the neck of an ox, with its upper ends attached to the bar of the yoke. Where is the oxbow in this painting?
It is located in the central curve of the river.

E | M | S

Have students find these objects.
An umbrella: *It is found in the lower center extending over the river.*
Thomas Cole sketching in a top hat: *He is located in the lower center between large rocks.*
Lightning: *It appears in the far left, center.*
Birds: *They are left of center on the edge of the storm.*
Smoke: *It appears in several places on the right.*

M | S

Have students compare and contrast the left and right sides of this painting. Which side is wilderness and which is cultivated farmland? This comparison may be written in a Venn diagram. Draw two overlapping circles. Where the circles overlap, list objects that appear on both sides of the painting. In the left circle, describe the objects on the left side of the painting, and in the right circle, describe objects on the right. Examples of Venn diagram answers:

large, rough, rugged
storm clouds, rain
wild forests, rocky

trees
indications of weather
land

small, neat trees
light, sunny day
cultivated fields

INTERPRET

E | M | S

Ask students why someone living in a city might want a picture like this in his home.
In the 1830s, many Americans were moving from farms to cities. This scene could remind them of the country's rural peace and beauty. Others might have seen this view when they were on vacation and wanted to remember it.

E | M

Ask a volunteer to pretend to be a TV weathercaster and give the weather forecast for the next few hours for this scene of the Connecticut River valley.

S

In the 1830s, America's wilderness was being settled. Untamed forests were transformed into cultivated farms and towns. Ask students what the approaching storm over the wild forest might symbolize.
It could suggest the coming destruction of the wilderness or the taming of wilderness by settlement.
Point out the double meaning of the Hebrew word (*Noah* and inverted *Almighty*) carved into the center hillside.
Ask students to consider what Cole's message might be about the rapidly changing face of the American continent.

CONNECTIONS

Historical Connections: Puritans; the idea of a City on a Hill

Historical Figures: Ralph Waldo Emerson; Henry David Thoreau

Literary Connections and Primary Documents: "Essay on American Scenery," Thomas Cole (secondary); *Nature*, Ralph Waldo Emerson (secondary); *Democracy in America*, Volume I (1835) and Volume II (1839), Alexis de Tocqueville (secondary)

Arts: Hudson River School; landscape painting

5b Cover Illustration for The Last of the Mohicans, 1919

The Last of the Mohicans, an American adventure tale by James Fenimore Cooper, became an instant bestseller when it was published in 1826. Its popularity continued, and by 1919, when N. C. Wyeth illustrated a new, deluxe edition of the book, Cooper's story had become a fixture in American boyhood. It has since fallen out of fashion, but its importance to American literature is firmly established: the protagonist, Natty Bumppo (called Hawkeye), a white scout raised by American Indians, is the first of many enterprising pioneer heroes to overcome the perils of the frontier. And even though *The Last of the Mohicans* had been illustrated before, Wyeth's pictures, like George Catlin's paintings in the previous century (see 6-B), did much to create an enduring image of the American Indian as a "noble savage."

Wyeth's teacher Howard Pyle had taught him to work only from experience. To prepare for *The Last of the Mohicans,* Wyeth made two trips to the Lake George region of New York, where the novel is set. He tramped through the woods and cooked over an open fire to gain an understanding of the wilderness and to allow the features of the landscape to impress themselves on his mind. Inspired by the crystal-clear summer atmosphere of the Adirondacks, Wyeth bathed his pictures in sky-blue tones that lend an air of tranquility to a violent and tragic story.

It was not possible for Wyeth to make the same careful study of the American Indians who figured in the novel. Cooper himself had confessed that when he wrote *The Last of the Mohicans,* he had never spent time among American Indians, and that most of what he knew of their lives and customs had been gleaned

from books or from stories passed down from his father. The novel takes place in 1757, during the French and Indian War, when the British and French fought over land that had long been home to Eastern Woodlands tribes. Wyeth was yet another generation removed from those historical events; like most Americans of his time, he possessed only the vaguest understanding of the original American peoples.

Although rooted in history, *The Last of the Mohicans* was Cooper's invention. To criticism that the characters were unrealistic, Cooper replied that the novel was intended only to evoke the past. The illustrator took the artist's poetic license one step further. This image, which appears on the cover of the book, was apparently inspired by Cooper's character Uncas, Hawkeye's faithful friend and one of the last Mohicans:

> At a little distance in advance stood Uncas, his whole person thrown powerfully into view. The travelers anxiously regarded the upright, flexible figure of the young Mohican, graceful and unrestrained in the attitudes and movements of nature.

Cooper stresses the American Indian's identification with the natural world, and Wyeth accordingly portrays Uncas in harmony with the landscape, framed by a formation of clouds. He retains other elements of Cooper's description as well, notably the account of Uncas's

> dark, glancing, fearful eye, alike terrible and calm; the bold outline of his high haughty features, pure in their native red…the dignified elevation of his receding forehead, together with all the finest proportions of a noble head, bared to the generous scalping tuft.

To capture the commanding presence of the character, Wyeth adopted a low viewpoint, so that the powerful body of Uncas appears larger than life as he advances right to the edge of the canvas, the unspoiled American landscape spread out below and behind him. In other respects, Wyeth alters Cooper's portrayal of Uncas. The Uncas whom Wyeth pictures is barechested, covered in war paint, and crowned with a feather, even though Cooper points out in the novel that Uncas's "person was more than usually screened by a green and fringed hunting shirt, like that of the white man." Even though the plot of *The Last of the Mohicans* depends upon the American Indians carrying muskets alongside European soldiers, Wyeth portrays Uncas with a dagger, a tomahawk, and a bow and arrow— weapons of precolonial warfare and the customary attributes of an Indian brave. While Cooper suggests the complexity of the character's position as a conventionally educated, English-speaking American Indian, Wyeth generalizes and romanticizes the Indian hero's appearance. In this way, he conforms to his era's understanding of American Indians, which was tightly bound to the ideal of an untamed wilderness.

5-B N. C. Wyeth (1882–1945), cover illustration for *The Last of the Mohicans,* 1919. Oil on canvas, 26 x 31¾ in. (66 x 80.6 cm.). Collection of the Brandywine River Museum, Chadds Ford, Pa., Anonymous gift, 1981. Reprinted with the permission of Atheneum Books for Young Readers, an imprint of Simon & Schuster Children's Publishing Division, from *The Last of the Mohicans* by James Fenimore Cooper, illustrated by N. C. Wyeth. Illustrations © 1919 Charles Scribner's Sons; copyright renewed 1947 Carolyn B. Wyeth.

TEACHING ACTIVITIES
E = ELEMENTARY | **M** = MIDDLE | **S** = SECONDARY

Encourage students to look closely at the figure and the background of this painting.

DESCRIBE AND ANALYZE

E | M | S
Where is the setting of this story?
This is set outdoors in a landscape. Explain that it is in upstate New York and that the shape of the hills and lake are similar to that of Lake George.

E | M | S
How did N. C. Wyeth show distance and space in this painting?
The mountains and river are small in relation to the figure, and the figure is set above the landscape in order to give a wide view of the valley. Middle and secondary students may also note that the background is lighter than the foreground, an artistic technique called aerial perspective.

E | M | S
Ask students to describe this character's clothing.
He wears a rough cloth or animal skin skirt, a leather strap across his chest, a thin belt holding his knife and tomahawk, an arm band, a feather in his hair, and body paint.
How does this clothing tell who he is?
In the early 1900s, this was how most Americans thought American Indians might have dressed. The weapons suggest that he is a warrior without a gun.
How does Wyeth emphasize the form of this warrior?
He makes him large, dark against a light background, outlines him in black, and surrounds him with a cloud that echoes his shape.

M | S
Ask students how Wyeth unified the landscape.
He used the same colors of blue and yellow throughout it.

INTERPRET

M | S
What does Wyeth suggest about the health and character of this American Indian?
He shows him to be strong, healthy, muscular, and standing straight. The intense stare of his eyes, his downturned mouth, and the set of his shoulders suggest that he is determined, alert, serious, and ready to act.

S
Explain to students that this painting is an illustration for a fictional novel, *The Last of the Mohicans.*
Ask why they think this is — or is not — an accurate depiction of an American Indian.
Even though James Fenimore Cooper described this character as wearing a shirt, Wyeth shows him shirtless. Wyeth also had very little knowledge of American Indian symbols.
Have students debate whether this novel should or should not have been illustrated with historically accurate likenesses of American Indians.

S
What might the cloud surrounding this character represent?
The cloud gives him a special character. It acts as his nimbus or aura.

CONNECTIONS

Historical Connections: French and Indian War; European colonies in North America; Huron, Mingo, Mohawk, Algonquin tribes and the Iroquois Confederacy; Pontiac's War

Historical Figures: King Philip; Marquis Louis-Joseph de Montcalm; Chief Logan; Pontiac

Geography: Adirondack region

Literary Connections and Primary Documents: *The Last of the Mohicans,* James Fenimore Cooper (middle, secondary); *Ishi, the Last Yahi: A Documentary History,* Robert Fleming Heizer and Theodora Kroeber (middle, secondary); *Hiawatha,* Henry Wadsworth Longfellow (middle); Pontiac's speech at Detroit (1763)

Arts: American Indian art; compare to work by George Catlin

6 a American Flamingo, 1838

American Flamingo is one of the 435 hand-colored engravings that make up John James Audubon's monumental *Birds of America,* issued in four volumes between 1826 and 1838. The massive publication includes life-size representations of nearly five hundred species of North American birds. Although Audubon was not the first to attempt such a comprehensive catalog, his work departed from conventional scientific illustration, which showed lifeless specimens against a blank background, by presenting the birds as they appeared in the wild. When his pictures were first published, some naturalists objected to Audubon's use of dramatic action and pictorial design, but these are the qualities that set his work apart and make it not only an invaluable record of early American wildlife but an unmatched work of American art.

John James Audubon was born in Haiti and educated in France, where he began to explore the natural environment and develop his talent for drawing and eye for beauty. In the first decade of the nineteenth century he immigrated to the United States to manage a farm his family owned near Philadelphia. He lost it through neglect, distracted by the overwhelming bounty and variety of exotic birds he found in the region. Audubon eventually set himself the heroic task of locating, collecting, and depicting every species of bird native to North America. He moved his family briefly to New Orleans, explored the environs of the Mississippi

River, a major flyway for migratory birds, and eventually wandered farther from home to comb the American frontier for unrecorded species.

Audubon's procedure was to study and sketch a bird in its natural habitat before killing it carefully, using fine shot to minimize damage. His critical innovation was to then thread wire through the specimen, allowing him to fashion a lifelike pose. He worked in watercolor, and had completed some four hundred paintings when he decided to publish them as a folio of prints. Failing to find support in Philadelphia, he sailed for England, where he became lionized as "The American Woodsman." The engraving firm Robert Havell and Son took on the challenge of reproducing Audubon's paintings on copper plates and tinting the resulting black-and-white prints by hand.

To make *Birds of America* useful to both professional and amateur ornithologists, Audubon portrayed his subjects at eye level so that their distinctive markings would be clearly visible. He also painted them as near as possible to their actual size. The images are huge, each about three feet by two feet; nevertheless, to make the larger specimens fit the page, Audubon had to mold them into unusual attitudes. Because the American flamingo can stand up to five feet high, Audubon was obliged to depict that bird bending down, about to dip its beak into the water. His solution has other advantages since it allows us to study not only the unmistakable plumage but other distinguishing traits that might otherwise be hidden from view: long spindly legs that help the flamingo wade into deep water, webbed toes to support it on muddy ground, a serpentine neck to twist the head backwards in the water, and a boomerang-shaped beak to filter water and trap food. Flamingos are uncommonly social creatures, so Audubon included other birds from the flock in the background, standing tall in shallow water; some appear in the more characteristic one-legged pose. The distant view also affords a glimpse of the flamingo's habitat, the marshes and barren mud flats not far from the coast.

Audubon's eye for design lends another dimension to his accurate draftsmanship. The flamingo's silhouette emphasizes the elegant curve of its body, even as the abrupt curve of its neck gives the shocking, momentary impression of a headless bird. The angle of the flamingo's beak echoes the edge of the rock on which it stands, just as the sharp angle of its front leg echoes the long, sinuous line of its neck. Audubon plays up the flamingo's trademark shade of pink by setting the bird against a background that appears, in comparison, drained of color.

Like other American artists who sought to record the unspoiled wilderness, Audubon recognized that much of the wildlife he portrayed was bound to vanish as civilization pushed westward. He himself had first encountered a flock of American flamingos in May 1832, while sailing from the Florida Keys. By the end of the nineteenth century, the birds had retreated to the southernmost point of Florida, and today can be seen in North America only in captivity.

6-A John James Audubon (1785–1851); Robert Havell (1793–1878), engraver, *American Flamingo*, 1838. Hand-colored engraving with aquatint, plate 38⅜ x 25⅛ in. (97 x 65 cm.); sheet 39⅞ x 26⅞ in. (101.28 x 68.26 cm.). From *The Birds of America* (plate CCCCXXXI). Gift of Mrs. Walter B. James, 1945 (8.431). Image © 2006 Board of Trustees, National Gallery of Art, Washington, D.C.

TEACHING ACTIVITIES
E = ELEMENTARY | **M** = MIDDLE | **S** = SECONDARY

Encourage students to look closely at this painting paying attention to the foreground and background, and what is outside of the picture's borders.

DESCRIBE AND ANALYZE

E | M | S
Ask students what they notice first when they look at this print. *It will probably be the large flamingo.*
Have them describe how Audubon emphasized the largest flamingo. *He made it fill the page, centered it in the composition, and placed its bright color against a relatively plain and muted background.*

E | M | S
Where are there patterns on this bird? *Patterns are found on the beak and in the pattern of the folded wings.*

E | M | S
What is in the background of this print? *We find other flamingos, marshes, water.*
What are the birds doing in this image? *They appear to be looking for food.*

E | M | S
Describe how Audubon indicated the large size of the flamingo's natural habitat.
He suggested distance by making water in the background lighter than that in the foreground and painting distant birds smaller and in lighter colors than the closest flamingo.

M | S
Audubon gave the flamingo its character by drawing many kinds of lines. Ask students to identify some of the different kinds of lines in the bird.
The bird has a wavy neck, wings made with smooth curves, and straight and angled legs.

E | M | S
Ask the students what they think the sketches at the top represent. *They are rough drawings of the beak and feet.*
Ask students to speculate about why they have been left in the print. *Perhaps to give additional information — how the beak looks when it is open, how the foot looks from above; to fill the space at the top so it doesn't look bare in comparison to the bottom; or to show that the artist observes as carefully as a scientist.*

INTERPRET

E | M | S
Ask students why they think Audubon painted his subjects life-size rather than just creating smaller pictures of them.
He wanted viewers to understand the actual size of these birds and to see the details in their bodies and wings.

E | M | S
Why do you think that Audubon positioned the flamingo like this with its neck bent down?
He wished to fit this big bird on the page, to create a pleasing composition, and to show how this tall bird was able to eat food in the water.

M | S
Have students explain what makes this print an artwork rather than just a scientific illustration.
Students may mention the life-like pose of the bird, the addition of the background, or the beauty of the composition.

S
Ask students if they think this flamingo looks alive or dead.
Students might think its pose and setting make it seem alive. Explain that photography hadn't been invented yet, and that Audubon had to kill the birds and arrange them in life-like positions so he could take the time necessary to study them in exacting detail.

S
Encourage students to consider why Audubon and other artists were intent on documenting American wildlife at this time in America's history.
As America was being settled and developed, there was a great interest in science and in learning about American plants and animals. Artists often joined expeditions to explore and document the American continent and its life forms.

S
Ask how this print of a flamingo is different from the plastic flamingos that people sometimes place in their yards. Are both types of flamingos art?

CONNECTIONS

Historical Connections: Jacksonian era

Geography: Florida Keys (Indian Key — natural habitat of the North American flamingo, now extinct.)

Science: classification of species; conservation and protection of species; birds

Literary Connections and Primary Documents: *My Style of Drawing Birds,* John James Audubon

6b Catlin Painting the Portrait of Mah-to-toh-pa—Mandan, 1861/1869

"There is occasionally a chief or warrior of such extraordinary renown, that he is allowed to wear horns on his head-dress.... The reader will see this custom exemplified in the portrait of Mah-to-toh-pa.... [He is] the only man in the nation who was allowed to wear the horns."

So wrote George Catlin in *Letters and Notes on the Manners, Customs, and Conditions of the North American Indians,* begun during the artist's two-thousand mile journey along the upper Missouri River to what is now North Dakota. It was the first of three self-financed trips between 1832 and 1836 that Catlin undertook in order to capture what he rightly believed to be the final and most thorough visual record of the indigenous cultures of the frontier. Just two years earlier, the Indian Resettlement Act, designed to send Eastern Woodlands tribes inland in order to "save" them from the steady encroachment of white civilization, had passed Congress.

George Catlin agreed with the resettlement policy. In his practical (yet sentimental) values, he was representative of the Jacksonian era, in which the United States, finally in control of the wilderness, felt a wave of nostalgia for what it was about to lose. Born in Wilkes-Barre, Pennsylvania, Catlin was a mostly self-trained, but successful, portrait painter with a business in Philadelphia. In 1828, according to the artist, an encounter with a delegation of Winnebago on their way to Washington changed the course of his career.

Catlin painted a full-length portrait of Mah-to-toh-pa, second chief of the Mandan people, in late summer of 1832. The Mandan, a stationary agricultural and hunting tribe living in

domed timber-and-earth lodges, occupied two villages above the Missouri River near present-day Bismarck. Catlin and Mah-to-toh-pa developed a close relationship: the painter was one of only two white men to observe the Mandan sacred rite, the O-kee-pa, before the tribe's extinction from smallpox in 1837.

In his *Notes,* the artist writes that Mah-to-toh-pa spent all morning dressing for his likeness. When he arrived in Catlin's dwelling, surrounded by admiring women and children, he brought a buffalo-skin robe that he had painted with the history of his battles. And he was wearing the headdress mentioned above. In addition to the war-club seen here, Mah-to-toh-pa carried bow and arrows, a lance, a shield, tomahawk, and a scalping knife, and wore a magnificent bear-claw necklace. Catlin's method was to work quickly, "chalking out" the outlines of the figure on canvas, building up the head and bust in warm tones, and then often blocking in the rest of the work, including the body and details of the costumes, to be finished later. On careful inspection we can see that the artist does not represent the chief's costume as he described it. Missing are the robe, the necklace, and all the instruments of war. Catlin admits in his *Notes* that he altered the chief's dress to enhance the "grace and simplicity of the figure," although some historians believe the artist took away the weapons because he did not want Mah-to-toh-pa to appear overly threatening to a white audience.

In 1838, Catlin organized his five hundred or so paintings and artifacts into a touring show that he called his Indian Gallery. When the government showed no interest in buying it, he moved the gallery to London. Unfortunately, Catlin lost his life's work plus many priceless artifacts to creditors; his works were acquired as a gift to the Smithsonian and the National Gallery of Art only after his death.

This image of Catlin painting the chief is one the artist reproduced from memory later in his life; it derives from a print that served as the frontispiece to his *Notes,* published in 1841, when he was living in England. Catlin's *Notes* tell us that the painting is incorrect in many details: the location is not indoors, and the individuals surrounding the chief include braves. Even Catlin's attire is a little too neat for the wilderness. Surrounded by onlookers, he seems to be showing off a bit, and indeed, when we look carefully, it becomes apparent that Catlin's role as artist is really the subject of this work. The glowing canvas on its makeshift easel occupies the center of the painting, and our eyes travel between Mah-to-toh-pa and his likeness. The open-mouthed audience, who according to Catlin were aghast at his skill in capturing what many Indians believed to be a part of the sitter's spirit, is eloquent testimony to the artist's ambition and stunning accomplishment.

6-B George Catlin (1796–1872), *Catlin Painting the Portrait of Mah-to-toh-pa—Mandan,* 1861/1869. Oil on card mounted on paperboard, 18½ x 24 in. (47 x 62.3 cm.). Paul Mellon Collection. Image © 2006 Board of Trustees, National Gallery of Art, Washington, D.C.

TEACHING ACTIVITIES

E = ELEMENTARY | M = MIDDLE | S = SECONDARY

Have students look carefully at this painting, noticing its different elements.

DESCRIBE AND ANALYZE **E | M**

Ask students to locate these elements.
Two dogs: *They are located in the front and center.*
Artist and easel: *They are found in the center.*
Quiver: *It is in the left front.*
Five horses: *They are found in the background.*

E

Have students describe the setting for this painting.
It's on a level grassy area beside a river. Trees are in the background.

E | M | S

Ask students to describe the chief's dress.
He wears a long feathered headdress, ornaments in his hair, a decorated shirt or tunic, leggings, and moccasins.
Ask students to describe Catlin's easel.
It's made of three tree branches tied together like a teepee.
Ask students how Catlin emphasized Mah-to-toh-pa in this painting.
He is a light figure in front of a much darker crowd of onlookers, larger than the other figures, and near the center of the painting. He and Catlin are the only ones standing.
What else did Catlin emphasize?
The portrait on the easel almost glows.

M | S

Have students explain the main subject of this scene. Is it Catlin painting or a Mandan chief?
It depicts Catlin creating art and is not just a portrait of the Mandan chief.

INTERPRET **E | M | S**

Why do you think all these people are so interested in watching Catlin paint a portrait?
They were familiar with American Indian paintings and may have been curious to see how the white man made his images. Also, to many, creating realistic likenesses of people may have seemed like capturing their spirit on paper or canvas.

E | M | S

Ask students why historians value Catlin's paintings.
Catlin shows details of American Indians' dress and life before they adopted European clothes and customs.

M | S

Tell students that when Catlin first painted Mah-to-toh-pa's portrait, they were indoors, but Catlin changed the setting when he painted this version. Ask students why they think Catlin might have done this.
One answer is that perhaps he thought an outdoor setting would be grander, would better reflect the Mandans' home on the plains, and would allow him to include more people in the scene.

M | S

Explain to students that Catlin did not include in this painting all the weapons that the chief was wearing when he posed for it. He said he left these out because he wanted to emphasize the grace and simplicity of this figure. Ask students if they think it is or is not all right for an artist to change details in a painting such as this. How would our impression of Ma-to-toh-pa change if he were wearing all his weapons?

CONNECTIONS

Historical Connections: Lewis and Clark expedition; Louisiana Purchase; Manifest Destiny; Westward Expansion; American Indian tribes and histories; Trail of Tears; Indian Removal Act

Historical Figures: Thomas Jefferson; Andrew Jackson; Meriwether Lewis; William Clark; Sacajawea

Geography: Westward Expansion; lands of American Indian tribes

Literary Connections and Primary Documents: *The Story of Sacajawea: Guide to Lewis and Clark,* Della Rowland (elementary); *I Will Fight No More Forever,* Chief Joseph (elementary); *Letters and Notes on the Manners, Customs, and Condition of the North American Indians,* George Catlin (middle, secondary)

7a State Capitol, Columbus, Ohio, 1838–1861

The Ohio State Capitol sits on Capitol Square amid the city bustle of Columbus. Its serene exterior, constructed of native Ohio limestone, gives little indication of the many architects responsible for it, the politics involved, or the time it took to build.

The idea for a new structure to replace the small brick building where the Ohio Legislature had met since 1816 came to fruition in January 1838; the Legislature passed the Ohio Statehouse Bill and the city of Columbus finally seemed secure as the site for the Capitol. The era of Andrew Jackson (1829–1837), with its populist appeal and increasing voter participation, had awakened the self-consciousness of state legislatures. Ohioans were eager to have a structure that expressed their particular identity. As an 1839 building commission report stated: "A state destitute of great public works…is not likely to have its institutions cherished and sustained, and its soil defended."

The competition for the commission, advertised in Ohio, Philadelphia, New York, and Washington newspapers, drew between fifty and sixty entries. The new Capitol was to be in Greek Revival mode, a style that recalled the birthplace of democracy. Three similar designs were chosen by the Capitol Commission as acceptable in 1838. All were compact, rectangular structures that sat on high foundations. The entrances designed by the first- and second-place winners, Henry Walter of Ohio and Martin Thompson of New York, respectively, had projecting porches crowned by pediments (triangular gables). In third place was Thomas Cole, the New York painter (see 5-A), who eliminated the pediment and created the most

compact and horizontal building of them all, articulated by pilasters (square pillars attached to the wall) with inset windows and a stepped-back, columned porch. Although each contestant's conception was distinct, all the winning designs departed from a strictly Greek style by incorporating a dome.

Still plagued by indecision, the Commission began to lay the foundation for the Capitol in 1838. Cole's design was chosen (with modifications) as the favored one in 1839, although the reasons underlying this are unclear. Unlike the other entrants, the painter had no solid experience in building and used the expertise of his draughtsman nephew to help him draw up his plans. Cole did have architectural pretensions, however, and had listed himself as an architect in the 1834–1835 New York architects' directory. Moreover, he had lived in Ohio in his youth and was a close friend of William Adams, a member of the Capitol Commission. On receiving third place, Cole wrote Adams to complain, "In justice, I ought to have *first* premium."

Probably as consolation, Walter, the first-place winner, was appointed supervisor of the works. The cornerstone was laid on July 4, 1839, and by the end of the year, the walls of the Capitol's foundation, erected with convict labor, were well underway. However, economic factors caused by the bank panic of 1837 and a failed resolution to relocate the capital away from Columbus left the project stagnant for eight years, a pasture for livestock. Work resumed in 1848, and from that point until the Capitol's completion in 1861, four more architects would put their imprint on the building and wrestle with the Legislature and the Commission, all but the last to resign in frustration.

The design of the Ohio Capitol took its final form between 1848 and 1854 under the guidance of William Russell West, who brought the Doric columns of the porch in line with the body of the building, adhering to the compact form of Cole's original plan. West is also responsible for the rather small, eccentric pediment that seems to float over the porch and shields the observer's eye from the base of the drum lying behind it. His most obvious change, however, was in the temple-like cupola that stands over the drum, encasing the interior rotunda windows. By dispensing with the dome and substituting a conical roof, West adhered not only to budgetary concerns, but to the spirit of Greek Revival.

The Ohio State Capitol, restored in 1993, is testament to a period that expressed its democratic ideals in monumental form. Its pair of recessed porches, with their eight columns, bows to the scheme for the east and west fronts of the Parthenon in Athens. The cupola also refers to another type of Greek temple, the round *tholos*. Cole's inspiration for pilasters instead of columns to articulate the cupola and the body of the building gives the Capitol a regular, stately rhythm, entirely fitting for the seat of government. A structure, as the 1839 Commission stated, meant "not for ourselves only, but for future generations."

7-A Ithiel Town and A. J. Davis, architects; design largely by Thomas Cole, Ohio State Capitol, Columbus, Ohio, 1838–1861. Photograph © Tom Patterson, Cincinnati, Ohio.

TEACHING ACTIVITIES

E = ELEMENTARY | M = MIDDLE | S = SECONDARY

Encourage students to look closely at all the different parts of this building.

DESCRIBE AND ANALYZE

E | M | S

Have students compare this building to the modern ones behind it.
The modern buildings are taller with flat roofs and many more windows.
Why is this nineteenth-century building shorter than the modern ones?
Building materials and techniques of this era limited the height of buildings. Also elevators were not common in buildings until later in the century.

E | M | S

Show students pictures of Greek temples such as the Parthenon. (They are plentiful on the Internet.)
Explain that the Ohio State Capitol is an example of Greek Revival, a popular nineteenth-century architectural style based on classical Greek and Roman structures. Ask students how this resembles Greek architecture.
It has columns, a pediment, and is symmetrical. Like the ruins of ancient Greek buildings, which have been stripped of color, it is built of light stone.

M | S

Locate and identify these architectural features that are found on classical Greek and Roman architecture.
Pediment: *It is the triangle above the entrance.*
Columns: *They are the upright posts in the shape of cylinders on the porch.*
Capitals: *They sit like hats at the very top of the columns; the simple capitals are a variation of the Greek Doric style.*
Pilasters: *These are the vertical structures that resemble columns, but are instead attached to the walls on each side of the porch.*
Drum: *It is the round doughnut-shaped structure at the top that supports the conical roof. It is not visible in this view.*
Entablature: *It is the two-part horizontal band supported by the column capitals and pilasters.*

M | S

How did the architects create a sense of harmony in this building?
They constructed most of the building from the same light limestone and repeated the shape and equal spacing of the pilasters and columns in a steady rhythm across the façade.

INTERPRET

M | S

Ask students to explain why Greek Revival was a popular architecture style for government buildings in the nineteenth century.
Ancient Greece invented democracy as a form of government. At this time in history, Americans were becoming more democratic with increased voter participation and awareness of their state legislatures, and states wished to express their identity in their statehouses.

S

Explain how the architect for this project was selected.
Architects submitted designs in a competition. Three top finalists, including landscape painter Thomas Cole, were selected. Even though Cole lacked building experience, his design was chosen.

CONNECTIONS **Historical Connections:** Northwest Ordinances; statehood

Historical Figures: Thomas Jefferson

Civics: role of state government

Geography: state capitals

Arts: Greek Revival; Doric mode; Thomas Cole

STATE CAPITOL, COLUMBUS OHIO, (1838–1861), THOMAS COLE [1801-1848]

GEORGE CALEB BINGHAM [1811–1879]

7b The County Election, 1852

The County Election pictures the American democratic system in progress. The story takes place in a small Midwestern town in the mid-nineteenth century, when the rituals of voting were still taking shape, particularly on the frontier. George Caleb Bingham, known as "the Missouri artist" for the state where he lived and worked, recognized the responsibilities as well as the rights of citizenship; and because he played an active part in Missouri politics, he gained a personal perspective on the contemporary electoral process. In *The County Election,* Bingham presents a raucous voting party as an enactment of democracy, bringing together a variety of residents in a rural community to make decisions for the common good.

In this crowded composition, Bingham suggests the inclusiveness of a democracy with representatives of every age and social stratum—except, of course, African Americans, who would not enjoy the right to vote until after the Civil War, and women, whose right to participate would not be recognized for another seventy years. The painting reveals other irregularities in the electoral system that would not be tolerated today. Because there was no system of voter registration, the man in red at the top of the courthouse steps swears on the Bible that he hasn't already cast a vote. Because there was no secret (or even paper) ballot, a voter calls out his choice to the election clerks behind the judge, who openly record it in a ledger. Because there were no restrictions on electioneering, the well-dressed gentleman behind the voter—evidently one of the candidates—is free to hand his card to citizens just before they cast their vote. Yet none of this appears to dull the spirit of the voting process.

The lack of a single dramatic focus in *The County Election* is an expression of the democratic ideal: all men appear as equals, with no one vote worth more than another. Several members of the electorate engage in serious discussion, perhaps debating the candidates' qualifications. Another group clusters around a newspaper, a potent tool of democracy. Nevertheless, Bingham seems to question the integrity of an election conducted so casually. In the left foreground, a portly man already sprawled in his chair accepts more hard cider from an African American precinct worker, presumably in exchange for a vote. Behind him, a well-to-do gentleman literally drags a slumping body to the polls as he casts a meaningful glance toward the candidate in blue. A figure beside the courthouse steps (directly below the man giving an oath) tosses a coin, as though the winner of this contest might as well be determined by luck (or money) as by an orderly election; and in the foreground, the actions of two boys, absorbed in a childhood pastime in which a knife thrown into the ground determines the winner, suggest that the political process is little more than a game of chance. More ominously, a tattered figure in the front right corner hangs his bandaged head, perhaps to imply that for all the apparent good will of the crowd, violence lies just beneath the surface.

Besides commenting on American electioneering in general, *The County Election* records a particular political event. As many of Bingham's contemporaries would have known, the painting depicts Election Day 1850 in Saline County, Missouri, when the artist himself was running for a place in the State Legislature. Bingham lost that election to E. D. Sappington, whom he represents as the unprincipled candidate in the shiny top hat. Sappington, with his workers, did try to buy votes with liquor, and because he was related to the judge and one of the clerks, the election's outcome naturally aroused suspicion. Bingham did not contest the results, but *The County Election* makes an obvious indictment of his political opponent. The artist himself makes an appearance in the picture as the figure in the stovepipe hat seated on the courthouse steps, attended by a friendly dog and two men in white hats who pause to look over his shoulder. Bingham's quiet concentration sets him apart from the crowd, and we can only wonder whether he is keeping track of the votes in order to tally them for himself, or sketching the unruly practices of a young democracy.

7-B George Caleb Bingham (1811–1879), *The County Election,* **1852. Oil on canvas, 38 x 52 in. (96.5 x 132.1 cm.). Saint Louis Art Museum, St. Louis, Mo., Gift of Bank of America.**

TEACHING ACTIVITIES

E = ELEMENTARY | M = MIDDLE | S = SECONDARY

Encourage students to look closely at this painting and notice the many different things people are doing.

DESCRIBE AND ANALYZE E|M|S

Ask students to guess what is happening in this painting. Look for clues. It's Election Day, 1852. Most of these people are voters.
Ask students to find these elements.
A white dog: *It is located in the center.*
A seated man in a top hat who might be sketching or writing: *He is located in the center — that's the artist.*
A man pouring drinks: *He is on the left.*
A man with a bandaged head and a horse and rider: *They are in the center distance.*

E|M|S

Where is this scene taking place?
It is located on the courthouse steps in a small Missouri town.

M|S

Ask students to describe how Bingham unified this scene so that many figures form a connected group.
He repeated shapes and colors and overlapped the bodies.

M|S

How did Bingham create an illusion of depth?
He made shapes overlap and made objects in the distance smaller. Parallel lines in the buildings and table slant up and get closer in the distance. Distant objects are much lighter and bluer.

INTERPRET E|M|S

Why are there no women in this scene?
American women could not vote in 1852.

E|M|S

Ask students to describe the different shapes of hats in this painting. What do the hats suggest about the occupations of these individuals?
The tall stiff hats with the small brims (top hats) probably belong to the politicians. Farmers and laborers wear hats with softer crowns and wider brims.

S

What message does Bingham give in this crowded scene about the election process in American democracy?
A whole community of men, from rich to poor, comes together to vote. Notice how no one figure is emphasized or made larger than others in this crowd. That suggests that all the votes are equal.

S

Have students compare this election scene to a contemporary American voting scene.
Today Americans vote with secret ballots in private booths rather than declaring their votes while surrounded by fellow citizens. Women and African Americans would be among the voters. Today campaigners are kept a legal distance from the actual polling place.

CONNECTIONS

Historical Connections: American frontier; Jacksonian era

Historical Figures: Andrew Jackson; Susan B. Anthony, Elizabeth Cady Stanton; Lucretia Mott; Sojourner Truth; Lyndon B. Johnson

Civics: U.S. Constitution; elections (local, state, federal); Voting Rights Act of 1965; Fourteenth and Fifteenth Amendments

Literary Connections and Primary Documents: *Vote!,* Eileen Christelow (elementary); *Democracy in America,* Volume I (1835) and Volume II (1839), Alexis de Tocqueville (secondary); Susan B. Anthony's speech at her trial of 1873 (middle, secondary); *The Ballot or the Bullet,* Malcolm X (secondary)

Arts: American Realism; genre painting

8a Looking Down Yosemite Valley, California, 1865

In a time when few Americans had ventured west of the Mississippi, *Looking Down Yosemite Valley, California* offered a welcome view of one of the natural wonders on the far side of the continent. After his first trip to the American West in 1859, Albert Bierstadt produced a sequence of landscape paintings that proved so popular with East Coast audiences that he was eager to return to paint more. The onset of the Civil War post-poned his trip, but in 1863 Bierstadt set off from Philadelphia to make the transcontinental journey by train, by stagecoach, and on horseback. When he finally reached California, the landscape surpassed his expectations. Born and educated in Germany, Bierstadt was well-acquainted with the beauty of the Alps; but nowhere in Europe, he maintained, "is there scenery whose grandeur can for one moment be held comparable with that of the Sierra Nevada in the Yosemite District." *Looking Down Yosemite Valley* supports that nationalistic claim and expresses the artist's own sense of wonder at his first sight of the majestic mountain landscape.

Bierstadt's exceptionally large canvas (five by eight feet) and panoramic view down the valley (twenty to thirty miles) were calculated to draw the viewer into the picture to enjoy the spectacle themselves. Some contemporary critics objected to these sensational devices, arguing that Bierstadt's methods made the picture look more like stage scenery than fine art — but this may in fact have been the desired effect. Bierstadt introduces no actors into his scene — not a single traveler, trapper, settler, or American Indian — and at the center of the composition, where we expect to find a dramatic climax to the action, there is only vacant space bathed in a golden light

that breaks through the clouds. In Bierstadt's scenario, the viewer takes the artist's point of view and discovers that before so magnificent a landscape, human beings dwindle to insignificance.

Yosemite had been isolated by its geography until just before mid-century, when the 1848 California Gold Rush brought a surge of non-indigenous people to the Sierras and the valley was "discovered." Americans were intrigued by the long-hidden valley, and Bierstadt satisfied their curiosity by documenting its major landmarks — the exposed granite block of El Capitán on the north side (the right of the canvas), opposite the spire of Sentinel Rock and masses of Cathedral Rocks — yet he exag-gerates even their imposing proportions. The golden haze that Bierstadt used to soften the edges of the magnificent cliffs may be meant to excuse his creative manipulation of the truth. As one San Francisco critic observed in 1865, "It looks as if it was painted in an El Dorado, in a distant land of gold; heard of in song and story; dreamed of but never seen."

Bierstadt possessed an uncanny understanding of what Americans in his time wanted to believe was waiting for them on the west-ern frontier: a Garden of Eden blessed by God, untouched by civil war, and holding the promise of a new beginning. His romantic paintings embody the collective hope that a remote landscape could heal a nation's wounds. The preservationist (and Sierra Club founder) John Muir, Bierstadt's near-contemporary, affirmed the idea that the Yosemite Valley could refresh the spirit: "The winds will blow their own freshness into you, and the storms their energy," he promised prospective tourists, "while cares will drop off like autumn leaves."

Looking Down Yosemite Valley would have been underway in Bierstadt's New York studio in 1864, when Abraham Lincoln set the territory aside as a state park. This was the first time the federal government had saved a tract of scenic land from development. But when the Transcontinental Railroad was completed five years later, the region was flooded with tourists who wanted to see for themselves the wondrous places they knew only from paintings and photographs. Returning to Yosemite in 1872, Bierstadt lamented the loss of the unspoiled wilderness he had portrayed only a few years earlier.

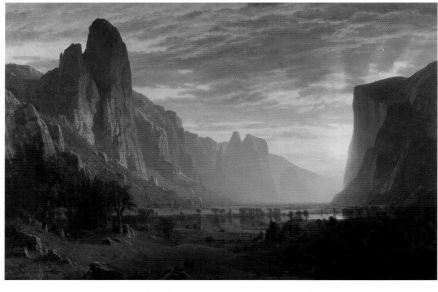

8-A Albert Bierstadt (1830–1902), *Looking Down Yosemite Valley, California*, 1865. Oil on canvas, 64½ x 96½ in. (163.83 x 245.11 cm.). Birmingham Museum of Art, Birmingham, Ala. (1991.879). Gift of the Birmingham Public Library.

TEACHING ACTIVITIES

E = ELEMENTARY | **M** = MIDDLE | **S** = SECONDARY

Encourage students to examine all the elements of this landscape.

DESCRIBE AND ANALYZE

E | M

Where do you see trees reflected in water? *It is in the center of the painting.*

E | M

Describe the texture of the rocks. *The rocks appear rough or weathered.*

E | M | S

Tell students to write three or four words that they think of when they first see this painting. Have each student in turn say one of the words that they wrote that another student hasn't offered so far. Write each word on the board or large paper. Encourage students to explain what made them think of this word. Notice how many times words that refer to size and grandeur are mentioned.

E | M | S

If a person were standing in the middle of this scene, about how large would he or she seem? Compare a six-foot tall person to one of the trees; imagine how this person would feel in comparison to these mountains. How might he or she describe this scene?

E | M | S

How has Bierstadt created an illusion of great distance or depth?
He made objects in the foreground darker, more detailed, and larger than distant ones. This approach is called aerial perspective.

M | S

Ask students what they see first when they look at this painting.
Students may see the light area in the middle of the scene.
How does this light add to the drama of this scene?
The light creates dark shadows that dramatically contrast with the light, shining areas.

M | S

On a map, locate Yosemite National Park. Have students compare photographs of Yosemite Valley with Bierstadt's painting to understand how he exaggerated the size of the rock formations. (Photographs of this scene are on the Internet.) Ask students to consider if the sun in the painting is rising or setting. (Consult a map for the orientation of the rock formations — in the painting Cathedral Spires and Sentinel Rock are on the left and El Capitán is on the right.)

INTERPRET

M | S

Bierstadt painted some of the rock formations in this painting taller than they really were. Ask students if they think this exaggeration was dishonest. Have them explain why they do or do not believe that it is all right for an artist to exaggerate features in a scene like this.
In addition to exaggerating the size of the rocks, how else did Bierstadt make the West seem even grander than it was?
He bathed this scene in a golden, glowing light.

S

Ask students what national event America was recovering from in 1865, when this scene was painted.
It was the Civil War.
Why did a scene like this offer hope to Americans?
Not only was it peaceful to look at, but also it reminded them of the Western frontier, spacious, beautiful country waiting to be settled. Many saw the West as the promise of a new beginning.

S

Ask students to explain the role Bierstadt's paintings played in the development of tourism to the West.
When people in the East saw Bierstadt's grand interpretation of western scenery, they wanted to see it for themselves. Within a few years, with the introduction of the railroad into this area, great numbers of tourists were able to visit Yosemite.

CONNECTIONS

Historical Connections: conservation movement; national parks; Westward Expansion

Historical Figures: Theodore Roosevelt; John Muir

Geography: Yosemite Valley; Sierra Nevada

Science: ecology; conservation; geology

Literary Connections and Primary Documents: *Nature*, Ralph Waldo Emerson (secondary); *A Thousand-Mile Walk to the Gulf*, John Muir (middle, secondary)

Arts: Hudson River School; compare with the works of Frederic Church

8 b "Sans Arc Lakota" Ledger Book, 1880–1881

Black Hawk was hard-pressed to feed his family of four during the harsh winter of 1880–1881. His tribe, the Sans Arc, was one of seven divisions of the Lakota, a nomadic group of Plains Indians who followed the great herds of buffalo that fed, clothed, and housed them. The herds had been hunted to near extinction, mostly by the settlers who came in increasing numbers, and the Plains tribes were being moved to reservations.

Black Hawk, a spiritual leader, had a vision dream, which William Edward Caton, the Indian trader at the Cheyenne Agency in Dakota, asked him to record, offering fifty cents in trade for every drawing he would make. Caton provided sheets of lined writing paper, colored pencils, and a pen. Black Hawk produced seventy-six drawings over the course of the winter and received thirty-eight dollars in exchange, a sizable amount for the time. In 1994, the book (by then in a private collection) sold at auction for nearly four hundred thousand dollars.

Black Hawk's drawings followed a long tradition of Plains Indian art. Lakota men painted images on their teepees and buffalo hide robes to display their accomplishments and brave deeds. Winter counts (communal histories of tribes or families) were also painted on buffalo hide. Each year, which began with the first snowfall, an image of an event that affected the whole group was added, serving as a memory aid for oral renditions of the tribe's history. As cloth, paper, and art tools were acquired through trade or in raids, the Lakota began to make images with these materials as well. Ledger books were valued because they were portable and provided many surfaces for drawing and painting, either on blank pages or superimposed on used ones. Black Hawk's work, though one of the finest examples, is not technically a ledger book, for he drew on separate sheets of paper that were bound in leather by Caton.

Black Hawk drew only two images of his dream before he began, like Audubon (see 6-A) and Catlin (see 6-B), to record the natural world and Lakota customs and ceremonies. He even recorded processions of Crow warriors, traditional enemies of the Lakota. In this image (8-B.1), the Crow are recognizable by their hairstyle: a short tuft swept up at the forehead, and long plaits augmented with extensions and daubed with clay in the back. The Crow were known for their beauty, and Black Hawk described their appearance in detail. Several sport metal bands on their upper arms, and all wear multiple-strand necklaces of white shell beads (wampum), as well as precious eagle feathers (twelve feathers were equal in value to a horse). Some feathers decorate the hair or are carried as fans—two with additional tiers of feathers—while others adorn war lances and forked coup sticks. (Touching an enemy with a coup stick in battle showed a man's bravery.) Faces are painted red and some bodies are painted red or yellow. The C-shaped horse prints on the middle two figures indicate skill in battle; another man's legs are marked with diagonal lines that mean "strikes the enemy." Three men carry beaded and fringed bags to hold the mirrors they acquired through trade.

The other drawing (8-B.2) shows a Lakota social dance performed by men and women. Both sexes wear their hair parted in the middle, the men with feather and quill ornaments, and the women with the part painted yellow or red. There are beaded belts, strips of brass buttons worn around the waist or across the body, shell jewelry, and a beaded bag to hold craft tools (first woman at the left). The most costly dress, worn by the fourth figure from the right, is decorated with rows of the upper canine (eye) teeth of elk, the only two elk's teeth that are ivory.

We know little about Black Hawk's life after he produced these ledger drawings. He does not appear in the records of the Cheyenne River Agency after 1889. Scholars believe that Black Hawk was killed at Wounded Knee in the newly formed state of South Dakota in December of the following year.

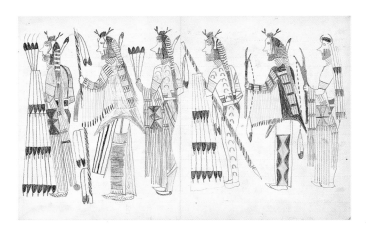

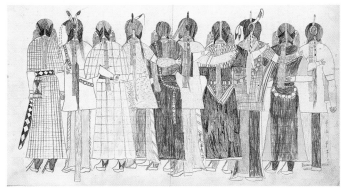

8-B.1 Black Hawk (c. 1832–1890), "Sans Arc Lakota" Ledger Book (plate no. 18), 1880–1881. Pen, ink, and pencil on paper, 9½ x 15½ in. (24.13 x 39.4 cm.). Entire book: 10¼ in. x 16½ in. x 1¾ in. (26.67 x 41.9 x 4.44 cm.); width with book opened: 33½ in. (85.1 cm.). T614; Thaw Collection, Fenimore Art Museum, Cooperstown, N.Y. Photograph 1998 by John Bigelow Taylor, New York.

8-B.2 Black Hawk (c. 1832–1890), "Sans Arc Lakota" Ledger Book (plate no. 3), 1880–1881. Pen, ink, and pencil on paper, 9½ x 15½ in. (24.13 x 39.4 cm.). Entire book: 10¼ in. x 16½ in. x 1¾ in. (26.67 x 41.9 x 4.44 cm.); width with book opened: 33½ in. (85.1 cm.). T614; Thaw Collection, Fenimore Art Museum, Cooperstown, N.Y. Photograph 1998 by John Bigelow Taylor, New York.

TEACHING ACTIVITIES

E = ELEMENTARY | **M** = MIDDLE | **S** = SECONDARY

Encourage students to carefully study the details of this ledger drawing.

DESCRIBE AND ANALYZE

E

Have students stand and link arms like the figures in the lower drawing. Discuss how standing and moving together like this shows unity with the group.

E|M|S

Ask students what the people are doing in both of these drawings. *In the top drawing, warriors are processing or parading; in the lower one, men and women are dancing.* Which figures are women? *The women have a colored part in the center of their hair.*

E|M|S

Have students identify repeated patterns in the drawings.
There are many repeated patterns, including the feathers, hoof prints, and fringe.

E|M|S

Ask students to describe how Black Hawk created a steady rhythm in each of these. *He drew a line of similar figures equally spaced across the page.* Ask students to imagine the regular drum beat to which these figures are moving.

E|M|S

Ask students what materials Black Hawk used to create fine details in these drawings.
He used lined writing paper, colored pencils, and a pen. The pencil strokes are visible in the long dresses.
Before the Lakota lived on reservations, what materials did their warrior-artists use to create similar traditional drawings of their history and traditions? *They painted similar images on teepee walls and robes made of buffalo hide.*

M|S

Have students compare Black Hawk's drawing of American Indians to Catlin's painting (6-B) and N. C. Wyeth's painting (5-B). Ask which of these they think shows the most historically accurate clothing. Why?
American Indian artist Black Hawk was more accurate and familiar with details of his own people's dress than artists of European descent. In his painting, Catlin left out significant details. Wyeth created his work based upon current stereotypes of Indians — for example, he didn't follow Cooper's description.
How is the clothing in Wyeth's and Catlin's art similar to that in Black Hawk's? *In all three pieces of art, Indians wear feathers in their hair. The chief in Catlin's painting wears a fringed shirt and leggings like some of the warriors in Black Hawk's painting. Wyeth's Mohican wears an armband and body and face paint as in Black Hawk's drawing.*

INTERPRET

E|M|S

What can we learn about the Lakota from these pictures that we might not understand if their history were just written with words? *We can see how they dressed.*

E|M|S

What were "winter counts" and why did the Lakota and other Plains Indians create these?
Winter counts were paintings on buffalo hide recording communal histories of tribes or families.

E|M|S

Ask students why it was difficult for Black Hawk and other Sans Arc Lakota families to have food during the winter of 1880–1881. *These Plains Indians were no longer able to hunt buffalo, one of their primary sources of food, because settlers had killed the buffalo to near extinction.*

E|M|S

Ask students how drawing these pictures helped Black Hawk earn money to feed his family. *William Edward Caton, the trader at the Cheyenne Agency in Dakota, paid Black Hawk thirty-eight dollars for the set of seventy-six drawings.*

M|S

Why do you think William Edward Caton wanted these drawings?
Perhaps he realized that American Indian culture and traditions were changing because Indians were no longer able to hunt and live as they had for centuries before settlers moved west.

CONNECTIONS

Historical Connections: Manifest Destiny; Westward Expansion; Battle of Tippecanoe; Plains Indians; Battle of Little Bighorn; Wounded Knee

Historical Figures: Tecumseh; Andrew Jackson; William Henry Harrison; Crazy Horse; George Armstrong Custer; Geronimo

Civics: Indian Removal Act

Geography: Great Plains region

Literary Connections and Primary Documents: *Little House in the Big Woods,* Laura Ingalls Wilder (elementary); *Four Ancestors: Stories, Songs, and Poems from Native North America,* Joseph Bruchac (middle)

Arts: compare to works by George Catlin; compare to Egyptian Book of the Dead

9a The Veteran in a New Field, 1865

After General Robert E. Lee's surrender at Appomattox in April 1865, the Union and Confederate armies were peacefully disbanded. The soldiers who had survived the ordeal were free to go home and resume their pre-war occupations. *The Veteran in a New Field* depicts one of those Civil War veterans recently returned from the front, harvesting a field of grain in the midday sun. The wheat has grown high, and the field stretches all the way to the horizon; an unusually bountiful crop had, in fact, marked the end of the war. The farmer's military jacket and canteen (with an insignia that identifies him as a former Union soldier) lie discarded in the foreground, almost covered by fallen stalks of grain.

Winslow Homer completed *The Veteran in a New Field* in the autumn of 1865, only a few months after Appomattox. The artist was a sort of veteran himself, having served on the front as an illustrator for the New York periodical *Harper's Weekly*. In the sketches he made to accompany military reports, Homer tended to focus on the commonplace activities of a soldier's life rather than the climax of combat. When he returned to civilian life and began to paint in oil, Homer continued to favor themes from ordinary life, such as this image of a soldier resuming work in the fields.

The optimistic spirit of Homer's painting only makes its darker undertones more moving. The "new field" of the title can't mean this field of grain, which is obviously mature and ready to harvest. It must refer instead to the change in the veteran's occupation—which necessarily calls to mind his previous activity on the battlefield. Because some of the bloodiest battles of the Civil War had been fought in wheat fields, fields of grain, in popular consciousness, were associated with fields of fallen

soldiers. One particularly disturbing photograph of soldiers who had died in battle at Gettysburg was published with the title "A Harvest of Death."

In keeping with those undertones, Homer's veteran handles a single-bladed scythe. By 1865, that simple farming implement was already out of date; a farmer would have used the more efficient cradle to mow a field that size. In the original version of the painting, the veteran did work with a cradled scythe (its outline is faintly visible on the left side of the canvas), but Homer evidently decided to paint it out. He replaced an emblem of modern technology with the more archaic tool, and gave a picture of a farmer in his field an unsettling reference to the work of the grim reaper, the age-old personification of death.

The Veteran in a New Field refers both to the desolation caused by the war and the country's hope for the future. It summons up the conflicting emotions that took hold of Americans—relief that the Civil War was over, and grief for the many lives that had been lost. Nor did the loss of lives end on the battlefield; only days after Appomattox came the assassination of Abraham Lincoln, and the nation sank into a collective state of mourning. *The Veteran in a New Field* thus takes on another dimension, as an expression of despair over the senseless death of a great president.

The image of a soldier returning to his farm would have reassured Homer's audience that life went on. The veteran appears to have set aside his Army training along with what remained of his military uniform to harvest a field that once again yields the gift of golden wheat, which in Christianity is a symbol of salvation. Even in the aftermath of the worst disasters, the artist seems to say, life has the capacity to restore itself.

9-A Winslow Homer (1836–1910), *The Veteran in a New Field,* **1865. Oil on canvas, 24⅛ x 38⅛ in. (61.3 x 96.8 cm.). The Metropolitan Museum of Art, Bequest of Miss Adelaide Milton de Groot (1876–1967), 1967 (67.187.131). Image © The Metropolitan Museum of Art.**

TEACHING ACTIVITIES

E = ELEMENTARY | M = MIDDLE | S = SECONDARY

Encourage students to study every aspect of this painting closely.

DESCRIBE AND ANALYZE

E

What is this man doing? *He is cutting wheat.*
How do we know? *He holds a scythe and there is cut wheat around him.*

E

Call students' attention to the light and shadows on the man. Where is the sun?
It is high and to his right.
How do you think the man feels in this sun? *He probably is hot and tired.*
How do we know? *He's working so hard in the sun that he has taken his jacket off and laid it on the ground in the right foreground.*

E | M | S

Describe how Homer divided the scene in this painting.
He divided it into three strips of color with a band of sky, a wider band of standing wheat, and another band of cut wheat in the foreground.
In what bands are the man's feet? *They are buried in cut wheat.*
In what band is his body? *It is in the standing wheat.*
Where is the top of his head? *It is in the sky.*

INTERPRET

M | S

Of what war was this man a veteran?
He was a veteran of the Civil War.
How does Homer show us this?
His military uniform jacket and canteen lie in the lower right corner.
What might laying aside his uniform represent?
He has set aside soldiering and returned to regular life.
Why is this a new field for him?
It may be literally a new field of grain, but it is also a new field of work for him after fighting for years.

M | S

If this man had been in a grain field the previous year, what would he probably have been doing?
Probably fighting a battle, since a number of Civil War battles were fought in grain fields.
What subjects had Winslow Homer been sketching for the past few years?
He had been sketching Civil War soldiers.

S

What does a figure carrying a scythe usually symbolize?
He symbolizes the grim reaper or death.
Whose deaths might Homer be alluding to?
He is alluding to dead soldiers and/or President Lincoln, who had been assassinated earlier that year. Previously, the veteran cut down soldiers in a field; now he cuts wheat.

S

What might a bountiful field of wheat represent?
It could symbolize hope, bounty, and the renewal of life.
Because a seemingly dead seed buried in the ground rises as a new plant, grain can be a symbol of rebirth or new beginnings. What might this suggest about the country after the Civil War?
It could suggest that the country will recover and flourish.

CONNECTIONS

Historical Connections: Civil War; Battle of Bull Run; Surrender at Appomattox (1865)

Historical Figures: Abraham Lincoln; Jefferson Davis; Robert E. Lee; Ulysses S. Grant; Stonewall Jackson; William Tecumseh Sherman; George McClellan

Geography: Northern and Southern states; slave and free states

Literary Connections and Primary Documents: *Bull Run,* Paul Fleischman (middle); Bible — Isaiah 2:4; 40:6–8 (middle, secondary); *The Red Badge of Courage,* Stephen Crane (secondary); *Across Five Aprils,* Irene Hunt (secondary); "Come Up from the Fields, Father," Walt Whitman (middle, secondary)

Music: "The Battle Hymn of the Republic"; "Dixie"

9b Abraham Lincoln, February 5, 1865

Abraham Lincoln was the first American president to use photography for political purposes. During his first presidential campaign in 1860, some thirty-five portraits of the candidate by the photographer Mathew Brady were circulated throughout the country. The immediacy of a photograph created a sense of intimacy between viewer and subject (or voter and candidate) that few painted portraits could achieve—particularly in the mid-nineteenth century, when the medium was still a novelty for many Americans. Acknowledging its power to move the populace, Lincoln gave portrait photography credit for his victory. "Make no mistake," he said. "Brady made me President!"

This photograph of Lincoln by Alexander Gardner was made some years later, when the burden of the presidency had taken its toll. Gardner had been one in a team of photographers employed by Brady to follow the Union troops and make a visual record of the Civil War. He began to work independently in 1863, when he established his own studio in Washington, D.C., and became known for his portraits of uniformed soldiers setting off for war. President Lincoln visited Gardner's studio one Sunday in February 1865, the final year of the Civil War, accompanied by the American portraitist Matthew Wilson. Wilson had been commissioned to paint the president's portrait, but because Lincoln could spare so little time to pose,

the artist needed recent photographs to work from. The pictures served their purpose, but the resulting painting—a traditional, formal, bust-length portrait in an oval format—is not particularly distinguished and hardly remembered today. Gardner's surprisingly candid photographs have proven more enduring, even though they were not originally intended to stand alone as works of art.

This half-length portrait of Lincoln is one of the finest from that February studio session. The president sits comfortably in a sturdy chair, his left elbow resting on its arm, his right on his own slightly elevated knee. There is nothing in this photograph to indicate Lincoln's exalted position: we might just as well be looking at a humble country doctor. His clothing appears plain (though not unfashionable) and his loosely knotted bowtie has been left slightly askew. By this point in his public life, the president had sat for dozens of photographs, and he would have been mindful of the need to hold perfectly still during the several minutes it took to make an exposure. In this print, Lincoln's eyes look steadily toward the camera but his hands fiddle impatiently with his eyeglasses and pencil as if to remind the photographer that he had more important things to do.

What draws and holds our attention is Lincoln's expression, which the poet Walt Whitman described as "a deep latent sadness." At the time this picture was taken, Lincoln had weathered the worst of the war and almost succeeded in his fight to preserve the Union, yet he was painfully aware how much that cause had cost the nation. Lincoln appears much older than his fifty-five years, and Gardner did nothing to flatter the president's haggard, careworn features. The photographer may even have exaggerated them, for the turn of Lincoln's head leaves one side of his face slightly in shadow, making his right eye and cheek appear hollow and cadaverous.

Gardner's photograph took on another dimension shortly after Abraham Lincoln's assassination on April 14, 1865. A Boston publishing firm exploited the nation's grief by producing prints of the portrait Matthew Wilson had based on Gardner's photographs. Gardner's own publisher countered a few days later by offering this and other photographs from the February studio session. They were advertised as the products of "Mr. Lincoln's last sitting." That unsupported (and until recently, unquestioned) claim gave rise to the tradition that Gardner's portraits had been taken just four days before Lincoln's death, investing them with a special aura of martyrdom. We now know that these were not in fact the last portraits of Abraham Lincoln. Even though Gardner's picture does not belong to the president's final days, it records his weary and worried countenance during the last long weeks of the war, when the surrender at Appomattox was still some months away.

9-B Alexander Gardner (1821–1882), *Abraham Lincoln,* **February 5, 1865. Photographic print. Prints and Photographs Division, Library of Congress, Washington, D.C.**

TEACHING ACTIVITIES
E = ELEMENTARY | **M** = MIDDLE | **S** = SECONDARY

Encourage students to look closely at all parts of this photographic portrait.

DESCRIBE AND ANALYZE

E | M | S
Compare this portrait to that of Lincoln on a penny. How are they different?
In this one he faces front, but he is shown in profile on the penny. Also, his beard is fuller on the penny.

E | M | S
Suggest that students sit as Lincoln sits in this photograph. Notice that his head is turned slightly so that we see the outline of his cheek. Imagine having to sit perfectly still for three full minutes.

E | M | S
Where is the light source for this photograph located?
It is above, left of center.
Notice in what part of the photograph the light creates dark shadows. Point out some of the darkest of these areas.
They are on his neck, under his right cheekbone, and under his right eyebrow.

E | M | S
Compare the size of his hands to his face. Which is in sharper focus, the hands or face?
The face is in sharper focus.
Why might his hands be slightly blurred? What might he be holding in his hands?
He holds a pen and eyeglasses; the blurring shows that Lincoln moved his hands during the long exposure.
Ask what the pen and glasses might symbolize.
Perhaps they show Lincoln's learning and the importance of the executive office of the president.

E | M | S
Describe how Lincoln is dressed.
He wears a dark suit, vest, watch chain, bowtie, and a white shirt.
His bowtie is crooked. What might a crooked bowtie suggest?
He is not perfect. Ordinary people might feel closer to him because he seemed more like a regular person.
Is there anything about his dress to suggest that he is president of the United States?
There is not.

INTERPRET

E | M | S
How old do you think Lincoln looks in this photograph? Why?
He was fifty-five years old, but he looks older. The stress of war may have aged him.

E | M | S
Ask students to describe Lincoln's expression. How does he feel? Is he sad, happy, bored, tired, or something else?
Although he has a slight smile, his face is haggard, and he is probably tired and sad after four years of bloody civil war.

S
Why was photography an important element in Lincoln's campaign for president?
Photography was still a new medium, just beginning to be used. Up until this time, portraits were painted or drawn.
A photograph seemed much more intimate. Voters were able to recognize him and feel that they knew him.

CONNECTIONS

Historical Connections: Civil War; Reconstruction; Lincoln's assassination

Historical Figures: Abraham Lincoln; John Wilkes Booth

Geography: Northern free states; Southern slave states; border states

Literary Connections and Primary Documents: *Honest Abe*, Edith Kunhardt (elementary); "O Captain! My Captain!," "When Lilacs Last in the Dooryard Bloom'd," Walt Whitman (secondary); Lincoln's Gettysburg Address (elementary, middle); Lincoln's Second Inaugural Address (middle, secondary); Lincoln's "House Divided" speech (middle, secondary); Emancipation Proclamation (elementary, middle)

Arts: photography; work of Mathew Brady

ABRAHAM LINCOLN, 1865, ALEXANDER GARDNER [1821–1882]

10a Robert Shaw Memorial, 1884–1897

The *Robert Gould Shaw and the Fith-fourth Regiment Memorial,* a monumental bronze relief sculpture standing at the edge of Boston Common, was begun twenty years after the end of the Civil War and not completed for another fourteen. It was an unusually complex project, but the sculptor, Augustus Saint-Gaudens, came to regard it as a labor of love. The memorial had been commissioned by a group of Bostonians to honor Colonel Robert Gould Shaw, the privileged son of abolitionist parents, who had given his life fighting for the Union cause. Saint-Gaudens originally envisioned an equestrian statue — the traditional hero on horseback — but Shaw's family objected to the format as pretentious. The revised design presents the officer riding beside a company of foot soldiers marching toward their destiny. When the monument was at last unveiled in 1897, the philosopher William James observed that it was the first American "soldier's monument" dedicated to a group of citizens united in the interests of their country, rather than to a single military hero.

Robert Shaw commanded the Fifty-fourth Massachusetts Volunteer Infantry. It was the first regiment of African Americans recruited in the North for service in the Union Army. Many of the volunteers had enlisted at the urging of the black orator Frederick Douglass, who believed (mistakenly, as it turned out) that former slaves and others of African descent would never be denied the full privileges of citizenship if they fought for those rights alongside white Americans. But arming black soldiers in defense of the Republic proved to be controversial and the Fifty-fourth bore the additional burden of having to prove its value.

In the summer of 1863, Shaw's regiment led an audacious assault on Fort Wagner, South Carolina. That fortress on Morris Island guarded Charleston Harbor, the principal port of the Confederacy, and was built on earthen parapets that rose thirty feet above the beach. It had only one land-facing side, which was bordered with a water-filled ditch ten feet wide. Shaw's battalions were already weakened and exhausted when they approached Fort Wagner on July 18, after a grueling two-day march through driving rain. And as their commanding officer would have known, the attack was doomed before it began, for the Union troops were overwhelmingly outnumbered by Confederates. Nevertheless, Shaw rode into battle flourishing his sword and shouting "Forward, Fifty-fourth!" As he crested the ramparts, three enemy bullets shot him down. His body was later stripped and thrown with those of his troops into a mass grave.

In the end, 281 soldiers and officers from the unit were lost at Fort Wagner — killed or never accounted for — and countless others were injured. Despite that dramatic defeat, the Massachusetts Fifty-fourth had successfully "established its reputation as a fighting regiment," in the words of one of its surviving officers, Frederick Douglass's son Lewis: "Not a man flinched." Reports of their extraordinary courage rallied African Americans to the cause, and Abraham Lincoln later surmised that the additional manpower they supplied had made the critical difference to the outcome of the war.

Saint-Gaudens symbolized this paradoxical military episode in which defeat gives rise to victory with the winged figure that hovers in low relief above the soldiers; she carries poppies, traditional emblems of death and remembrance, and an olive branch for victory and peace. Apart from that concession to allegory, Saint-Gaudens worked in a realistic style. If the portrait of Shaw appears idealized, his rigid posture and resolute gaze nonetheless accord with contemporary accounts of his brave demeanor as he entered battle like a sacrificial lamb. More remarkable is the stoic procession of soldiers, portrayed not as cogs in the machinery of war but as individuals participating in a moral crusade. In a time when African Americans were usually depicted as generic types, Saint-Gaudens searched out models and produced some forty portrait-heads in clay, even though he used only sixteen in the sculpture itself. The ragged uniforms of the recruits are each disheveled in a different way — not to undermine the soldier's gallantry, as some have argued, but to recall their long and dreary trudge to Charleston Harbor. "There they march," said William James, "warm-blooded champions of a better day for man."

In 1982, sixty-two names of African American soldiers who gave their lives at Fort Wagner were inscribed on the base of the *Shaw Memorial.*

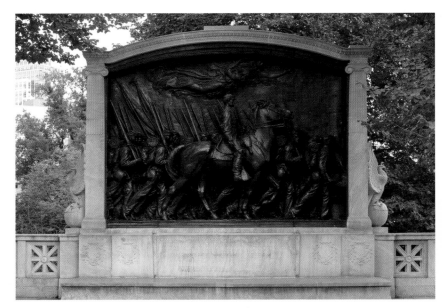

10-A Augustus Saint-Gaudens (1848–1907), *Robert Gould Shaw and the Fifty-fourth Regiment Memorial,* Beacon and Park streets, Boston, Massachusetts, 1884–1897. Bronze, 11 x 14 ft. (3.35 x 4.27 m.). Photograph by Carol M. Highsmith.

TEACHING ACTIVITIES

E = ELEMENTARY | **M** = MIDDLE | **S** = SECONDARY

Encourage students to look closely at all the details in this sculpture.

DESCRIBE AND ANALYZE

E | M
Ask students to find a drum. *It is on the far right.* Where are the flags? *They are on the left, behind the rifles.*

E | M | S
Have students look closely at the individual faces. Which ones wear mustaches and beards?

E | M | S
How are the foot soldiers dressed?
They wear caps, long-sleeve shirts, shoes, and long pants, and they carry canteens.
What do they carry on their backs? *They shoulder bed rolls and packs.*
What else do they carry? *They carry rifles.*
Compare the foot soldiers' dress to Colonel Shaw's.
Both wear caps with visors, but the foot soldiers' hats are more wrinkled. Shaw wears a long jacket and boots.
What does Shaw hold? *He holds a sword in one hand and his horse's reins in the other.*

E | M | S
Have students discuss how artists can create rhythm in works of visual art. How did Saint-Gaudens create a sense of rhythm in this relief?
He repeated the slant of leg and body lines and shapes at regular intervals across the sculpture. (Even the horse's legs match the slant of the marching soldiers' legs.) The repeated rifles create a steady rhythm in the top half of the sculpture. Only Shaw's upright form and his horse's neck interrupt the steady march across the sculpture.

E | M | S
How did Saint-Gaudens create a sense of depth in this sculpture? How do you know that some soldiers are closer to viewers than others?
Soldiers who are closer to us stand out farther from the background; they are in greater relief. The soldiers at the back are in low relief. The closer forms also overlap the more distant ones.
Which figure is closest to the viewer (in highest relief)? *Robert Shaw is.*

INTERPRET

E | M | S
Who is in command? *The man on the horse, Colonel Shaw, is.*
How do you know? *As the only mounted figure, he is above the other soldiers; he carries a sword, and his jacket has the fancy cuffs of an officer's uniform. Also, the title tells us that this honors Robert Shaw.*

E | M | S
This was commissioned to honor and remember Robert Shaw, but who else does it commemorate?
It honors the foot soldiers of the Fifty-fourth Massachusetts Volunteer Infantry.

M | S
Ask why students think this monument was made of bronze rather than marble or wood.
Bronze lasts longer outside; it reflects light and is dark and solemn. It can be worked in minute detail, and thin forms like rifles and reins do not break easily.

S
What does the winged figure in the sky hold? *She holds poppies and an olive branch.*
What do you think this figure in the sky represents? Why?
She may represent an angel. The poppies usually symbolize death and remembrance, and the olive branch, peace and victory.
Remind students that artificial poppies are worn on Veterans Day to remember America's war veterans.

CONNECTIONS

Historical Connections: Civil War; Massachusetts Fifty-fourth Regiment; Abolitionists; Bloody Kansas; Brown's Raid on Harper's Ferry; Underground Railroad

Historical Figures: Robert Gould Shaw; Frederick Douglass; John Brown; Harriet Tubman; Sojourner Truth; William Lloyd Garrison

Geography: James Island, S.C.; Morris Island, S.C. (the battle at Fort Wagner, also called Battery Wagner); Charleston Harbor (principal port of the Confederate Army)

Literary Connections and Primary Documents: *Frederick Douglass: The Black Lion*, Patricia McKissack (elementary); *Walking the Road to Freedom: A Story about Sojourner Truth*, Jeri Ferris (elementary); *Uncle Tom's Cabin*, Harriet Beecher Stowe (middle, secondary); "Frederick Douglass" and "Harriet Beecher Stowe," Paul Lawrence Dunbar (middle); "For the Union Dead," Robert Lowell (secondary); *Narrative of the Life of Frederick Douglass*, Frederick Douglass (secondary); Booker T. Washington's speech at the unveiling of the *Shaw Memorial* (1897) (secondary)

Arts: relief sculpture; beaux-arts movement; American Renaissance

On December 31, 1839, in McDowell County, North Carolina, Hannah and Pharoah, age twelve, were given as wedding presents by John and Rebecca Logan to their daughter Margaret Ruth and her husband, Thomas Young Greenlee. Taking their new owners' surname, the girl, a house servant, and the boy, a blacksmith, later married and had a daughter named Emm. We know little about them beyond this, except that the masterful quilt reproduced here was begun by Hannah Greenlee, perhaps in the 1880s, and finished by her daughter in 1896, sometime after Hannah's death. As a freedwoman after the war, Hannah probably continued the type of work she performed as a house servant: cooking, cleaning, and sewing. She may have intended to sell or give the quilt to her previous owners, since it remained with that family until they donated it to North Carolina's Historic Carson House.

This quilt looks very different from quilts made in the colonial period, when such items were confined to homes of the wealthy, where women had leisure time to devote to complicated needlework. In colonial whole-cloth quilts, for example, the top was one single piece whose only decoration was the pattern of the stitching itself. In another type, printed images of flowers and other motifs were cut out of expensive imported fabrics and sewn (appliquéd) to the top as decoration.

Hannah Greenlee's quilt is made of irregular scraps of fabric — some of them homespun — that are stitched together in the Crazy pattern developed in Victorian England and popular in America in the second half of the nineteenth century. Many early Crazy quilts were made of luxury materials like silk, velvet,

and satin. The random pattern is a flexible and thrifty way to construct a quilt, permitting small scraps of any size or shape to be used. The design can be worked in an overall pattern or — as in Greenlee's quilt — in separate squares that are then combined in a grid. Because the grid adds a degree of order to the chaos, this type is known as a Contained Crazy.

In each square of her quilt, numerous small strips are joined into ladders that lean this way and that. These stacked, colored bands resemble a type of traditional textile made in Ghana and the Ivory Coast called kente, in which bars of color and pattern are woven in thin strips that are then joined side to side to make wider cloth. Many scholars believe that elements of this African tradition, especially its aesthetic preference for asymmetry, inventiveness, and irregular blocks of bright color, live on in many African American quilts.

Each square of Greenlee's quilt is a separate abstract composition that is constantly changing depending on the direction from which it is viewed. Fancy stitching — sometimes following the outlines of the piecing, sometimes independent of them — creates another level of patterning as do the designs within the separate scraps of cloth. As in most quilts, the top layer is attached to two more beneath with stitching (quilting) that goes through all three. The bottom layer, called the liner, can be plain or decorated to make the quilt reversible. Sandwiched between the top and liner is the layer of insulation, called filling or batting, that traps pockets of air to give the quilt its warmth.

The invention of the cotton gin in 1793, the opening of a textile factory in Waltham, Massachusetts, in 1814, and the development of the power loom would make domestic printed fabrics widely available and affordable. By the 1840s, women were purchasing commercially printed fabric to sew rather than weave the fabrics themselves. Quilt patterns multiplied and were spread by family and friends, printed in ladies' magazines, and ordered through catalogs. The introduction of the sewing machine in the second half of the nineteenth century made sewing faster. In addition to still-usable parts of old clothes, scraps left over from a dress for the first day of school or Father's Sunday shirt were saved to make quilts that were rich with personal memories.

10-B.1 Hannah Greenlee (c. 1827–before 1896) and Emm Greenlee (died c. 1910), *Crazy Quilt*, begun by Hannah and finished by her daughter, Emm, 1896. Fabric scraps (some homespun), length 90 in., width 71½ in. (228.6 x 181.6 cm.). Historic Carson House, Marion, N.C., Gift of Ruth Greenlee.

Susan Noakes McCord was a farmwife who lived in McCordsville, Indiana. She raised vegetables, chickens, and seven children, and still found time between chores to make more than a dozen quilts. Many of her creations were based on standard quilt patterns that she transformed. This quilt, like Greenlee's, is a Contained Crazy quilt, but instead of rectangular bars, wedges of fabric are joined to form irregular wheels. The pattern is based on one called Grandmother's Fan, in which each uniform block of the quilt contains a fan set in the same corner. McCord varied the size of the fans and set them in all four corners of most blocks, aligning them to form fractured gears that twirl across the surface. Nothing is still. Wheels struggle to maintain their symmetry and rims wander off to do-si-do with other discs. Everywhere there is the nervous tremor of the zig-zag stitching.

Some of the most accomplished quilting is found in Amish examples made in Lancaster County, Pennsylvania, from the late-nineteenth to the mid-twentieth century. Before the incorporation of synthetic materials around 1940, Amish quilts tended to be made of fine wool. These quilts were given only a thin layer of filler, making delicate needlework possible. Although the stitches on these quilts average from nine to eleven per inch, stitches as small as eighteen to twenty per inch have been used (most quilts average six to eight stitches).

The Amish trace their lineal descent from the Anabaptist movement, which arose in the early 1500s as a result of the Protestant Reformation. Anabaptists were pacifists who

10-B.2 Susan Noakes McCord (1829–1909; McCordsville, Hancock County, Indiana), *Grandmother's Fan Quilt*, c. 1900. Wool, silk, and cotton, length 80½ in., width 70½ in. (204.47 x 179.07 cm.). From the Collections of The Henry Ford, Dearborn, Mich.

10-B.3 *Bars Pattern Quilt*, c. 1920. Top, plain-weave wool; back, grey-and-blue plain-weave cotton. Overall dimensions 72 x 80 in. (182.9 x 203.2 cm.). Gift of "The Great Women of Lancaster." Collections of the Heritage Center of Lancaster County, Lancaster, Pa.

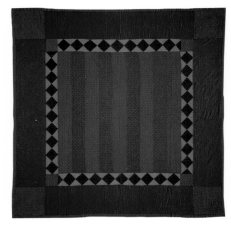

10-B.4 *Bars Pattern Quilt*, c. 1925. Top, plain-weave wool; back, brown-and-white printed-check plain-weave cotton. Overall dimensions 77.5 x 77.5 in. (196.6 x 196.6 cm.). Given in memory of Louise Stoltzfus. Collections of the Heritage Center of Lancaster County, Lancaster, Pa.

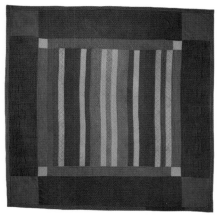

10-B.5 *Split Bars Pattern Quilt*, c. 1935. Top, plain-weave and crepe wool; back, black-and-white twill printed-pattern plain-weave cotton. Overall dimensions 76 x 76 in. (193 x 193 cm.). Collections of the Heritage Center of Lancaster County, Lancaster, Pa.

practiced adult baptism exclusively. The largest Anabaptist sect was Mennonite, named for founder Menno Simons. In 1693, a group of Mennonites led by Jacob Ammann, seeking a stricter observance of their religion, broke away to become the Amish. Heavily persecuted, the Amish were drawn to America by the religious tolerance promoted by William Penn. In the 1730s, they established their first sizeable communities in Lancaster County, Pennsylvania.

At the core of Amish life are religion, community, and family. The Amish, who live in small communities, value conformity to communal rule (the Ordnung), which varies according to local custom. Much of the technology developed since the Industrial Revolution is avoided. They aspire to a life of non-violence, simplicity, and humility; anything considered vain or reminiscent of the military (such as buttons or moustaches) is rejected. Amish clothing is generally patterned on late-nineteenth century rural farm attire.

Men's suits are black or dark blue, and simply cut. Women's dress is made in a variety of solid colors (generally avoiding bright red, orange, yellow, or pink) and usually includes some form of head covering.

Amish houses are modest, and quilts provide not only pattern and bold color but an outlet for women's creativity. Amish quilts made in Lancaster County between approximately 1875 and 1950 are noted for their rich, solid colors, symmetrical design, and emphasis on a central motif: characteristics that give the compositions a sense of quiet grandeur. Within a limited number of quilt patterns, the color choices allowed by the restrictions of the Bishop (the communally elected leader of a district), may nevertheless permit a broad range of visual effects. The strong color contrast in two of the quilts (10-B.3 and 10-B.4) causes the bars to begin to quiver as you look at them. In another (10-B.5), slender bars will appear to shift. The pulsing energy of the star quilt (10-B.6) is held in check by the wide purple border that just touches the tips of its points.

Many quilts are enriched with stitches in one or more patterns — diamond shapes, feathers, wreaths, vines, and flowers — that add another layer of technical and visual complexity. Although earlier quilts like those reproduced here are thought to be the result of individual efforts among the Lancaster County Amish, in more recent times women often have gathered together to share their needle working skills in community events called quilting bees or "frolics".

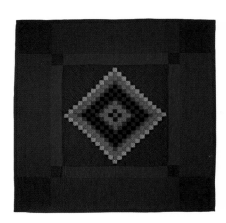

10-B.8 *Diamond in the Square—Sunshine and Shadow Variation Pattern Quilt,* c. 1935. **Top, purple plain- and twill-weave wool; back, purple twill-weave cotton, c. 1935. Overall dimensions 80 x 80 in. (203.2 x 203.2 cm). Gift of "The Great Women of Lancaster." Collections of the Heritage Center of Lancaster County, Lancaster, Pa.**

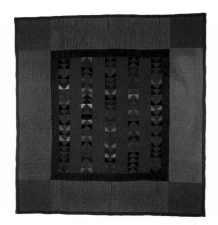

10-B.7 *Bars—Wild Goose Chase Pattern Quilt,* c. 1920. **Top, plain-weave and crepe wool; back, wine-and-white floral-print, plain-weave cotton. Overall dimensions 72.5 x 79.5 in. (184 x 201.9 cm.). Gift of Irene N. Walsh. Collections of the Heritage Center of Lancaster County, Lancaster, Pa.**

B.6 *Lone Star Pattern Quilt,* c. 1920. **Top, plain-weave wool; back, red, green, and white printed-plaid, plain-weave cotton. Overall dimensions 89 x 89 in. (193 x 193 cm.). Gift of Irene N. Walsh. Collections of the Heritage Center of Lancaster County, Lancaster, Pa.**

TEACHING ACTIVITIES

E = ELEMENTARY | **M** = MIDDLE | **S** = SECONDARY

Encourage students to look closely at these quilts, noting color and pattern.

DESCRIBE AND ANALYZE

E
Ask students to point out ladders and circles in Greenlee's *Crazy Quilt.*

E | M | S
Ask students why they think quilt patterns like Greenlee's were called crazy quilts.
It's an informal pattern with shapes that go in random directions.

E | M | S
Encourage students to find pieces of a printed fabric repeated several times in Greenlee's quilt.
A brown and pink floral is repeated in the second row, third square, and in the third row, second and third squares. A red, white, and black plaid is in the third row, second and third squares.

E | M | S
Have students locate stitched or embroidered designs on Greenlee's *Crazy Quilt.*
Stitched designs are in the second row, second square, and in the third row, first square, as well as in many other places.

E | M | S
In McCord's *Grandmother's Fan Quilt,* how are most of the squares alike? *A fan is in each corner of almost all the squares.*
Find the two squares with fans in only two corners. *They are in the second row, fifth square, and in the bottom row, fifth square.*

E | M | S
Have students compare the patterns of Greenlee's *Crazy Quilt* to that of McCord's *Grandmother's Fan Quilt.* What is the main difference between these two quilts? *Greenlee's is made primarily of parallel lines like ladders and McCord's has wedge shapes forming circles.* How did both quilters create unity in their quilt designs? *They repeated colors, shapes, and patterns, and arranged their design into an ordered grid.*

M | S
Ask which quilts on this poster the students think took the most advance planning and why.
It was probably the Amish quilts because of their geometric regularity.
Which ones do you think took the longest time to sew?
The ones made from many small pieces of fabric and with the finest stitches took the longest to construct.

INTERPRET

E | M | S
Ask students why women made quilts. *The main reason was to keep their families warm, but quilts also added decoration and color to homes. Many women also enjoyed designing and sewing quilts.*

E | M | S
Ask why quilters often sewed small bits of fabric together rather than using one large piece of material. *By using fabric scraps and pieces of discarded clothing, they could create inexpensive bed covers.*

E | M | S
Ask students how quilts could record a family's history. *Quilt pieces made from old clothes could remind the family of the people who wore them and special occasions when they wore them.*

M | S
Show students examples of kente cloth. (There are many images of kente cloth on the Internet.) Ask how Greenlee's quilt is similar to kente cloth designs. *They both have contrasting parallel bands of color that resemble ladders.*

S
Ask students what nineteenth-century developments made it easier for American women to make quilts.
The invention of the cotton gin and power loom and opening of New England textile factories made commercially woven and printed fabric available and affordable. Catalogs and magazines printed quilt patterns. The introduction of sewing machines made sewing quicker.

CONNECTIONS

Historical Connections: Slavery; Reconstruction; women's oral history; Industrial Revolution

Geography: Central and West Africa (origins of the African American quilting tradition); Southern slave states; Amish Country (Eastern Pennsylvania, Eastern Ohio, Northern Indiana, Eastern Illinois)

Literary Connections and Primary Documents: *From Sea to Shining Sea: A Treasury of American Folklore and Folk Songs,* Amy Cohn (elementary); *Under the Quilt of Night,* Deborah Hopkinson (elementary); *Homespun Sarah,* Verla Kay (elementary); *Stitching Stars: The Story Quilts of Harriet Powers,* Mary Lyons (middle)

Mathematics: geometric elements

Arts: folk art

11a John Biglin in a Single Scull, c. 1873

Thomas Eakins was in the vanguard of the army of Americans who invaded Paris during the latter part of the nineteenth century to complete their artistic education. After returning to his hometown of Philadelphia in 1870, Eakins never left the United States again. He believed that great artists relied not on their knowledge of other artists' works but on personal experience. For the rest of his career, Eakins remained committed to recording realistic scenes from contemporary American life.

During the three years Eakins was abroad, competitive rowing on the Schuykill River, which runs through Philadelphia, had become the city's leading sport. In England, rowing had long been regarded as the exclusive activity of gentlemen, but in Philadelphia anyone could take part, since rowing clubs made the expensive equipment available to all. Those who chose not to participate could gather on the banks of the river to cheer the oarsmen on, and rowing competitions became some of the most popular sporting events of the century. Eakins was an enthusiastic rower himself, but after his time in Paris he regarded the activity less as a form of recreation than a fertile source of subject matter that combined his dedication to modern life with his interest in anatomy. Even before he embarked on a classical European education that involved drawing from the nude, Eakins had studied human anatomy as part of his artistic training. Fascinated by the mechanics of movement, he was naturally drawn to athletes in action.

At first Eakins painted only acquaintances, but in 1872 the Biglin brothers came to town to compete in a championship race. They were both professional rowers, and John Biglin was a superstar, unmatched as a single sculler (a rower who pulls an oar in each hand) and believed to possess the ideal rower's physique. Here, Biglin appears in his scull, or racing shell, in the heat of competition, his face fixed in concentration as a second shell streams forward on a parallel course. Eakins has chosen the critical moment when the oarsman reaches the end of a backward stroke and prepares to dip his oars into the water; his next stroke will propel his racing shell ahead of the competition and right out of the picture's frame. The river is full of activity on this bright summer day, with a fleet of sailboats and a crew team visible in the distance, but our attention is focused on Biglin, whose body and scull form an elongated triangle in the center of the picture. The composition itself, with broad, even bands of sky and water, emphasizes the horizontal and imparts a stillness to the scene that counteracts the excitement of the competition.

When Eakins painted *John Biglin in a Single Scull,* he had only recently begun to work in watercolor. However, he applied himself to mastering the medium with the dedication and self-discipline he admired in the athletes he portrayed. Unlike oil paint, watercolor does not allow for error: it can't be scraped off the surface and painted over if the artist makes a mistake or changes his mind. Many painters enjoy the spontaneity of the watercolor technique, but Eakins worked to ensure that everything came out right on his first attempt. To establish the exact position of the rower, he first made an oil painting that could be corrected, if necessary. And to place the reflections accurately in the water, he made detailed perspective drawings almost twice the size of the final work.

The painstaking process seems to have paid off. Eakins sent a replica of *John Biglin* to his Paris teacher, Jean-Léon Gérôme, to demonstrate the progress he'd made since returning to Philadelphia. Gérôme praised Eakins's watercolor as "entirely good." "I am very pleased," he wrote, "to have in the New World a pupil such as you who does me honor."

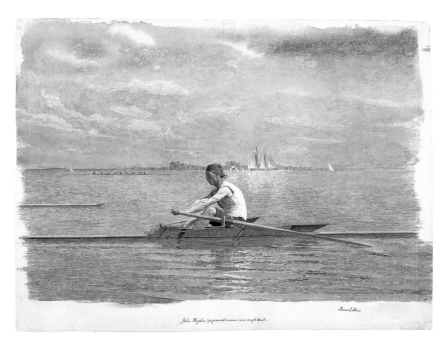

11-A Thomas Eakins (1844–1916), *John Biglin in a Single Scull,* c. 1873. Watercolor on off-white wove paper, 19⁹⁄₁₆ x 24⅞ in. (49.2 x 63.2 cm.). The Metropolitan Museum of Art, Fletcher Fund, 1924 (24.108). Photograph © 1994 The Metropolitan Museum of Art.

TEACHING ACTIVITIES
E = ELEMENTARY | **M** = MIDDLE | **S** = SECONDARY

Encourage students to look closely at the background as well as the foreground of this watercolor painting.

DESCRIBE AND ANALYZE

E | M | S

Ask students to find these elements.
Sailboats: *They are located in the far distance.*
Tower: *It is found in the center distance.*
Second scull: *It is located on the far left.*
Crew team: *A crew team is located in the left background.*

E | M | S

Describe the rower's arms.
They are very muscular.
What did Eakins need to know in order to accurately draw and paint this man's arms?
He had to understand human anatomy and also had to closely observe how the man looked and moved as he rowed.

E | M | S

How did Eakins show distance in this painting?
Distant objects, including water ripples, are less detailed, smaller, lighter, and bluer than objects in the foreground.
Where are the spaces between the ripples largest?
The spaces between the ripples are largest in the foreground, where they are closest to the viewer.

E | M | S

In watercolor, artists sometimes purposely leave areas blank to reveal the white color of the paper.
Where do you see very white areas that are probably the paper?
These areas are located in the highlights on the waves in the foreground, the clouds, and the lightest part of Biglin's shirt.

E | M | S

Ask students what geometric shape Biglin's head, body, boat, and arms form, and ask them to point out the shape.
They form a triangle.

INTERPRET

E | M | S

Have students extend their arms and lean forward and pretend to row as John Biglin does in the painting. Ask them how his hands and arms might move in the next few seconds.

E | M | S

Ask students which direction the boat is moving. *It is moving to the right.*
Which boat is ahead in the scull race? *John Biglin's scull is ahead.*
Imagine where the second boat could be within a minute or two.
Biglin could leave it behind, or the other scull could catch up with Biglin and soon pass him.

E | M | S

Have students describe this man's expression. What can you tell about his character from this painting?
He seems serious and determined.

S

What does this picture suggest about Americans' leisure activities in the late 1880s?
John Biglin's dress suggests that he is not wealthy. There are many boats on this river in Philadelphia, a large American city. Many Americans had time to pursue water sports.
Why is Biglin the only single scull rower shown in the painting?
The subject is Biglin as an individual, challenging himself as much as competing against others.

CONNECTIONS

Geography: rivers
Science: anatomy

Literary Connections and Primary Documents: Eakins's letters home to his family (middle, secondary); *Tom Sawyer*, Mark Twain (middle); and *The Adventures of Huckleberry Finn*, Mark Twain (secondary)

Arts: photography; Realism

JOHN BIGLIN IN A SINGLE SCULL, c.1873, THOMAS EAKINS [1844–1916]

11b The Peacock Room, 1876–1877

Born in Massachusetts, James McNeill Whistler went to Paris at the age of twenty-one with the ambition to become an artist. He established his professional life in London and never returned to his native land. Over the years, he became one of the most artistically progressive painters of the nineteenth century. As an expatriate, Whistler was not influenced by the American tendency to endow art with moral purpose. In fact, he went so far as to embrace the philosophy of aestheticism, or "art for art's sake," which recognizes beauty as the only justification for art.

During the 1870s, at the height of his career, Whistler was concerned with the presentation of works of art. He designed frames for his paintings and sometimes even orchestrated the exhibitions in which they were displayed. His desire for an aesthetic that embraced everything was finally realized in the dining room he decorated for the London residence of the British ship-owner, Frederick Richards Leyland, his principal patron. That decoration, now known as the Peacock Room, strengthened Whistler's reputation as an artist whose aesthetic flair went well beyond the boundaries of a picture frame.

11-B James McNeill Whistler (1834–1903), _Harmony in Blue and Gold: The Peacock Room_, 1876–1877 (two views). Oil paint and gold leaf on canvas, leather, and wood, room dimensions: height 13 ft. 11⅜ in., width 33 ft. 2 in., depth 19 ft. 9½ in. (425.8 x 1010.9 x 608.3 cm.). Freer Gallery of Art, Smithsonian Institution, Washington, D.C., Gift of Charles Lang Freer, F1904.61.

To Whistler's way of thinking, the dining room should complement the frame of one of his own paintings, _The Princess from the Land of Porcelain,_ which held the place of honor above the mantelpiece. Whistler had painted it a dozen years earlier, when he was seized by a passion for blue-and-white Chinese porcelain. According to his mother, he considered the porcelain among "the finest specimens of art," and _The Princess_ was conceived to celebrate the beauty of the figures that adorned it. Leyland himself possessed a large collection of blue-and-white china, and his dining room had been designed for its display, with an elaborate latticework of shelving that provided a beautiful "frame" for each pot.

Yet, Whistler was unsatisfied with Leyland's room of porcelain, and with his patron's permission he began to make modest changes to the original decoration. Eventually, his creativity ran wild. He went so far as to paint over costly gilt-leather wall-hangings, creating an uninterrupted field of peacock blue above the shelving (which he gilded). By the time he had finished, every inch of the room was covered in his designs. Except for the greenish-blue walls, every surface shimmers with gold and copper leaf; even the places half-hidden by the shelving bear a rich, tapestry-like design to set off the gleaming surfaces of the porcelain. Whistler imagined the Peacock Room as a painting on a grand scale and in three dimensions, a work of art that could be entered through a door. The overall aesthetic effect — which can never be adequately conveyed in words or pictures — has been likened to the beauty of a Japanese lacquer box.

Although Whistler was famously disdainful of nature (its "song," he complained, was almost always out of tune), he admitted that the natural world could sometimes serve as a source of decorative motifs and color schemes. For the Leyland dining room, he adopted the natural patterns and iridescent coloration of a peacock feather. But for the peacocks themselves, he found models in art, rather than nature. The magnificent, life-sized birds adorning the floor-to-ceiling shutters allude to the bird-and-flower prints of the Japanese artist Hiroshige; the pair of golden peacocks on the broad wall opposite _The Princess_ are copied from the ornamental birds Whistler had seen adorning Japanese vases.

The mural has a story to tell. Halfway through the project, Whistler quarreled with Leyland over payment for the decoration. Eventually he settled for half the amount he had originally demanded in exchange for Leyland's promise to stay away while he finished the room to his satisfaction. Although Leyland would seem to have had the better part of that bargain, Whistler ensured that posterity would remember the offending patron as a rich man who couldn't bear to part with his pennies, even in exchange for an immortal masterpiece. The proud peacock on the right, faintly ridiculous with his ruffled feathers, represents Leyland, whose fondness for ruffled shirts Whistler suggested with the silver feathers on his neck. At his feet lie the coins he had so carelessly cut out of Whistler's fee. The put-upon bird on the left, crowned with a single silver feather, represents the artist, with his signature shock of white hair. Titled "Art and Money," the Peacock Room mural was meant as a cautionary tale with a moral at the end — that riches may be spent, but beauty endures.

TEACHING ACTIVITIES

E = ELEMENTARY | M = MIDDLE | S = SECONDARY

Encourage students to look closely at all the areas of this room.

DESCRIBE AND ANALYZE

E|M|S

Ask students to locate four gold peacocks in this room.
Two are on a shutter on the left and two are on the back wall.
In addition to the images of the peacocks, why do people usually call this room "the Peacock Room"?
It is peacock blue, the color of peacock feathers.

E|M|S

Have students write a list of adjectives to describe this room. Ask them to share their words with the class. Many may mention riches or wealth. Ask them what makes this room seem rich.
There is an extensive use of gold here, and gold is associated with riches.

M|S

What objects in this room might seem exotic or foreign to Western Europeans and Americans?
The peacocks are Asian birds. Blue and white Chinese ceramics fill the shelves. The woman in the painting above the fireplace stands on an Oriental rug, in front of an Asian screen, and wears a robe like a kimono.

E|M|S

How did Whistler create harmony in this room or make it seem as if it all goes together?
He painted most of the room peacock blue and repeated metallic gold details throughout the room. Only the warm pink tones of the painting contrast with the blues and greens.

E|M|S

Where do repeated shapes in this room form patterns?
They occur in the ceiling, along the back wall, and around the fireplace.

E|M|S

Describe how Whistler made his painting of the woman an important part of the room's overall design.
The painting is centered over the fireplace and surrounded by gold shelves and panels that match its gold frame.

INTERPRET

E|M|S

Imagine people in this room when it was first designed. How would they dress?
In the 1870s, women wore long, elaborately constructed dresses and men, cravats or bow ties, fitted jackets, and long trousers.
What might they do in a room like this?
The room was originally a dining room. Students may imagine parties or groups of wealthy people dining and admiring the room and its collection of ceramics.

S

How does this room embody Whistler's philosophy of "art for art's sake"?
The owner intended it to be a dining room and a place to display a collection of fine East Asian porcelain, but after Whistler painted it, the room draws more attention to itself as a work of art. It contains no moral message, but there is symbolism in the design of the peacock fight, which refers to a dispute between Whistler and the room's owner.

CONNECTIONS

Historical Connections: British/European imperialism; Imperial Japan; Spanish-American War

Historical Figures: Theodore Roosevelt; Commodore Matthew Perry

Geography: U.S. territories

Arts: Impressionism; Japanese prints; "art for art's sake"; influence of John Singer Sargent and William Merritt Chase

THE PEACOCK ROOM, 1876–1877, JAMES McNEILL WHISTLER [1834-1903]

Portrait of a Boy, 1890

12a

In December 1889, the expatriate artist John Singer Sargent, accompanied by his younger sister Violet, arrived from London at New York harbor. Not yet thirty-four, Sargent was approaching the highpoint of his fame on both sides of the Atlantic as a portraitist. His previous American visit, an eight-month trip undertaken in 1887–1888, had resulted in an enthusiastic reception, many new commissions, and the promise of future contacts in Boston, Newport, and New York.

Like Gilbert Stuart before him (see *George Washington*, 3-B), Sargent painted formal portraits for the Gilded Age's patrician class in the manner of European aristocratic portraiture. He also brought with him a fresh, new way to depict a subject that was popular in both England and the United States—children—at a time when childhood was being singled out as a critical period in human development (and in national progress). Because children were understood to be the direct link to the future, they warranted special attention. From the widespread manufacturing of special books, toys, and clothing to child protection laws, the later nineteenth century ushered in what writer Sadakichi Hartmann called, in a 1907 article for *Cosmopolitan* magazine, the "age of the child."

Dismissing his contemporaries' sentimental approach to childhood as a period of lost innocence, Sargent approached his youthful sitters directly, painting them naturalistically and with a keen, psychologically penetrating eye. His many portraits of the young heirs of America's upper class also helped to further the artist's career, pleasing conservative critics and reassuring future patrons who might harbor some lingering doubts as to whether they wanted to submit themselves to Sargent's forceful brushwork and bravura technique.

Sargent's portrait of the young Homer Saint-Gaudens, the son of the sculptor Augustus Saint-Gaudens (see 10-A), and his mother Augusta, a cousin of Winslow Homer (see 9-A), is an intimate portrait for a friend, not a commission that paid the bills. Sargent first encountered Saint-Gaudens in Paris in 1878. When the artists met again in New York in 1890, Saint-Gaudens expressed interest in sculpting an image of Violet, and the painting was done in the spirit of an exchange. Nonetheless, the fact that Sargent preferred a generic title, *Portrait of a Boy,* to the specific name of the child, and excluded his mother's name entirely may indicate the artist's desire to elevate his depiction of Homer Saint-Gaudens to a universal statement about the nature of boys (or perhaps just American ones).

In *Portrait of a Boy*, ten-year-old Homer confronts the artist and viewer head-on and eye to eye with a bored, yet penetrating glance, while behind him, and painted in a more summary manner, Augusta is absorbed in reading. Homer is dressed (uncomfortably, it appears) in a "Little Lord Fauntleroy" suit, an outfit based on the title character from Frances Hodgson Burnett's wildly popular, serialized story of Cedric, an American boy who, through Yankee ingenuity and the wisdom imparted by his mother, was able to lay claim to his aristocratic English heritage. Cedric's costume, derived from the attire worn by Sir Joshua Reynolds's *Blue Boy* of 1770, was so popular with mothers that, by the turn of the century, wearing it became synonymous with being a "mama's boy."

Homer, however, wearing his fancy suit, does not appear to be the obedient child listening to his mother's every word. We know from Homer's adult recollections of these sittings that Augusta was vainly attempting to entertain her son with the story of a naval battle from the War of 1812. Sargent expressed the boy's impatience and nervous energy not only through his pose but also through the structure of the composition. The child slumps sideways in the ornate studio chair. And while his right foot turns languidly inward, his left foot is braced against the rung, ready to spring. The latent energy of his spread, bent fingers matches the complexity of the swirling pattern of the red carpet, and this unease is intensified by Homer's pose, which is at a slight angle to both the viewer and to his mother.

As with Sargent's more ambitious pictures, the portrait of Homer and his mother was conceived with an eye to enriching the painter's reputation. Critics were quick to praise the immediacy of the subject: "The exquisite truth of its pose and the rare vitality of every line of the body, not less than the beautiful face itself reveal the power of a master." The painting won a gold medal at the Art Club of Philadelphia the year it was painted, and was one of the works Sargent chose to exhibit at the Chicago World's Fair in 1893.

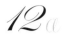

12-A John Singer Sargent (1856–1925). *Portrait of a Boy,* **1890. Oil on canvas, 56⅛ x 39½ in. (142.56 x 100.33 cm.). Carnegie Museum of Art, Pittsburgh; Patrons Arts Fund (32.1). Photograph © 2007 Carnegie Museum of Art, Pittsburgh, Pa.**

TEACHING ACTIVITIES

E = ELEMENTARY | M = MIDDLE | S = SECONDARY

Encourage students to study the figures in this painting closely

DESCRIBE AND ANALYZE

E | M | S

Posing for a portrait painted in oils can be a long process involving many sittings. Have students sit on a chair (or low table) in the pose Homer assumes in this painting. Ask them to describe how it makes them feel.
Sitting slumped over and sideways with one foot dangling limply and the other poised against the rung of the chair gives a sense of being unsettled, with a desire to squirm around.

E | M | S

Ask students to sit with a book on their laps and read out loud, as Homer's mother does. Ask them to describe how this pose makes them feel.
Sitting as Homer's mother does probably makes them feel focused and still, but also very aware of what the person who leans on them is doing.

E | M | S

Ask students what the difference between the two poses says about how each sitter probably felt about posing for this picture.

E | M

Homer is dressed in an outfit based on a story that was extremely popular with mothers. However, this costume was also beginning to be associated with being a "mamma's boy." Ask students if they think Homer is portrayed as a "mamma's boy" and to point out why or why not?
Homer isn't acting obediently. He is sitting restlessly and awkwardly in his chair with a bored expression on his face, fingers spread, and his back at an angle to his mother.

Ask students to imagine how they would pose under similar circumstances.

E | M | S

How has Sargent used the room and accessories in this painting to intensify Homer's feeling of impatience?
The chair is too large for the boy to sit comfortably (his feet do not reach the floor), and the swirling pattern of the carpet reflects his frustration with posing.

E | M | S

Ask students who is more important in this double portrait.
Homer is.

How did the artist emphasize Homer's importance?
Sargent has positioned Homer in the foreground at the center of the painting. The boy sprawls across a large, ornate chair and looks directly at the viewer (or painter). There is a strong light shining on his face, hands, and bowtie, and he is painted in more detail than his mother is. His importance is also reflected in the title, Portrait of a Boy.

INTERPRET

E | M | S

Sargent made his living painting portraits of wealthy Americans and Europeans. How do you think this work, done for a friend, might have differed if it had been commissioned by a wealthy family who wanted to hang it in a prominent place in their home?
Like George Washington in Gilbert Stuart's portrait (3-B), Homer's mother probably would have been shown wearing more formal and expensive clothing and perhaps also been portrayed looking out of the painting. Homer may have been made to appear less restless, and the room and accessories would have been more elaborate.

M | S

Sargent was praised for his "truthful" portrayal of children at a time when childhood was becoming an important focus in Europe and America. Pretend you are an art critic and explain what you consider to be "truthful" about Homer Saint-Gaudens in this work.

CONNECTIONS

Historical Connections: the Gilded Age; industrialism; child labor; orphan trains

Historical Figures: Historical Figures: Jane Addams; John Peter Altgeld; Charles Loring Brace; Andrew Carnegie; John D. Rockefeller; Cornelius Vanderbilt

Economics: capitalism

Literary Connections and Primary Documents: *Little Lord Fauntleroy,* Frances Hodgson Burnett (middle, secondary); *The Adventures of Huckleberry Finn,* Mark Twain (secondary), and *Tom Sawyer,* Mark Twain (middle); *Little Women,* Louisa

May Alcott (middle); stories of Horatio Alger (1834–1899), (middle)

Arts: portraiture; American expatriate artists; influence of Velásquez, Van Dyck; Lewis Hine



PORTRAIT OF A BOY, 1890, JOHN SINGER SARGENT [1856–1925]

55

12*b* Allies Day, May 1917, 1917

One month after the United States officially entered the First World War, the city of New York festooned Fifth Avenue with flags. As a welcoming gesture to the British and French war commissioners, the Stars and Stripes hung alongside the Union Jack and the French Tricolor to create a patriotic pattern of red, white, and blue. Childe Hassam, an American of British descent who had studied and worked in Paris, took personal pride in the new military alliance.

Allies Day, May 1917 is not Hassam's only flag painting, but it quickly became (and has remained) the most famous of the ensemble. Hassam began the series in 1916, when thousands of Americans demonstrated support for the Allied cause by marching up Fifth Avenue in the Preparedness Parade. Moved by this and other war-related ceremonies, he eventually produced some thirty views of New York streets bedecked in banners. Because Hassam was influenced by French Impressionism, he was naturally drawn to the sun-struck spectacle of those colorful, celebratory occasions. But the flag paintings transcend the pageantry to express Hassam's conviction about the moral and financial supremacy of the United States.

Although it may appear as casual as a snapshot, *Allies Day* is meticulously composed. To paint it, Hassam set up his easel on the balcony of a building at the corner of Fifth Avenue and Fifty-second Street, which allowed a view of springtime foliage north toward Central Park. Flags are everywhere, but they cluster on the right and bottom edges of the canvas, making a colorful frame for the buildings lining the west side of the avenue. In the immediate foreground the emblems of the Allied nations hang neatly in a row (the Union Jack appears on the Red Ensign, the unofficial flag of Canada) to establish the theme that Hassam varies and repeats. With different patterns but matching colors, the flags represent the harmony of three nations joined in a single cause — "the Fight for democracy," as Hassam himself defined his painting's significance. But in this flurry of symbolic meaning, only one banner hangs entirely clear of other flags and flagpoles. Hassam's contemporaries would have instantly recognized his purpose in placing the Stars and Stripes at the pinnacle of the composition, set against a cloudless sky.

If *Allies Day* portrays a historic occasion and symbolizes the nationalistic temper of the times, it also offers a telling description of landmarks on Fifth Avenue, known at the time as Millionaire's Row. The façades are all bathed in morning sunlight, but the brightest façade in the row, Saint Thomas Church, is also the newest, constructed in the Gothic-revival style and consecrated only the year before this work was painted. Beyond it stands the University Club, recalling a Renaissance palazzo, beside an expensive hotel called the Gotham (now the Peninsula). Next to it, just barely visible, is the sloping façade of the Fifth Avenue Presbyterian Church. Many of the flags point toward these buildings as if to identify them as the subject of the picture; all served the richest, most prominent members of New York society, linking them to the nation's prosperity. Hassam may have featured the two ecclesiastic structures — particularly Saint Thomas, which gleams in the sunlight — in order to suggest that the new alliance of the United States with the Old World nations of Britain and France had even won divine approval.

As Hassam's most patriotic picture, *Allies Day, May 1917* became instantly famous through the sale of color reproductions to benefit the war effort. The flag paintings were exhibited together for the first time four days after the armistice was declared in November 1918, to document the story of the American entry into the Great War and to commemorate its victorious conclusion.

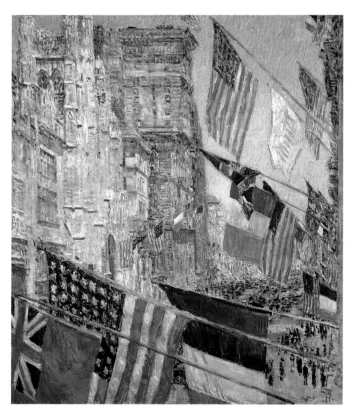

12-B Childe Hassam (1859–1935), *Allies Day, May 1917*, 1917. Oil on canvas, 36½ x 30¼ in. (92.7 x 76.8 cm.). Gift of Ethelyn McKinney in memory of her brother, Glenn Ford McKinney. Image © 2006 Board of Trustees, National Gallery of Art, Washington, D.C.

TEACHING ACTIVITIES
E = ELEMENTARY | **M** = MIDDLE | **S** = SECONDARY | **Encourage students to view this painting carefully,** distinguishing all the separate elements.

DESCRIBE AND ANALYZE

E | M | S

Have the students describe the brushstrokes in this painting.
They can be distinguished separately, as if the artist has just made them. They are not blended together to make a smooth surface and are of different sizes.

E | M | S

Ask students to find the church tower. *It is on the left.*
Where are the trees in Central Park? *They are the green in the lower center of the painting.*
What is happening in the street? *The street is filled with people. Perhaps there is a parade.*

E | M | S

Have students locate several United States flags, two British Union Jacks, three French Tricolors, and a red flag with a small Union Jack on it that represents Canada.

E | M | S

Have students look at street and satellite maps of New York City to see where Hassam was when he painted this and how this view has changed. *He was on a balcony at the corner of Fifth Avenue and Fifty-second Street looking north toward Central Park.*

E | M | S

Where are the shadows and what color are they? *They are under projecting parts of the buildings and in the street, and they are blue.*

E | M | S

How is this painting like an impression rather than a finished artwork?
The bright colors, unblended brushstrokes, and lack of intricate detail make it seem like a quick glance at a scene.
Explain that Impressionism, which began in France in the late 1860s, was a popular painting style in America at this time.

INTERPRET

E | M | S

Which flag in the middle ground stands alone and is not overlapped by other flags? *The American flag is surrounded by light blue sky.*
What does this suggest about how Hassam felt about his country? *He thought America was unique and was proud of his country.*

M | S

What international event was happening when this was painted? *It was painted during World War I.*
Why were so many flags flying in New York City on this day? *A month before this was painted, the United States officially entered the war. On this day the British and French war commissioners were visiting New York.*

M | S

What do these flags flying together symbolize? *They symbolize the fact that these three nations were standing together to fight the war.*
What elements do the flags have in common? *They are all red, blue, and white.*

M | S

What does this painting show about America's spirit in 1917?
Americans were proud of their country and optimistic about the future and this alliance with France, Britain, and Canada.

M | S

Why did this painting become famous soon after it was completed?
Color reproductions of it were sold to benefit the war effort.
Why did Americans want copies of this painting?
For the beauty of the art and to show support for America and its allies as it joined them in the war.

CONNECTIONS

Historical Connections: American isolationism; World War I; League of Nations

Historical Figures: Woodrow Wilson; Archduke Franz Ferdinand

Civics: history of the American flag

Geography: the Allied Powers (France, Russia, United Kingdom, Italy, United States); the Central Powers (Austria-Hungary, Germany, Ottoman Empire); the Western Front

Literary Connections and Primary Documents: *The Sun Also Rises, A Farewell to Arms,* Ernest Hemingway (secondary); *The Waste Land,* T. S. Eliot (secondary)

Music: "The Star Spangled Banner"

Arts: Impressionism; American Impressionism

ALLIES DAY, MAY 1917, 1917, CHILDE HASSAM [1859–1935]

Ba Brooklyn Bridge, New York, 1929

When the Brooklyn Bridge opened to traffic in 1883, it was the largest suspension bridge in the world, and its towers were the tallest structures in the Western Hemisphere. As the years went by, that triumph of engineering and architecture began to lose its power to inspire awe. By 1929, when Walker Evans began to photograph it, the bridge had settled into the unexciting link between the New York boroughs of Brooklyn and Manhattan; it was hardly even noticed by the harried commuters who crossed it every day. Evans's gift was to perceive something familiar as if it had never been seen before and therefore to restore the Brooklyn Bridge's original wonder.

Evans became interested in photography as a child, when he collected penny postcards and took pictures of his friends and family with an inexpensive Kodak camera. As a young man, he developed a passion for literature, and he spent 1927 in Paris as an aspiring writer. Upon his return, he began to revisit his childhood hobby, hoping to apply literary concepts such as irony and lyricism to photography. As the technical possibilities of the medium had expanded, photography had grown from its original documentary and commercial functions (and its function as a popular pastime) into a form of fine art. It was still an art that had not entirely freed itself from the rules of nineteenth-century Western painting. Evans's European experience, however, had converted him to the strict geometries of modernist art. He disliked the preciousness of "art photography," and endeavored to capture the sincerity of a snapshot in his own work.

From the windows of the rooms he rented in Brooklyn Heights, Evans had a fine view of the Brooklyn Bridge. Inspired to take a closer look, he recorded his impressions with the simple camera he habitually carried in his pocket. The resulting series of photographs captures the bold forms of the bridge in stark, arresting, geometric designs. These images helped to establish the Brooklyn Bridge as an emblem of modernity, and to popularize its use as a motif among modern American artists.

Previous photographers had focused on a lateral view of the bridge, taking in the bold shapes and sweeping scallops of the structure as a whole, and keeping the Manhattan skyline visible in the distance. Evans takes an altogether different perspective, shocking the viewer out of complacency. In this photograph, the enormous piers and arches are shown through a web of steel cables. The only immediately identifiable element in the composition is the lamppost on the right, which gives the picture a sense of scale, yet appears strangely separate from its setting. At first, the pattern of radiating lines is disorienting, but once our eyes grow accustomed to the photographer's point of view, we discover we are on the central pedestrian walkway of the Brooklyn Bridge. The composition is slightly asymmetrical, which suggests that Evans had taken his picture standing just off-center of the bridge's walkway. The sharp angle of perspective, emphasized by the quickly receding lines of the cables, suggests that he set the camera low, perhaps even on the ground.

This clever calculation includes no sign that the Brooklyn Bridge serves any practical purpose. Normally vibrant with the commotion of twentieth-century transportation, the thoroughfare here appears quiet and eerily depopulated, an object meant to be appreciated only as a work of art. The unusual vantage point also eliminates the expected views of city and river, so that the bridge appears to float in an empty sky. Because Evans has detached it from its urban context, the Brooklyn Bridge also appears removed from its own time: the heavy forms and medieval-style piers and arches recall the gates of an ancient fortress, while the pattern of steel cables hints at some untried, futuristic technology. In this remarkably compact image (the print is no larger than the vest pocket that held his camera), Evans presents us with two new and substantial concepts that would forever alter our perception of the Brooklyn Bridge: as an icon of modernity and as a monument that already belongs to history.

13-A Walker Evans (1903–1975), *Brooklyn Bridge, New York, 1929*, printed c. 1970. Gelatin silver print, 6¾ x 4¹³⁄₁₆ in. (17.2 x 12.2 cm.). The Metropolitan Museum of Art, Gift of Arnold H. Crane, 1972 (1972.742.3). © The Walker Evans Archive, The Metropolitan Museum of Art.

TEACHING ACTIVITIES
E = ELEMENTARY | M = MIDDLE | S = SECONDARY

| **Encourage students to look closely at this photograph,** paying attention to the directions of the bridge and cable lines.

DESCRIBE AND ANALYZE **E | M | S**

Ask students if they would recognize the image in this photograph as a bridge if it were not titled. Is this the shape they visualize when they think of a bridge?
Most students will probably say it is not.
Why not?
It's from a different viewpoint than the one from which we usually see a bridge.
When most artists create a picture of a bridge, what view do they show of it?
Most photographs show a side view.
Where was the camera when this photograph was taken?
It was down low, looking up at one of the bridge's two towers.
Show students other views of the Brooklyn Bridge so they will understand the unusual viewpoint of this photograph.

E

Ask students to find the lamppost in this art.
It is on the right side.

E | M | S

Have students locate the point to which all the cable lines seem to lead.
It is near the top center of the bridge tower.
Is this point centered in the photograph?
No, it isn't.
Is the balance in this picture symmetrical or asymmetrical?
It is asymmetrical.

M | S

Ask students if they have ever seen windows that were shaped like the arches on this bridge. Where did they see these?
These pointed arches resemble Gothic arches usually found in medieval churches and architecture. Students might have seen pointed arches in a church.
Gothic cathedrals were the great engineering achievements of medieval Europe. Ask students what the presence of Gothic arches in the Brooklyn Bridge might have symbolized.
The reference to Gothic architecture might have symbolized that the Brooklyn Bridge was an American marvel of engineering, equivalent to the Gothic cathedrals of Europe.

INTERPRET **M | S**

Evans wanted his photographs to show the national character of America. How does this photograph satisfy his aim?
The Brooklyn Bridge, in America's largest city, was a structure that Americans were proud of. It was a modern feat of engineering and architecture. Evans's photograph shows the beauty of a structure that thousands of Americans used every day.

S

Until the late nineteenth and early twentieth centuries, photography was primarily a means of documentation and was not considered art. The photographer who took this picture considered photography to be an art form. Do you agree with him? Use this photograph to support your reasoning.

S

Evans used a modern medium (photography) to create a modern image of a famous structure. When he had studied art in Paris, he saw modern European art that featured abstract, simplified forms. How is this photograph like abstract modern art?
Its unconventional viewpoint makes the shape of the bridge seem abstract and not easily recognizable. The stark dark shape against the plain light background with the explosion of lines leading to it makes it seem like a contemporary geometric composition.

CONNECTIONS

Historical Connections: modernism in America; history of the city, especially New York

Historical Figures: John and Washington Roebling

Geography: East River; topographical issues that impeded the construction of the bridge (for example, deep bedrock underneath the caisson on the Manhattan side of the bridge)

Science: civil engineering; late nineteenth-century inventions

Literary Connections and Primary Documents: "Crossing Brooklyn Ferry," Walt Whitman (secondary); *The Great Gatsby*, F. Scott Fitzgerald (secondary); *The Bridge*, Hart Crane (middle, secondary)

Arts: Abstraction; Futurism

13₆ Autumn Landscape—The River of Life, 1923–1924

Louis Comfort Tiffany, son of the founder of the New York City jewelry store that still bears the family name, took no interest in his father's business. Instead, he trained as a painter in Paris, and upon returning to New York decided to channel his talents into the decorative arts. "I believe there is more in it than in painting pictures," he declared. By the 1890s, Tiffany was exploring the possibilities of colored glass, a medium that had remained virtually unchanged since the Middle Ages. In the late nineteenth century, it was experiencing a revival, owing to the large number of churches under construction in prospering American cities. Gradually, stained glass made its way into secular settings, with biblical subjects giving way to naturalistic motifs and woodland themes. These luminous windows worked like landscape paintings to introduce a sense of natural beauty into an urban home. Their dense designs had the added advantage of blocking views of dirty streets and back alleys that an ordinary window might reveal.

Autumn Landscape was commissioned by real estate magnate Loren Delbert Towle for his Gothic Revival mansion in Boston. The window was meant to light the landing of a grand staircase, and, by presenting a landscape view that receded into the distance, it would offer the illusion of extending a necessarily confined space. But even in domestic interiors, stained glass never entirely lost its religious overtones. Tiffany divided this composition into lancet windows reminiscent of a medieval cathedral. In keeping with the American landscape tradition, the theme of *Autumn Landscape*—The River of Life also invites a spiritual interpretation. Tiffany generally reserved the traditional subject, in which a mountain stream flows through the rocks and cascades into a placid foreground pool, for memorial windows in churches and mausoleums; here, the season enhances the symbolism of a lifetime winding to a close, with the sun sinking low on a late autumn afternoon. As it happened, the window did become a memorial of sorts, for the Boston client died before it could be installed in his residence. *Autumn Landscape* was subsequently sold to the Metropolitan Museum of Art where, divorced from its intended setting of a private interior for the privileged few, it became a work of art available to the public.

Tiffany's ambition was to use glass to create the effect of oil or watercolor painting, without resorting to the application of enameled decoration. To this end, he developed new techniques for producing and manipulating colored glass, and he eventually achieved a range of visual and tactile effects that would have been impossible with paint alone. *Autumn Landscape,* one of his later productions, makes use of nearly every method in Tiffany's extensive repertoire: mottled glass for the dusky sky; confetti glass (with thin flakes of colored glass embedded in the surface) for the shifting colors of the autumn foliage; marbleized glass for the boulders; rippled glass for the foreground pool. To deepen the color and enhance the depth of the distant mountains, Tiffany applied layers of glass to the back of the window, a technique called "plating." But as he would have been aware, the full effect of the window depended on the intensity of the natural light that shone through it to magically alter the landscape throughout the day and the year.

As a window that resembles an elaborately framed easel painting, *Autumn Landscape* fulfills the aesthetic movement's mission of introducing art into daily life. Like his contemporary James McNeill Whistler, who is often regarded as the movement's leading American exponent (see 11-B), Tiffany concerned himself with the entire range of a room's decorative effects, weaving them into a single, harmonious design. He found countless ways to give his art a practical purpose, designing everything from books to furniture; however, in any medium, he said, his primary consideration had always been simply "the pursuit of beauty."

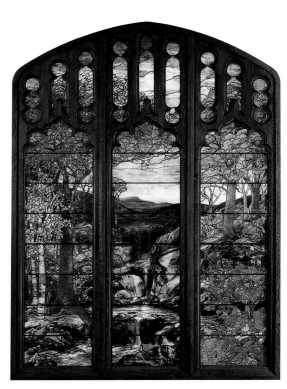

13-B Louis Comfort Tiffany (1848–1933), *Autumn Landscape*—**The River of Life, 1923–1924, Tiffany Studios (1902–1938). Leaded Favrile-glass window, 11 ft. x 8 ft. 6 in. (335.3 x 259.1 cm.). The Metropolitan Museum of Art, Gift of Robert W. de Forest, 1925 (25.173). Photograph © 1997 The Metropolitan Museum of Art.**

TEACHING ACTIVITIES

E = ELEMENTARY | M = MIDDLE | S = SECONDARY

Encourage students to look closely at this stained glass window, examining the scene depicted and how it is put together.

DESCRIBE AND ANALYZE

E | M | S

Ask students what they see first in this window.
They will probably see the sun in the center.
Why is our attention drawn to this area?
It is the lightest part of the window and contains the strongest contrast of light and dark.

E | M

Where did Tiffany repeat colors in this window? Locate where he has used these hues.
Red: *It is found in the trees, top left and lower right.*
Blue: *It is located in the sky, mountains, and stream.*
Green: *This color is found in the pond, in the left center tree, and in the gold trees on the right.*

E | M | S

How would this window feel if you ran your fingers over its surface?
It would feel rough in some areas and smooth in others.
Where do you see rough textures? *These are found in the trees and rocks.*
Where do you see smooth textures? *They are located in the pool and the light sky.*
Tiffany used a variety of techniques to create special textures and colors of glass. Point out these areas.
Mottled glass: *It is located in the dark parts of the sky.*
Confetti glass: *We see it in the foliage.*
Marbleized glass: *It is found in the boulders.*
Rippled glass: *It occurs in the closest pool.*

E | M | S

What time of the day is depicted?
Because the sun is near the horizon, it is early morning or late afternoon.
Why will this art look different at different times of the day?
The light shining through it will be different depending on how high or low the sun is in the sky and whether it is a bright or overcast day.

INTERPRET

E | M | S

Stained-glass windows are commonly seen in churches, but this window was created for a stairwell in a man's private home. Why would someone rather have a stained-glass window in a house than clear glass?
The window is beautiful, and provides privacy or blocks unsightly views.

M | S

On which side of a house — north, south, east, or west — might you want to install this window, and why?
The south side would receive light all year; the west side, in the afternoon and evening; the east, in the morning; and the north side would never receive direct light.

S

How would this landscape make the space of a small stairwell feel larger?
Instead of a wall at the top of the stairs, the window would open up a deep vista and make the inside space look as if it continues outside into the landscape.

S

Because the man who commissioned this window died before it was installed, it seemed like a memorial for him.
Why are autumn scenes and sunsets often featured in memorials to the dead?
Sometimes a year is a metaphor for a lifetime. The autumn of a person's life refers to a later stage of life and the sunset marks the end of a day.
Describe the mood of this scene.
It is very serene and peaceful.

CONNECTIONS | **Historical Connections:** the Gilded Age; the Great Depression | **Literary Connections and Primary Documents:** *The Great Gatsby*, F. Scott Fitzgerald (secondary) | **Arts:** arts and crafts movement; Art Nouveau; aesthetic movement

teaching activities

Mary Cassatt decided to become an artist at age sixteen, when most women of her era and social status were looking forward only to marriage. Defying convention, she studied art in Philadelphia before heading to Europe and settling in Paris, where she remained for most of her life. As a woman, Cassatt was not permitted to enroll in the École des Beaux-Arts, the leading art academy in France, but she found private instruction and educated herself by copying paintings in the Louvre Museum. Years later, she recalled that her life had changed when she met the artist Edgar Degas, who invited her to join the Impressionist circle. Partly because women were not welcome in the Paris cafés where the Impressionists often discovered their subject matter, she specialized in domestic paintings, particularly of mothers and children.

In the late 1880s, when Cassatt was well established in her career, she fell under the influence of Japanese prints and dramatically altered her own style of painting. Abandoning the feathery brushwork, pastel colors, and insubstantial forms of Impressionism, Cassatt began to create bold, unconventional patterns of flat color and solid forms. *The Boating Party,* painted on the south coast of France, exemplifies the change. Rather than attempting to capture a fleeting visual impression, Cassatt arranged abstract shapes in a shallow space using saturated areas of color that may have been inspired by the brilliant Mediterranean light. To heighten the decorative effect, she flattened the scene, placing the horizon line at the top of the composition in Japanese fashion. From our unusual vantage point, the three figures look like paper dolls pasted on a vivid background.

The Boating Party is among Cassatt's most ambitious canvases. The composition is controlled by visual rhymes. The boat's yellow benches and horizontal support echo the horizontals of the far-off shoreline. The billowing sail echoes the curve of the boat, creating a strong visual movement to the left that counteracts the broad angle formed by an oar and the boatman's left arm. Without the sail for balance, the large, dark figure of the boatman would weigh the picture to the right, and the boating party would lose its equilibrium.

At first glance, the painting seems a straightforward depiction of a nineteenth-century middle-class outing. Yet the artist included subtle hints about the figures' relationships to one another that complicate this interpretation. Although Cassatt usually explored the familiar theme of mother and child, in this rendition the foreground is dominated by a male figure whose form is pressed against the picture plane and cast in silhouette by the sail's shadow. In contrast, the female element of the composition—the woman and her child—appears in soft, pastel shades that reflect the summer sunlight. The boatman, bending forward to begin another stroke of his oar, braces himself with one foot, while the woman maintains her stable position only by planting her feet on the floor of the boat. The sprawling baby, lulled by the rhythm of the water, looks liable to slide right off the mother's lap. This slight awkwardness is a result of the boat's movement, and the glances of the mother and child toward the boatman's half-hidden features and back again suggest a complex, personal relationship, adding psychological tension to this pleasant excursion on a sunny afternoon.

Cassatt's many paintings of mothers with children invariably recall the Renaissance theme of the Madonna and Child. Here, the woman appears enthroned in the prow of the boat, the child's sun hat encircles its head like a halo, and the man bows before them like a supplicant. In referring to this traditional image, Cassatt invests an everyday scene of contemporary life with a sense of reverence—perhaps to express her view of women as powerful forces of creativity (and procreativity). Yet the painting's meaning remains open to interpretation. Perhaps Cassatt touches on a truth that must have been evident to a woman painter who so closely observed the strictures of late nineteenth-century society; if the woman is elevated and admired, she may also be confined to the shallow space behind the oars, a passive participant without the power to control her own destiny.

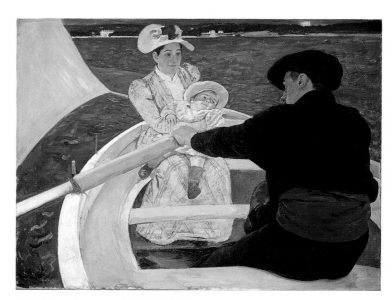

14-A Mary Cassatt (1844–1926), *The Boating Party,* **1893/1894. Oil on canvas, 35⁷⁄₁₆ x 46⅛ in. (90 x 117.3 cm.). Chester Dale Collection. Image © 2006 Board of Trustees, National Gallery of Art, Washington, D.C.**

TEACHING ACTIVITIES
E = ELEMENTARY | M = MIDDLE | S = SECONDARY

Encourage students to study this painting closely, including the foreground and background, and the colors used.

DESCRIBE AND ANALYZE

E
Have students find the boat's sail, the distant buildings, and the man's shoe.

E | M | S
Ask students to locate the horizon line. Where would a viewer have to be to see the people and boat from this angle?
A viewer would have to be located a little above them, perhaps on a dock or standing in the boat.
Where are the horizontal lines in this painting?
They occur on the shoreline and the yellow boat seats and supports.
Find the curved parallel lines of the boat and sail.

E | M | S
What is the center of interest in this composition? *It is the child.*
How has Cassatt emphasized this part of the painting?
The curved lines of the boat, oar, and adults' arms lead to the child.

E | M | S
Where did Cassatt repeat yellow in this painting?
Yellow is repeated in the boat, oars, and the woman's hat.
How does blue unify this painting?
Cassatt repeats blue in large areas of water and inside the boat.

INTERPRET

E | M | S
Why does the man have his foot on the yellow boat support?
Students may say that he is getting ready to pull the oars or is steadying himself.
Describe the movement that the boat might make in the water.
It may be rocking and surging as the oars are pulled.
Have students imagine that the man and woman are talking to each other. What might they say? What do their faces and bodies suggest about their relationship?

M | S
How is the composition of this painting like a snapshot?
It's asymmetrical, with part of the figures continuing off the picture.
Where are there broad areas of color?
Broad areas of color are found in the sail, the man's back, the yellow parts of boat, the blue shadow in the boat, and the water. (Asymmetrical balance and broad, flat areas of color were typical of the Japanese prints that became available in Europe and the United States following the opening of Japan by Commodore Perry in 1854; these prints influenced artists in the decades that followed.)

M | S
Are there any other ways in which the painting appears flat?
The boat looks tipped up and the water is painted the same way in the foreground and the background, so that the idea of distance is reduced.

M | S
In what ways do forms seem to move toward the edges of the painting?
Students may give any number of examples: the woman leans left, the man leans right; the sail pulls to one corner, the oar points to another; the edges of the boat bulge out toward the sides; the horizon nearly reaches the top; and the lower yellow boat seat continues beyond the bottom.
What pulls the three figures together?
The white area of the boat surrounds them; they look at each other; and their hands are close.
What might this feeling of expansion and contraction have to do with the subject of the painting?
It echoes the rowing motion of the man. Students might also point out that it could also emphasize this brief and precious moment—when the man, woman, and child are intimately connected.

CONNECTIONS

Historical Connections: nineteenth-century women; women's rights movement

Historical Figures: Elizabeth Cady Stanton; Susan B. Anthony; Grimke sisters; Sojourner Truth

Civics: Nineteenth Amendment

Literary Connections and Primary Documents: *The Awakening,* Kate Chopin (secondary); Susan B. Anthony's speech at her trial of 1873 (middle, secondary)

Arts: Impressionism; American Impressionism

14b Brooklyn Bridge, c. 1919–1920

To Joseph Stella and other progressive artists of the early twentieth century, the timeworn conventions of European painting seemed powerless to convey the dynamism of modern life. An Italian immigrant, Stella arrived in New York City at a time of unprecedented urban growth and social change in America. He first encountered the new approaches of modernist painting on a trip to Paris and took particular interest in Futurism, an Italian movement that claimed to be "violently revolutionary" in its opposition to the traditions that had prevailed in art ever since the Renaissance. Upon returning to the United States, Stella himself converted to Futurism, convinced that only its new vision of reality could capture the complexities of the machine age.

In the Brooklyn Bridge, Stella found a subject that impressed him, he said, "as the shrine containing all the efforts of the new civilization of America." *Brooklyn Bridge,* his signature image, addressed the two aesthetic currents of his time — representation and abstraction — to suggest the deeper significance of this modern architectural icon. Stella photographed its various components — the maze of wires and cables, the granite piers and Gothic arches, the pedestrian walkway and subway tunnels, the thrilling prospect of Manhattan skyscrapers — as an abstract pattern of line, form, and color that evokes an idea of the bridge rather than faithfully describing it. Yet, as one critic observed,

Stella's interpretation seemed "more real, more true than a literal transcription of the bridge could be." A "literal transcription" would have represented only its appearance, the impression it left upon Stella's retina. A Futurist rendition could also account for more subjective impressions, the physical and psychological sensations it produced on the artist.

Stella had been inspired to paint the Brooklyn Bridge by his own intense experience of it late one night as he stood alone on the promenade, listening to the noises peculiar to the modern city: "the underground tumult of the trains in perpetual motion," "the shrill sulphurous voice of the trolley wires," "the strange moanings of appeal from tug boats." With its thrusting diagonals and pulsating colors, *Brooklyn Bridge* is a visual translation of that urban atonality and the artist's sense of claustrophobia. The taut cable lines tying the complex composition together seem to represent the psychological tension of the artist's conflicting emotional states. Stella felt terrified, "a defenseless prey to the surrounding swarming darkness — crushed by the mountainous black impenetrability of the skyscrapers"; at the same time, he felt spiritually uplifted, "as if on the threshold of a new religion or in the presence of a new divinity." In this Futurist interpretation, the pointed arches of the bridge are open to the sky like the ruins of a Gothic cathedral, and the allusions to stained-glass windows suggest his spiritual epiphany.

More subtly, *Brooklyn Bridge* recalls a touchstone of Stella's native culture: the medieval Italian poet Dante's spiritual journey from hell to heaven in *The Divine Comedy*. "To render more pungent the mystery of my metallic apparition," Stella explained, "…I excavated here and there caves as subterranean passages to infernal recesses." The rounded arch of a subway tunnel, red with the hellish glare of a signal light, occupies the *inferno* in the center of the painting. Just above it, a foreshortened view of the promenade where Stella stood makes a comparatively short link between the terrors of the underworld and the radiance of the heavens. The forces of movement in the painting converge at the top "in a superb assertion of their powers" to the status of divinity. A third tower (in reality, the bridge has only two) stands at the pinnacle of the pyramid, lit up like a movie marquee by the rushing cables, "the dynamic pillars," as Stella described them, of the composition. For Stella, the Brooklyn Bridge — with its noises and tremors and terrors and comforts — represented a spiritual passage to redemption, a visual way of showing transcendence in a secular world.

14-B Joseph Stella (1877–1946), *Brooklyn Bridge*, c. 1919–1920. Oil on canvas, 84 x 76 in. (213.36 x 193.04 cm.). Yale University Art Gallery, New Haven, Conn. Gift of Collection Société Anonyme.

TEACHING ACTIVITIES
E = ELEMENTARY | **M** = MIDDLE | **S** = SECONDARY

Encourage students to study this painting closely and see if they recognize any objects.

DESCRIBE AND ANALYZE

E | M | S
Have students find these objects.
Towers of the Brooklyn Bridge: *They are at top, center.*
Traffic signal light: *It is at the lower center.*
Bridge cables: *They run from the edges to the center of the composition. Note in particular the two curving pieces connected to the bridge tower.*

E | M | S
What time of day is it?
It is night. The sky is dark; there are deep dark shadows and shining lights.
Are there any cars on the bridge? *Perhaps. Some of the lights look like headlights.*

E | M | S
Turn the painting upside down. Does the picture seem top heavy or bottom heavy?
It appears top heavy.
Why?
The shapes are larger on the top and the forms are thinner on the bottom. The cable lines also are directed to the bottom center and seem to disappear.
Turn the painting right side up again. What are the thin upright forms at the top?
They are tall buildings: a city skyline.
Do some objects seem close and others far away? Why?
The thin white buildings seem farther away because they are placed higher in the painting and are smaller than the traffic light at the bottom. The cables also get smaller and several angle toward each other as though they were parallel lines converging in the distance.

S
How does Stella suggest the complexity of the modern machine era? How has he indicated its dynamic movement?
He jumbles the thick and thin lines, showing bits and pieces of forms as though they are glimpsed only briefly; he blurs the colors and adds diagonal and curving lines that suggest movement.
Have students identify some vertical lines in this painting. How do they affect the dynamics of the composition?
They give some order to the chaos.

INTERPRET

E | M | S
Encourage students to imagine what Stella heard as he stood on this bridge at night.
The bridge is over a river. He might have heard tugboat horns, sirens, subway trains, and cars and trucks rumbling over the bridge.

M | S
What do you think Stella found fascinating about the bridge?
He was intrigued by its huge scale, the complexity of the cable lines, and its dizzying angles. When you drive over the bridge, things are seen as fragments; headlights flash here and there, and you hear traffic in the water and on the bridge. For Stella the experience was urban, modern, and a bit frightening.

CONNECTIONS

Historical Connections: industrialism; the rise of the city; the immigrant experience; Ellis Island

Historical Figures: John and Washington Roebling

Science: civil engineering

Literary Connections and Primary Documents: "Crossing Brooklyn Ferry," Walt Whitman (secondary); *The Bridge*, Hart Crane (middle, secondary); *The Brooklyn Bridge (A Page in My Life)*, Joseph Stella (secondary); *The Breadgivers*, Anzia Yezierska (middle); *The Joy Luck Club*, Amy Tan (secondary); *My Ántonia*, Willa Cather (middle, secondary); "The New Colossus," Emma Lazarus (secondary); *East Goes West*, Younghill Kang (secondary)

Arts: Futurism

BROOKLYN BRIDGE, c. 1919–1920, JOSEPH STELLA [1877–1946]

15a

American Landscape, 1930

The only trace of humanity in Charles Sheeler's austere *American Landscape* is a tiny figure scurrying across the railroad tracks. With one arm outstretched, he appears frozen in action, as if in a snapshot, precisely halfway between two uncoupled freight cars. The calculated placement of this anonymous person suggests that he was included in the composition only to lend scale to the enormous factories, which dwarf even the train and displace every other living thing. Sheeler coined the term "Precisionism" to describe this emotionally detached approach to the modern world. Influenced by the mechanisms of modern technology, Precisionist art employs sharply defined, largely geometric forms, and often gauges the landscape's transformation in the wake of industrial progress.

American Landscape toys with our expectations. In a painting of that title, we hope to find a peaceful view of mountains and trees, or perhaps cottages and crops, in the manner of Thomas Cole or Albert Bierstadt (see 5-A and 8-A). Instead, Sheeler gives us factories, silos, and smokestacks. The work expresses the artist's view that the forces of human culture, propelled by industrialism, have overtaken the forces of nature that once laid claim to American landscape painting. Here, all that's left of the natural world is the sky, and not even it escapes the effects of mass production: the smoke rising from a smokestack blends into the clouds, making them just another by-product of industry. Like many traditional American landscapes, this one is organized around a body of water. Yet here, the water is contained in a canal, an artificial channel that controls its flow.

Sheeler earned his living as a professional photographer. In 1927, he spent six weeks taking pictures of the Ford Motor Company's enormous auto plant west of Detroit. The company commissioned the project as a testament to Ford's preeminence: the plant at River Rouge was a marvel of mechanical efficiency—with miles of canals, conveyor belts, and railroad tracks connecting steel mills, blast furnaces, glass plants, and the famed assembly line. Henry Ford himself had invented the term "mass production" to describe his innovation of making workers on a movable production line part of the machinery. If the belt-driven process dehumanized workers, it helped to democratize capitalism by making manufactured goods affordable to a wider public. "There is but one rule for the industrialist," Ford declared, "and that is: Make the highest quality goods possible at the lowest cost possible." To twenty-first century viewers, *American Landscape* may appear as an indictment of the machine age, but to Sheeler's contemporaries, it would have stood for the triumph of American ingenuity.

Sheeler derived *American Landscape* from the background of one of his River Rouge photographs. To achieve the impersonal effect of the mechanical image, he eliminated every sign of brushwork and any other indication that the painting had been conceived by a distinct artistic personality and made by hand. In this way, Sheeler downplays his own presence, as if he were just as anonymous as the faceless figure stranded on the train tracks. After his time at River Rouge, Sheeler observed that factories had become a "substitute for religious expression." The stillness and silence of the scene impart an air of reverence traditionally associated with a place of worship— or, in American painting, some awe-inspiring view of nature. But nature as a divine presence is absent; it is industry, with its cold and indifferent factories, that prevails.

15-A Charles Sheeler (1883–1965), *American Landscape,* 1930. Oil on canvas, 24 x 31 in. (61 x 78.8 cm.). Gift of Abby Aldrich Rockefeller (166.1934). The Museum of Modern Art, New York. Digital Image © The Museum of Modern Art / Licensed by SCALA / Art Resource, New York.

TEACHING ACTIVITIES
E = ELEMENTARY | **M** = MIDDLE | **S** = SECONDARY

Encourage students to look closely at all the details in this painting.

DESCRIBE AND ANALYZE

E | M | S

Have students locate the tiny figure.
He is on the railroad tracks.
Where is the ladder?
It is located in the right corner.
Where are the silos?
They are on the left.

E | M | S

How does Sheeler indicate distance in this painting?
The parallel horizontal lines are converging, coming closer together, to the left of the painting. Objects overlap and distant structures are smaller, with fewer details.

E | M | S

What lines look as if they were drawn with a ruler?
The lines on the edge of the canal, the train and tracks, and the buildings look as if they were composed with a straight edge.
Much of this painting is geometric. What parts are not?
The water and the reflections in the water, the sky and smoke, and the pile of ore are irregular in shape.

E | M | S

Ask students how large the buildings seem in comparison to the man. *They are huge.*
This plant mass-produced automobiles. Raw materials and ores were transformed into cars. Long conveyor belts moved materials within the factory. What structures in this view possibly house conveyor belts?
The long, thin white structure in front of the silos and other large buildings are possible sheds.
What does this painting say about the scale of American industry in 1930?
Sheeler was impressed with the massive scale of American industry and this plant.

INTERPRET

M | S

Have students visualize how industrial progress changed this view of the American landscape. Encourage them to imagine how this scene looked before the canal, railroad, and factories were built.
The river might have curved and been lined with trees and plants. Smoke would not fill the sky.
Ask students if they think this painting seems more positive or negative regarding industrial development. How might an average American in 1930 answer this question? How did factories like this affect the lives of American consumers?
Factories like this employed many people and the mass-produced goods they made were affordable to middle-class Americans. Early twentieth-century Americans were proud of their country's industrial development and appreciated the rise in their standard of living made possible by mass production. Today, Americans are more sensitive to the effects of industrial development on the environment.

CONNECTIONS

Historical Connections: industrialism; progressive movement; the Great Depression

Historical Figures: Samuel Gompers

Civics: substantive due process

Geography: growth of cities

Economics: labor unions; industrial expansion; transportation innovations

Science: machinery

Literary Connections and Primary Documents: *The Jungle,* Upton Sinclair (secondary); "Chicago," Carl Sandburg (secondary)

Arts: photography; film; Modernism; Precisionism; compare to Cézanne; contrast with Cole

15b The Chrysler Building, 1926–1930

The Chrysler Building could only have been constructed in the competitive climate of Manhattan in the 1920s. The American economy was flourishing, and there was not enough office space to go around; urban builders were encouraged to aim high. In 1926, Walter P. Chrysler, one of the wealthiest men in the automotive industry, entered his bid in the unofficial competition to build the tallest structure in New York City. He wanted an office building exalted enough to symbolize his own astounding ascent in the business world. Brooklyn-born architect William Van Alen, who had a reputation for progressive, flamboyant design, met Chrysler's challenge with a seventy-seven-story building, the first in the world to exceed a height of one thousand feet.

The pyramidal form of the Chrysler Building was dictated by a 1916 zoning ordinance requiring buildings to be stepped back as they rose to allow sunlight to reach the streets. This restriction allowed architects to take a more sculptural approach to urban design. Instead of the tall, bland, rectangular boxes that had begun to colonize the city, inventive and dynamic forms began to lend interest and variety to the Manhattan skyline. The ordinance also focused attention on the summit of a building. Atop the Chrysler, seven overlapping arches diminish toward the top to create the illusion of a building even taller than it is. The distinctive decoration, a pattern of narrow triangles set in semicircles, has been likened to a sunburst, but it might equally recall the spokes of a wheel.

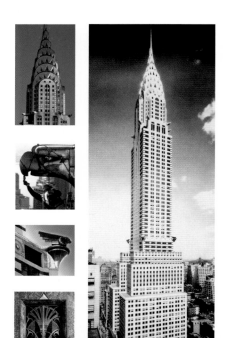

Van Alen's signal contribution to American architecture was to apply to modern skyscrapers the visual vocabulary of Art Deco, an international decorative style that emphasized streamlined motifs and often employed nontraditional materials.

To make the Chrysler Building distinct from others of its kind, Van Alen chose motifs appropriate to the machine age, particularly the automobile. The spire's gleaming stainless steel cladding calls to mind the polished chrome of a brand new car. Stylized American eagle heads protrude from some corners of the building in playful reference to the gargoyles on Gothic cathedrals. Other corners are embellished with the winged forms of a Chrysler radiator cap. One ornamental frieze incorporates a band of hubcaps.

If the exterior ornament enhances the modernity of the skyscraper, the interior was designed to recall the distant past, and positions the Chrysler Building among the wonders of the world. The most spectacular features of the grand lobby are the elevator doors, adorned in brass and marquetry (decorative inlays on a wood base) with the lotus flower motif. The discovery in 1922 of King Tutankhamen's tomb had unleashed an enthusiasm for archaic and exotic cultures, and the Chrysler Building was designed at the height of this mania for all things Egyptian. In addition to the lotus decoration, the public rooms display a range of ancient Egyptian motifs intended to suggest the building's association with the great pyramids of the pharaohs. The paintings on the lobby ceiling record the heroic progress of the tower's construction, as if the monument to Chrysler had already assumed a place in history equal to that of the Great Pyramids.

Both Chrysler and Van Alen were intent upon making this building the tallest in the city, but toward the end of construction there was uncertainty over whether it could indeed hold that distinction. A rapidly rising office tower in Lower Manhattan had already reached 840 feet, and its architect, Van Alen's former business partner, who acknowledged competition from the Chrysler, pushed his building even higher by adding a sixty-foot steel cap. Not to be outdone, Van Alen had his workers secretly assemble a twenty-seven-ton steel tip, or vertex, which was hoisted at the last minute to the top of the building as a magnificent surprise to the city. With that, the Chrysler not only exceeded the height of its Wall Street competition, but surpassed even the Eiffel Tower in Paris. As it happened, that hard-won prize would be lost within the year to the Empire State Building, which is 202 feet higher.

William Van Alen's reputation suffered after the completion of his most famous building. Accused by Chrysler of taking bribes from contractors, the architect never received full payment for his work. The effects of the Depression on the building industry further added to his woes. Today, Van Alen, with no major studies dedicated to his work, is little known in the history of architecture. On his death, the *New York Times* failed to even publish an obituary.

William Van Alen (1883–1954), The Chrysler Building, 42nd Street and Lexington Avenue, New York, 1926–1930. Steel frame, brick, concrete, masonry, and metal cladding, height 1046 ft. (318.82 m.).

15-B.1 *right,* **The Chrysler Building, Manhattan, 1930. Photographic print. Library of Congress, Prints and Photographs Division, Washington, D.C.**

15-B.2 *top left,* **detail. Steeple of the Chrysler Building. © Photo Company/zefa/CORBIS.**

15-B.3 *top center left,* **detail. Workers waterproofing Art Deco stainless steel eagle ornament of sixty-first floor. © Nathan Benn/CORBIS.**

15-B.4 *bottom center left,* **detail. Thirty-first floor decoration based on radiator cap and hubcap designs. Photograph by Scott Murphy, Ambient Images, Inc.**

15-B.5 *bottom left,* **detail. Art Deco elevator doors at the Chrysler Building. © Nathan Benn/CORBIS.**

TEACHING ACTIVITIES

E = ELEMENTARY | **M** = MIDDLE | **S** = SECONDARY

Encourage students to look closely at all the parts of this building.

DESCRIBE AND ANALYZE

E

Ask students to locate triangles, squares, rectangles, and semi-circles on the Chrysler Building.

Semi-circles and triangles are near the top. Squares and rectangles form the windows. Some of the triangles are windows. These geometric shapes were important to Art Deco-style architecture.

E | M | S

Focus students' attention on the metal sculpture detail in 15-B.4. What does it look like? What might it symbolize?

It might suggest an animal or the winged cap of the ancient Roman god, Mercury. It also suggests speed.

Why does this look man-made rather than like a natural object?

The shapes have been simplified and streamlined into geometric forms.

Notice that this sculpture stands on a round base. Have students locate these large replicas of a 1929 Chrysler radiator cap on the corners of the thirty-first floor.

E | M | S

Call students' attention to a worker waterproofing a detail ornament (15-B.3). Ask students what animal the ornament represents.

It represents an eagle.

Have students find the ornaments that project outward like medieval gargoyles above the sixty-first floor.

E | M | S

As students look at the elevator doors (lower left detail), ask them to find the stylized flower and plant shapes. The large central flower is a lotus blossom, an important symbol in ancient Egypt. Notice how arcs divide this design into geometric shapes. Ask students to identify another vertical series of arcs on this building.

The sunburst arches at the top of the building are a series of arcs similar to this.

INTERPRET

E | M | S

How is this building like an automobile?

Parts of it are of shiny steel like a new car, and it has decorations that look like hubcaps and radiator caps.

S

Why did corporations and architects race to build tall skyscrapers in the 1920s?

The economy was flourishing, corporations needed more office space, and Chrysler wanted to own the tallest building in New York City.

Why do you think the spire was added to the top?

It was added to make it taller than all the other buildings.

What happened in 1929 to halt this building spree?

The stock market crashed.

S

New York City building codes required that tall buildings such as this step back their upper stories. What were the benefits of making tall buildings smaller near the top?

This allowed more light and air to reach the streets and made the buildings look even taller than they really were.

CONNECTIONS **Historical Connections:** modern age; machine age; automobile industry; skyscrapers; Roaring Twenties **Science:** engineering; steel **Arts:** Art Deco; architecture

16a House by the Railroad, 1925

The sunlight illuminating *House by the Railroad* is bright enough to cast deep shadows on the stately Victorian mansion, but not to chase away an air of sadness. The painting expresses Edward Hopper's central theme: the alienation of modern life. Instead of happy, anecdotal pictures celebrating the energy and prosperity of the Roaring Twenties, Hopper portrayed modern life with unsentimental scenes of either physical or psychological isolation. Most are set in the city, where people often look uncomfortable and out of place. Others, like *House by the Railroad,* picture solitary buildings in commonplace landscapes. Hopper's *House by the Railroad* is symbolic of the loss that is felt when modern progress leaves an agrarian society behind.

The single focus of the painting is a large gray house in an imported French style. Although Hopper customarily worked from life, he invented this house based on some he came across in New England and others he may have seen on Paris boulevards. This architectural style became fashionable in America during the mid-nineteenth century. Its hallmark is a double-pitched roof pierced with dormer windows that give height and light to the attic level. From this we might assume that the once-grand Victorian house in Hopper's painting had been built for a large family with the means to construct a residence in the latest style. If to our eyes these antique features lend the house a certain charm, in Hopper's time it would have appeared a clumsy relic from an awkward era — "an ugly house," as one critic phrased it, "in an ugly place."

Like the house, the site once may have been more attractive. The tall, hooded windows must have overlooked a landscape; the double veranda and tower were presumably positioned to take advantage of a view, probably over miles of lush countryside. Now the many windows appear tightly closed, with shades mostly drawn, as if they have become obsolete for a landscape that holds little to admire. It is possible that the house has been deserted; in any event, nature's absence is also pronounced, similar to the industrial scene in Charles Sheeler's *American Landscape* (see 15-A). *House by the Railroad* might even be considered the domestic complement to Sheeler's work, although Hopper seems not to have felt Sheeler's contradictory attitude toward modern life. Whether he regarded the house as lastingly beautiful or hopelessly old-fashioned, Hopper presents it as an enduring emblem of the past.

The two themes of modern progress and historical continuity come together in the second man-made feature of the painting, a railroad track running so close to the house that a passing train would have rattled its windows. From our curiously low viewpoint, the track appears to slice through the lower edge of the structure — or, to regard it in a different way, to become part of the house itself, a new foundation for American life. An enduring sign of progress, the railroad was the primary agent of industrial change. It enlarged existing cities and created new ones on the frontier. It also provided Americans with unprecedented mobility, allowing them to explore other regions of the country. But as Albert Bierstadt (see 8-A) observed in the previous century, the railroad came at the cost of the American wilderness. Even earlier in the nineteenth century, Thomas Cole had considered the consequences of American migration from the early settlements on the East Coast. As *The Oxbow* (see 5-A) suggests, a well-tended countryside held practical and aesthetic advantages but forever altered the unspoiled landscape that was America's pride.

Hopper rejected European influences, maintaining that American art should capture the character of the nation. Like Cole and Bierstadt, he expresses the tension between nature and culture. Although railroad tracks are typically associated with the noise, speed, and rapid change of modern life, this scene is curiously still and silent, as if the rush of industrialization has passed it by. Hopper, working in the period between the two world wars, appears to have found little to celebrate in the urbanization of America, which had destroyed its original, pastoral aspect. Here, the railroad track is the color of earth, taking the place of the stream, valley, or farmland that once formed the background of American culture.

16-A Edward Hopper (1882–1967), *House by the Railroad*, 1925. Oil on canvas, 24 x 29 in. (61 x 73.7 cm.). Given anonymously (3.1930). The Museum of Modern Art, New York. Digital Image © The Museum of Modern Art/Licensed by SCALA / Art Resource, New York.

TEACHING ACTIVITIES
E = ELEMENTARY | M = MIDDLE | S = SECONDARY

Encourage students to look closely at this painting and imagine whether anyone lives in the house.

DESCRIBE AND ANALYZE

M | S

Ask students to describe the mood of this painting. Students may see it as lonely, empty, bleak, or barren. Ask them to explain why it seems like this.
The dull gray color of the house, its deep shadow, windows with nothing visible inside, empty porch, and lack of vegetation all contribute to the lonely mood. Even the railroad track separates the viewers from the house, hiding the steps to the porch and making it seem even less accessible.

E | M | S

Where is the sun? *It is on the left.*
Where are the darkest shadows? *They are on the right, under the porch overhang.*
Ask what these dark shadows suggest about the house.

E | M | S

Have students describe the architecture of this house. What shape are its windows and roof?
It is of ornate Victorian style with arched windows; the house has porches, brick chimneys, and an extremely steep, curved Mansard roof. The main body is three stories tall and the tower section has four stories.

S

Ask students how a real estate agent might write an ad for this house. What are its strong features? How could its location be described positively?

INTERPRET

E | M

Ask students to imagine how this scene would change if a train went by on this track.
It would be noisy and the house might shake. At night, lights would shine in the windows.

E | M | S

Ask students what they think was built first, the house or the railroad track. Ask them to explain why they think this.
Because this is an old-fashioned house with dated architectural features and it is too close to the railroad track, the track was probably laid after the house.

M | S

Have students think of a building in their community that seems old, outdated, and ugly, but not so old that it is a treasured antique. Explain that this is how Hopper probably felt about this house. Its Victorian architecture was dated and out of style in 1925, but today that style has regained some of its popularity.

S

What elements in this painting help convey a sense of loneliness?
The empty track and the lack of any activity enforce a sense of loneliness.
Why might many people come near this house each day? What might they think about the house and its inhabitants? Will they probably ever meet the people who live in this house?
Train passengers come close to the house each day but speed past it. They might even see people behind the windows or on the porch but cannot meet or talk with them. The speed of modern life sometimes isolates people even when it brings them physically near each other.

CONNECTIONS

Historical Connections: railroads in the United States

Geography: Midwest region; the changing landscape of rural America during the early twentieth century; urban sprawl; the effect of industrialization on rural America

Science: advances in transportation

Literary Connections and Primary Documents: *Our Town*, Thornton Wilder (middle)

Arts: Victorian architecture

HOUSE BY THE RAILROAD, 1925, EDWARD HOPPER [1882–1967]

16b Fallingwater, 1935–1939

Fallingwater is a man-made dwelling suspended above a waterfall. It offers an imaginative solution to a perennial American problem: how to enjoy a civilized life without intruding upon the natural world. Especially in the United States, which had once possessed infinite acres of unspoiled land, technological progress almost always comes at the expense of nature. A long tradition of American landscape painting had developed partly to satisfy city dwellers with restorative glimpses of the countryside they'd left behind (see 5-A). With Fallingwater, Frank Lloyd Wright went one step further — designing a house nestled into a mountainside, with views that made the house appear to be part of nature itself.

Fallingwater was commissioned by Edgar J. Kaufmann, founder of a prominent Pittsburgh department store. To escape the pressures of business, Kaufmann and his family regularly left the city for their sixty-acre woodland retreat in the Allegheny Mountains. By 1935, the Kaufmanns' country cabin was falling apart, and Wright was invited to design them a new weekend residence. Kaufmann undoubtedly envisioned a house overlooking the most outstanding feature of the property, a mountain stream cascading over dramatically projecting slabs of stone. Wright believed that a country home should become part of the landscape. He studied the site from every point of

view before making the audacious proposal to build the house on the side of the cliff. The waterfall itself would be invisible from the interior but wholly integrated into the plan, with a stairway from the living room giving direct access and the rush of falling water always echoing through the house.

Wright had never been constrained by convention, but even for him, the design for Fallingwater is a stunning feat of invention and one of the most original and groundbreaking concepts in the history of architecture. A traditional country house would have been set back from the road on a manicured lawn with a pleasing view of the wilder regions that lay safely beyond its boundaries. Wright reversed that idea. Fallingwater, a large, low structure hovering like a boulder over the falls, seems almost as much a part of nature as apart from it. Every element of the architecture is meant to blur the distinction between the natural and built environments, and to integrate the residents into the out-of-doors. Deeply recessed rooms, fieldstone interiors, and unusually low ceilings create the impression of a cave — a private, sheltered space within the natural scheme of things.

If, through light and sound and structure, Fallingwater evokes the feeling of existing in the unspoiled American wilderness, everything else about it is unmistakably modern. The house is a marvel of twentieth-century technology. Although it proved impractical for all sorts of reasons, it was the architect's (if not the client's) dream house, and Wright would not permit a single alteration to his plan. The most striking element of the design — and the biggest engineering challenge — is the series of reinforced concrete terraces cantilevered above the rocky ledges and parallel to the natural lines of the site. Although firmly anchored in solid rock, the terrace platforms appear to defy gravity; Wright compared them to trays balanced on a waiter's fingers. Between the terraces are rooms with glass walls — transparent boundaries between inside and out. Walls not made of glass are built of locally quarried stone, and the massive, central fireplace is composed of boulders removed from the site to make way for construction but restored to form the hearth, the traditional heart of a home. As the distinguished scholar and architecture critic Ada Louise Huxtable has observed, the effect of Fallingwater "is not of nature violated, but of nature completed — a dual enrichment."

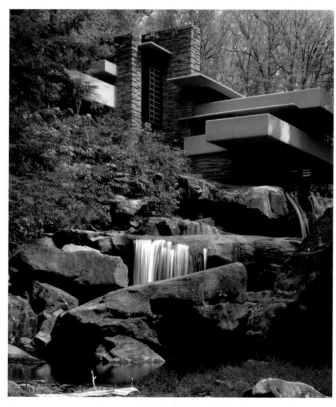

16-B Frank Lloyd Wright (1867–1959), Fallingwater (Kaufmann House), Mill Run, Pennsylvania, 1935–1939. Photograph courtesy of the Western Pennsylvania Conservancy. © 2008 Frank Lloyd Wright Foundation, Scottsdale, Ariz. / Artists Rights Society (ARS), New York.

TEACHING ACTIVITIES

E = ELEMENTARY | M = MIDDLE | S = SECONDARY

Encourage students to study this house carefully, keeping in mind the land around it.

**DESCRIBE AND
ANALYZE**

E

Why is this house called Fallingwater?
The house extends over a waterfall.

E|M|S

Have students locate the balconies, the man on the lower balcony, a vertical column of stone, and a vertical area of glass windows.

E|M|S

Ask which exterior materials on this house are natural and which are man-made.
The stone is natural, and the concrete, glass, and metal are man-made.
Notice how the textures of these materials contrast with each other. Describe the textures of the different parts of the house.
The glass is smooth and shiny and the rock is very rough. The concrete is gritty, but not as rough as the stone, nor as smooth as the glass.

M|S

How did Wright preserve the natural beauty of this site?
He made the house blend into the natural landscape by echoing the shape of the cliff and boulders. He built a large portion of the house from rock quarried on site. He did not plant large expanses of lawn, bulldoze the site to make it level, or cut down many trees.

M|S

To understand how cantilevers are balanced, have each student set a pencil on the desk so that the point extends over the edge of the desk. They should gradually push the pencil toward the edge of the desk until it begins to fall. Then have them put a weight such as a book or their finger on the eraser end of the pencil. How much farther can they extend the pencil over the edge with the weight on one end?
Ask students what parts of Fallingwater are cantilevered.
The horizontal balconies are cantilevered.
What part of the building appears to create the weight to hold them in place?
The vertical stone column fulfills this function.

M|S

Ask how Wright created an impression of a natural cave.
He deeply recessed the rooms under the balconies, used natural fieldstone for floors and walls that were not glass, and made the ceilings low.

INTERPRET

E|M|S

Why might a city dweller enjoy this house? Imagine being on one of the balconies. What would you hear?
A retreat in the country would be a change of scenery for those who live in a city. From the balcony you hear the sound of the waterfall.

E|M|S

The Kaufmanns wanted a vacation home on their land. Why was the location that Wright chose for the house a surprise to them? Where would most architects probably have located the house to take advantage of the natural waterfall?
Most architects would locate the house to have a view of the waterfall instead of placing the house on top of it.

S

How is Fallingwater like a piece of contemporary abstract art from the twentieth century?
It's been simplified into basic, essential shapes without added ornamentation.

CONNECTIONS

Science: ecology; physics
Mathematics: geometry

Literary Connections and Primary Documents: *Frank Lloyd Wright for Kids: His Life and Ideas,* Kathleen Thorne-Thomsen (elementary); *Silent Spring,* Rachel Carson (secondary)

Arts: architecture; Prairie Style; Modernism

17a The Migration Series, no. 57, 1940–1941

Jacob Lawrence did not need to look far to find a heroic African American woman for this image of a solitary black laundress: his mother had spent long hours cleaning homes to support her children. Both she and the artist's father had "come up" — a phrase used to indicate one of the most important events in African American history since Reconstruction: the migration of African Americans out of the rural South. This exodus was gathering strength at the time of World War I, and fundamentally altered the ethnic mix of New York City and great industrial centers such as Chicago, Detroit, Cleveland, and Pittsburgh.

Lawrence was born in New Jersey, and settled with his mother and two siblings in Harlem at age thirteen. Harlem in the 1920s was rich in talent and creativity, and young Jacob, encouraged by well-known painter Charles Alston and sculptor Augusta Savage, dared to hope he could earn his living as an artist. "She [Augusta] was the first person to give me the idea of being an artist as a job," Lawrence later recounted. "I always wanted to be an artist, but assumed I'd have to work in a laundry or something of that nature."

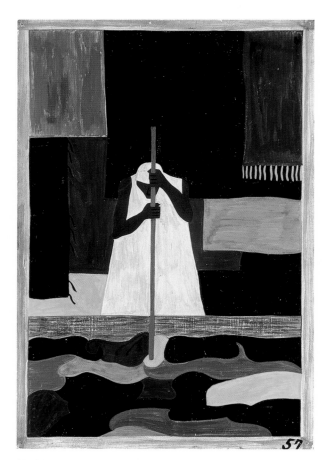

17-A Jacob Lawrence (1917–2000), *The Migration of the Negro Panel no. 57,* 1940–1941. Casein tempera on hardboard, 18 x 12 in. (45.72 x 30.48 cm.). The Phillips Collection, Washington, D.C. Acquired 1942. © 2008 The Jacob and Gwendolyn Lawrence Foundation, Seattle / Artists Rights Society (ARS), New York.

The subject of the migration occurred to him in the mid-1930s. To prepare, Lawrence recalled anecdotes told by family and friends and spent months at the Harlem branch of the New York Public Library researching historical events. He was the first visual artist to engage this important topic, and he envisioned his work in a form unique to him: a painted and written narrative in the spirit of the West African griot — a professional poet renowned as a repository of tradition and history.

The Migration Series was painted in tempera paint on small boards (here, twelve by eighteen inches) prepared with a shiny white glue base called gesso that emerges on the surface as tiny, textured dots. Lawrence, intent on constructing a seamless narrative, chose to work with a single hue at a time on all sixty panels. He used drawings only as a guide, painted with colors straight from the jar, and enlivened his compositions with vigorous brushstrokes that help further the movement of the story. The captions placed below each image are composed in a matter-of-fact tone; they were written first and are an integral part of the work, not simply an explanation of the image.

Lawrence often described the migration as "people on the move," and his series begins and ends with crowds of people at a train station (a potent symbol for growth and change in American history; see 15-A, 16-A, and 18-A). In the first panel, people stream away from the viewer through gates labeled "Chicago," "New York," and "St. Louis"; in the last one, they face us, still and silent, behind an empty track. The caption, which states, "And the migrants kept coming," renders the message sent by the painting ambiguous and evocative. Are the migrants leaving us, or have they just arrived? What is our relationship to them?

Lawrence also asks those questions of the laundress, who appears toward the end of the series. Her monumental, semi-pyramidal form, anchored between the brown vat containing a swirling pattern of orange, green, yellow, and black items and the overlapping rectangles of her completed work, is thrust toward us by her brilliant white smock. With head bent in physical and mental concentration, she wields an orange dolly, or washing stick, in a precise vertical: a powerful stabilizing force in the painting, and a visual metaphor for her strength and determination.

Lawrence showed *The Migration Series* in Harlem before being invited to bring it to a downtown setting that had previously displayed only the work of white artists. The exhibition received rave reviews and Lawrence's acceptance by the art world and the public was confirmed when twenty-six of the panels were reproduced in *Fortune* magazine. Lawrence had intended the series to remain intact, but agreed to divide it between two museums, the even numbers going to the Museum of Modern Art in New York City, and the odd numbers to the Phillips Collection in Washington, D.C.

TEACHING ACTIVITIES

E = ELEMENTARY | **M** = MIDDLE | **S** = SECONDARY

Allow the students to study this painting, paying attention to all the the parts of the composition.

DESCRIBE AND ANALYZE

E | M | S

Ask students what they think this woman is doing.
She is stirring laundry with a washing stick.
Encourage students to try standing and holding their arms like the woman in this painting.
What do they know about this woman from this painting?
She is a strong and hard-working, dark-skinned woman.

E | M

What shapes do you see in this painting?
There are rectangles and irregular rounded shapes.
What do the large rectangles and the irregular rounded shapes represent?
The large rectangles are laundry drying, and the irregular forms are laundry being washed.

E | M | S

Lawrence painted all the panels for *The Migration Series* at the same time, one color at a time. How did this affect the way the series looks?
Because the same colors are on each panel, the panels seem unified.
Have students discuss where Lawrence repeated colors in this painting.

INTERPRET

E | M | S

Ask students who was migrating in *The Migration Series*. Where were they going?
African Americans were moving from the South to the North.
Why were they leaving the South?
They were seeking a better life with higher-paying jobs.
What type of jobs had African Americans traditionally done in the South?
They were farm laborers and domestic workers, although some were professionals, such as doctors and teachers.
What type of jobs were many migrants hoping to find in the North?
Many were seeking factory jobs.

E | M | S

Ask students how Lawrence learned about scenes from the migration.
He listened to his family and friends' stories, and he researched historical events from this time period in the Harlem branch of the New York Public Library.

M | S

Help students find Harlem on a New York City street map. (It is just north of Central Park.) Ask students why Jacob Lawrence's art was first exhibited in Harlem.
He lived in Harlem, where many African Americans lived.
What was significant about Lawrence being asked to exhibit his art in a downtown gallery?
Previously, African American artists had been excluded from downtown galleries.
Have students compare Jacob Lawrence's image of a migrant mother with Dorothea Lange's photograph *Migrant Mother* (18-B). What does each artist emphasize about the lives of these women?
Lawrence emphasizes the hard manual labor that this woman is doing, while Lange emphasizes a mother's care and concern for her children.

S

Ask students why Lawrence was like a West African griot. (A griot is a professional poet who perpetuates history and genealogy through tales and music.)
Like a griot, Lawrence tells the story of a people through art.

CONNECTIONS

Historical Connections: the Great Migration; Harlem Renaissance; the Great Depression

Historical Figures: Marcus Garvey; Langston Hughes; Booker T. Washington; W. E. B. DuBois

Geography: Southern sharecropping states (Miss., Ala., Ga., Ark., S.C., N.C., Fla.); Industrial cities of the North (Detroit, Chicago, New York, Philadelphia, Boston)

Literary Connections and Primary Documents: "Theme for English B," Langston Hughes (secondary); *Black Boy* and *Native Son*, Richard Wright (secondary); *Invisible Man*, Ralph Ellison (secondary)

Music: jazz

THE MIGRATION SERIES, PANEL NO. 57, 1940–1941, JACOB LAWRENCE [1917–2000]

17b The Dove, 1964

The figure of the dove in Romare Bearden's collage perches unobtrusively on a door sill above a busy Harlem, New York, street scene. The artist created the essence of a vibrant, ever changing neighborhood by gluing cut-up photographs, clippings from newspapers and magazines, and colored paper to a piece of cardboard in such a way that the viewer's eye, like an inhabitant of the street itself, is constantly on the move, jumping from light areas to dark areas and from pattern to pattern. We glimpse people with large heads and hands and small feet walking, sitting, smoking, and peering from open doors and windows; we eye cats roaming—perhaps looking for a meal—and spy body parts that emerge mysteriously from undefined openings in the buildings. Amid all this activity it is hard to imagine any sense of order, but Bearden carefully composed *The Dove* so that, beginning with the white cat at bottom left, we travel into and around the street, always noticing something different.

Romare Bearden was born around 1911 in Charlotte, North Carolina, and migrated with his family to Harlem in 1914, where his writer-mother hosted the leaders of the African American artistic and intellectual mainstream at their home. Although Bearden graduated from New York University with a degree in education and made his living as a New York social worker until he was in his mid-fifties, painting was his chosen profession. In 1944, he had his first solo show at a major Washington, D.C., gallery. By the late 1950s, Bearden was a well-known artist working in an abstract style that incorporated influences from the great masters in the history of art as well as his own memories of African American life in North Carolina, Harlem, and Pittsburgh (where his grandparents lived). Between 1963 and 1964, however, Bearden took an artistic step that would alter the direction of his work and bring him international attention.

The Dove collage was among twenty-one works Bearden made during his involvement with Spiral, an organization of fifteen African American artists formed in July 1963, one month before the historic march on Washington led by Martin Luther King Jr. (see 19-B). The optimistic explanation of the spiral—"because, from a starting point, it moves outward, embracing all directions, yet constantly upward"—symbolized the attitude of the group, which undertook to answer the question "What is black art?" and to investigate the role of the black artist in a climate of segregation. Bearden brought in a few collages and suggested (unsuccessfully) that the group collaborate on a project. In the early 1960s, artists, particularly painters, were reinventing collage (from the French term "to glue"), a technique that had been popular in Europe in the early twentieth century. It is a medium that encourages the freedom to improvise, and Bearden, who loved and composed jazz, incorporated the rhythms and syncopations of that musical style into his collages. Bearden may also have had in mind the tradition of African American patchwork quiltmaking. Although he insisted that his works had no political agenda, the Spiral-inspired collages and the subsequent series of large black and white photostats (copier-like images that he named "Projections") made from them were groundbreaking. Bearden was one of the first artists to depict black popular culture from an African American point of view, and he addressed a wide range of subjects based on his rural and urban experience of black life. Moreover, he did so in a manner that broke up and rearranged mass-produced images in an almost abstract way, creating new relationships and interpretations. On viewing the "Projections," one critic pointed out that "through the use of optical shifts and arrangements similar to a jigsaw puzzle, [the artworks] cover more ground…than a group of photographs presented in a conventional fashion." Although *The Dove* was given its title after it was made, it is not difficult to attach a meaning such as hope or peace to the serene bird that appears in the center of urban life, or to see a predatory connection in the white prowling cat, which the bird appears to be watching.

The Dove and the twenty other collages done by Bearden opened up a new direction in his art. He continued to explore the medium of collage until his death, creating works that are, in the words of writer Ralph Ellison, "visual poetry."

17-B Romare Bearden (c. 1911–1988), *The Dove*, 1964. Cut-and-pasted photoreproductions and papers, gouache, pencil, and colored pencil, on cardboard, 13⅜ x 18¾ in. (34 x 47.6 cm.). Blanchette Rockefeller Fund (377.1971). The Museum of Modern Art, New York. Digital Image © The Museum of Modern Art / Licensed by SCALA/Art Resource, New York. Art © Estate of Romare Bearden Trusts / Licensed by VAGA, New York.

TEACHING ACTIVITIES

E = ELEMENTARY | M = MIDDLE | S = SECONDARY

| Encourage students to look closely at all the parts of this collage.

DESCRIBE AND ANALYZE

E | M | S

Ask students to find these elements.
Dove: *It is at the top.*
Black cat: *It is at the center.*
White cat: *It is in the lower left corner.*

E | M | S

Ask students to describe the setting for this scene.
It is a city street. Some students may know this is a Harlem neighborhood in New York City.
What architectural details would you see on a city street?
Complicated but weathered wooden moldings surround the doors and windows; there are steps, and grids on some windows. The fire escape has a wrought iron railing.

E | M | S

Where did Bearden repeat textures in the shape of brick?
He repeated these textures above the street, in the upper half of the composition.
What do these brick textures represent?
They represent walls of brick (tenement) buildings.

E | M | S

Bearden rearranges pieces of magazine and newspaper images to create new messages. Locate a figure. What is this figure doing? Find people looking out windows, sitting on steps, and walking on the street.
Most of the figures are composed of more than one cut-out. In the center a man holding a cigarette sits on steps. Another man, wearing a white hat low over his eyes, walks down the sidewalk. To the left of the black cat, a woman leans on her elbows and looks out a basement window.

M | S

Ask the students to consider how we perceive our environment. For example, when we're sitting in a room or walking down the street, do we see everything at once in equal detail?
We see the scene in fragments.
How is Bearden's collage like the way we take in a scene in real life?
We see a complicated or active scene piece by piece over time.

INTERPRET

M | S

Bearden grew up in New York City during the Harlem Renaissance of the 1920s, and he loved jazz. How is his collage like jazz?
Both encourage the artist to improvise and try new arrangements. The fragmented style is like the upbeat syncopation of jazz rhythms, which opens up a musical composition.

M | S

Describe the mood and energy of this scene.
It is bustling, everything is close and crowded; people are walking and milling about, watching and being watched; and it seems that there would be lots of sound.

M | S

Bearden wanted to show African American life in America from an African American point of view. Ask students to explain how well they think he accomplishes that in this collage.

CONNECTIONS

Historical Connections: Black history; the Great Migration; Harlem Renaissance; civil rights movement

Historical Figures: Zora Neal Hurston; Langston Hughes; Jean Toomer; Richard Wright

Geography: urban geography; human geography

Literary Connections and Primary Documents: *If Only I Had a Horn: Young Louis Armstrong*, Leonard Jenkins (elementary); *Duke Ellington: The Piano Prince and His Orchestra*, Andrea Davis Pinkney (elementary); *Sweet Music in Harlem*, Debbie A. Taylor (elementary); *Their Eyes Were Watching God*, Zora Neal Hurston (secondary); *Cane*, Jean Toomer (secondary)

Music: jazz; blues

Arts: collage; mixed media

18ầ The Sources of Country Music, 1975

Thomas Hart Benton was eighty-four in 1973, when he came out of retirement to paint a mural for the Country Music Hall of Fame and Museum in Nashville, Tennessee. His assignment was to describe the regional sources of the musical style known as "country," and Benton couldn't resist the opportunity to paint one last celebration of homegrown American traditions. Benton himself was a skilled harmonica player who had been raised on the old-time music of the Missouri Ozarks. It was during his lifetime that the multimillion-dollar country-music industry in Nashville had replaced the community-based music of rural America. As an artist, he had gained a popular following in the 1930s with works that spoke to ordinary people. Along with other Midwestern Regionalists such as Grant Wood (see 3-A), Benton rejected "Parisian aesthetics," the European influence on American art, and scorned abstract art as "an academic world of empty pattern." His ambition was to paint meaningful, intelligible subjects — "the living world of active men and women" — that would hold broad, popular appeal. By virtue of its subject and its setting, the Nashville mural was to be a painting, Benton said, "aimed at persons who do not ordinarily visit art museums."

The Sources of Country Music presents five distinct scenes to survey the music of ordinary Americans. The central subject of a barn dance, with a pair of fiddlers calling out sets to a group of square dancers, describes the dominant music of the frontier. A comparatively calm scene shows three women in their Sunday best with hymnals in their hands, suggesting the importance of church music in Protestant America. In the foreground, two barefoot mountain women sing to the sounds of a lap dulcimer, an old instrument associated with Appalachian ballads. In the

opposite corner an armed cowboy, one foot on his saddle, accompanies himself with a guitar. An African American man, apparently a cotton picker in the Deep South, strums a tune on a banjo, an instrument slaves brought with them to the New World. Beyond him, on the other side of the railroad tracks, a group of black women dance on the distant riverbank. Despite the range of regional styles, instruments, and customs, the mural seems to pulsate to a single beat, as if Benton took care to ensure that all the musicians played the same note and sang their varied American songs in tune.

The mural preserves an image of American folkways that were rapidly disappearing. Benton's characteristically dynamic style expresses the powerful rhythms of music while suggesting the inevitability of change. Many of the robust, nearly life-size figures balance on uneven, shifting ground. The fiddlers look liable to fall into the mysteriously bowed floor, and the log on which the banjo player sits threatens to roll down the steep slope of the red-clay landscape. Even the telephone poles seem to sway in the background. The steam engine, an indication of change, represents the end of an agrarian life and the homogenization of American culture, which necessarily entailed the loss of regional customs.

The mural pays homage to the country music singer and movie star Tex Ritter, who had helped to persuade Benton to accept the Nashville commission but died before it was completed. Benton represents Ritter as the singing cowboy who turns to face the coal-black engine steaming along the horizon. The train itself was modeled on the Cannonball Special, driven and wrecked by Casey Jones, the hero of an American ballad; it also calls to mind "The Wabash Cannonball," a popular folk song about a mythical train that glides through the country, then rumbles off to heaven. The engine, which may signify the positive as well as the negative aspects of American progress (see Edward Hopper's House by the Railroad, 16-A) is the only element of the complex composition that Benton felt he couldn't get quite right. Unfortunately, we will never know how he wanted the train to look. Benton is said to have died of a massive heart attack while standing before the mural in January 1975, trying to decide whether to research and repaint the train. Whether the story is true or not, his final work was never signed.

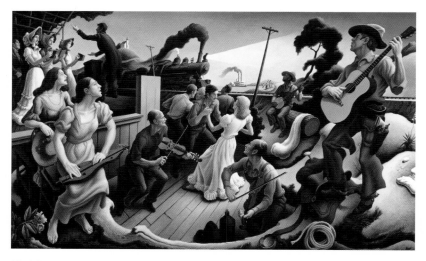

18-A Thomas Hart Benton (1889–1975), *The Sources of Country Music,* **1975. Acrylic on canvas, 72 x 120 in. (182.9 x 304.8 cm.). The Country Music Hall of Fame® and Museum, Nashville, Tenn. The Country Music Hall of Fame® and Museum is operated by the Country Music Foundation, Inc., a Section 501(c)(3) not-for-profit educational organization chartered by the State of Tennessee in 1964. Art © Thomas Hart Benton and Rita P. Benton Testamentary Trusts/UMB Bank Trustee.**

TEACHING ACTIVITIES

E = ELEMENTARY | **M** = MIDDLE | **S** = SECONDARY

| **Encourage students to study this painting carefully,** paying attention to the way the artist has grouped the elements in his work.

DESCRIBE AND ANALYZE

E | M | S

Have students find five scenes in this painting that show regional musicians. These represent the roots of American country music. Can students identify what type of music each of these represents?

Church and choir music: *Three women with a choir director (upper left) are representative of church and choir music.*

Appalachian singers: *Two barefoot women playing the dulcimer (left) represent Appalachia.*

Barn dance: *Two fiddlers and dancers (center) are representative of barn dancing.*

Singing cowboy: *A man with a guitar (right) represents the "singing cowboy."*

African American music of the Deep South: *The man with a banjo and a group of women on the distant riverbank (center right) represent African American music of the Deep South.*

M | S

How did Benton join these different scenes into one unified composition?

He overlapped forms, used the same painting style throughout, repeated colors, and made most of the figures face in toward the center of the painting. Just as all these musical influences came together in American country music, they hold together as a unified composition in this painting.

E | M | S

How did Benton create a sense of rhythm and movement throughout this composition?

Most of the vertical lines and bodies slant to the right, creating visual movement in that direction. The train leans forward as it speeds to the right. Even the telephone poles seem to sway.

INTERPRET

E | M | S

What things and people are making music and sound in this scene?

The choir, Appalachian women, banjo player, and cowboy are singing. The train rumbles and whistles, the riverboat whistles, and dancers stamp their feet on a wooden floor. The dulcimer, fiddles, banjo, and guitar are all being played.

Benton wanted all the musicians to play the same note and sing their varied music in tune. Do you think this painting seems like noisy confusion or are all the parts in harmony?

M | S

What does the steam engine represent?

The steam engine represents change — the end of agrarian life as Americans left farms for cities and regional cultures blended together.

M | S

Why did Benton include in the painting a homage to Tex Ritter, the singing cowboy?

Ritter helped persuade Benton to paint this picture but died before it was completed.

Why did Benton not sign this painting?

He died before he completed it.

Before he died, Benton was trying to decide whether he should repaint the train. Why do you think he wanted to do this?

| **CONNECTIONS** | **Geography:** Midwest region; the South; the West | **Music:** bluegrass; country, gospel; historically American instruments | **Arts:** Regionalism |

THE SOURCES OF COUNTRY MUSIC, 1975, THOMAS HART BENTON [1889–1975]

18b Migrant Mother, 1936

The Great Depression was especially hard on farmers. They not only suffered through the national economic crisis but endured a string of natural disasters, including floods and dust storms that devastated their crops and destroyed their livelihoods. Thousands of poverty-stricken families migrated to the agricultural fields of California in search of work, only to find that life was not much better there. The Resettlement Administration (later the Farm Security Administration), one of the agencies established by Franklin D. Roosevelt's progressive social policies, employed a team of photographers to document the lives of these migrant workers. The object was to demonstrate the need for federal assistance and justify legislation that would make it possible. Dorothea Lange was among the agency photographers whose task, as the program's director explained, was to "introduce America to Americans."

In March 1936, having just completed a month-long assignment for the Resettlement Administration, Lange was driving home through San Luis Obispo County when the crudely lettered sign of a migrant workers' campsite caught her eye. Instinct rather than reason compelled her to stop: "I drove into that wet and soggy camp and parked my car like a homing pigeon." Laborers were leaving as she arrived, for late-winter rains had destroyed the pea crop, and with it every opportunity for work. But just inside the camp, sheltered in a makeshift tent, she found a careworn woman with several unkempt children. As Lange was later to learn, the family was immobilized: after days of eating nothing but frozen vegetables taken from the fields, they had sold the tires from their car to buy food.

In the space of ten minutes Lange photographed the squalid scene, moving closer to her subject with each exposure. The last was the close-up view of the woman with three children that we now know as *Migrant Mother*. With that photograph, Lange achieved what she had set out to do for the Resettlement Association: "to register the things about those people that were more important than how poor they were," she explained, "—their pride, their strength, their spirit."

Migrant Mother does not take in a single detail of the pea pickers' camp—the bleak landscape and muddy ground, the tattered tents and dilapidated pickup trucks. Still, the photograph evokes the uncertainty and despair resulting from continual poverty. The mother's furrowed brow and deeply lined face make her look much older than she is (thirty-two). Her right hand touches the down-turned corner of her mouth in an unconscious gesture of anxiety. Her sleeve is tattered and her dress untidy; another of Lange's photographs shows the mother nursing the baby who now lies sleeping in her lap. Evidently she has done all she can for her family and has nothing left to offer. The older children press against her body in a mute appeal for comfort, but she seems as oblivious to them as she does to Lange's camera. Lange herself knew only the outline of the woman's circumstances; she never even learned her name, or that she was a full-blooded American Indian raised in Oklahoma, in the Indian Territory of the Cherokee Nation.

The morning after Lange visited the camp, she printed the photographs and took them to the *San Francisco News*. They were published as illustrations to an article recounting the plight of the destitute pea pickers, and the story was repeated in newspapers throughout the nation. The photographs were shocking: it was unconscionable that the workers who put food on American tables could not feed themselves. Spurred to action by pictures that revealed not the economic causes, but the human consequences of poverty, the federal government promptly sent twenty thousand pounds of food to California migrant workers.

For all its power and effectiveness as a documentary photograph, *Migrant Mother* endures as a work of art. With the mother at the center of a classically triangular composition and two small heads on either side, the image bears the iconic emotional and symbolic character of a classical monument or a Renaissance Madonna. Yet Lange herself could never understand its particular appeal. When she once complained about the continual use of this photograph to the neglect of her others, she was reminded by a friend that "time is the greatest of editors, and the most reliable."

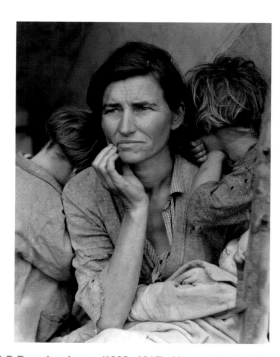

18-B Dorothea Lange (1895–1965), *Migrant Mother (Destitute pea pickers in California. Mother of seven children. Age thirty-two. Nipomo, California),* **February 1936. Black-and-white photograph. Farm Security Administration, Office of War Information, Photograph Collection. Library of Congress, Prints and Photographs Division, Washington, D.C.**

TEACHING ACTIVITIES

E = ELEMENTARY | **M** = MIDDLE | **S** = SECONDARY

Encourage students to look closely at this photograph noticing the details in the figures of the woman and the children.

DESCRIBE AND ANALYZE

E|M|S

Ask students what they first notice when they look at this photograph.

They probably will notice the woman's face.

Discuss why our attention is drawn to this part of the image.

Light shines on the woman's face, her right arm and hand lead toward her face, and the children turn toward her.

E|M|S

Describe the woman's clothing.

The sleeve of her sweater is ragged and torn. She wears an open-neck, checked shirt under her sweater.

What does the clothing suggest about the woman and children?

They are poor.

M|S

Discuss with students how Lange focuses our attention on just the woman and her children. What doesn't she show? What is in the background?

As Lange moved closer and closer to this scene, snapping photographs as she approached, she gradually cropped out the background—the tent that the woman was sitting in front of. In this close-up, the woman and her children fill the composition.

INTERPRET

E|M|S

Have students describe the expression on this woman's face. How does she feel? What might she be thinking?

She seems to stare out into space with a furrowed brow and down-turned mouth. She appears worried and tired. Perhaps she's wondering what to do next or where they will find food.

E|M|S

Ask students to speculate on why the children turned their heads away from the camera.

Maybe they were shy, or maybe they were afraid of a strange woman with a camera and are seeking their mother's comfort. Lange could also have posed them this way for greater effect.

E|M|S

Why might Lange have decided to take such a close-up photograph?

It brings us closer to the subject and makes it more personal.

S

Ask students why the Resettlement Administration may have wanted to document the effects of the Great Depression in photographs rather than just words and statistics.

Photographs can be powerful eyewitness accounts that allow people to quickly grasp the meaning and emotion of an event.

S

Explain that this photograph was published in newspapers. Ask students how they think Americans responded to it.

They were outraged that this should happen in America; the federal government responded by shipping thousands of pounds of food to feed the migrants.

CONNECTIONS

Historical Connections: the Great Depression; the Dust Bowl

Historical Figures: Franklin Delano Roosevelt; Eleanor Roosevelt

Civics: the New Deal

Geography: western migration as a result of the Dust Bowl

Literary Connections and Primary Documents: *The Grapes of Wrath* and *Of Mice and Men*, John Steinbeck (secondary)

Arts: photography

19a Freedom of Speech, The Saturday Evening Post, 1943

After Japan attacked Pearl Harbor on December 7, 1941, America was soon bustling to marshal its forces on the home front as well as abroad. Norman Rockwell, already well known as an illustrator for one of the country's most popular magazines, *The Saturday Evening Post,* had created the affable, gangly character of Willie Gillis for the magazine's cover, and *Post* readers eagerly followed Willie as he developed from boy to man during the tenure of his imaginary military service. Rockwell considered himself the heir of the great illustrators who left their mark during World War I, and, like them, he wanted to contribute something substantial to his country.

A critical component of the World War II war effort was the creation of visual images based on Franklin D. Roosevelt's appeal to the four essential human freedoms he spoke about in his State of the Union address on January 6, 1941 — freedom of speech and expression, freedom from want, freedom from fear, and freedom of worship. Yet, by the summer of 1942, two-thirds of Americans still knew nothing about the Four Freedoms, even though government agencies had disseminated photographs, prints, and even a textile design referring to them. It is unclear whether Rockwell or a member of the Office of War Information suggested he take on the Four Freedoms.

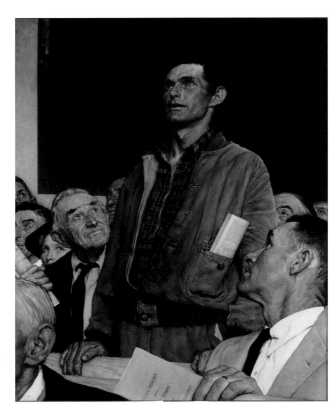

19-A Norman Rockwell (1894–1978), *Freedom of Speech,*
The Saturday Evening Post, **February 20, 1943. Oil on canvas,**
45¾ x 35½ in. (116.205 x 90.170 cm.). The Norman Rockwell Art
Collection Trust, Norman Rockwell Museum, Stockbridge, Mass.
www.nrm.org ©1943 SEPS: Licensed by Curtis Publishing,
Indianapolis, Ind. All rights reserved. www.curtispublishing.com.

What is uncontested is that his renditions were not only vital to the war effort, but have become enshrined in American culture.

Painting the Four Freedoms was important to Rockwell for more than patriotic reasons. He hoped one of them would become his statement as an artist. Rockwell had been born into a world in which painters crossed easily from the commercial world to that of the gallery, as Winslow Homer had done (see 9-A). By the 1940s, however, a division had emerged between the fine arts and the work for hire that Rockwell produced. The detailed, homespun images he employed to reach a mass audience were not appealing to an art community that now lionized intellectual and abstract works. But Rockwell knew his strengths did not lie in that direction: "Boys batting flies on vacant lots," he explained in 1936, "little girls playing jacks on the front steps; old men plodding home at twilight, umbrella in hand — all these things arouse feeling in me."

Rockwell's ability to capture something universal in the commonplace is behind the success of the Four Freedoms pictures. For *Freedom of Speech,* the first painting he completed, the artist attempted four different compositions in which a man dressed in work clothes, the community's "Annual Report" folded in his pocket, stands to give his opinion at a New England town meeting. In this, the final version, Rockwell depicts him from slightly below eye level, encircled by his fellow townspeople and by us, the viewers, who take our place two benches in front of him. The timeless properties of this work are the result of Rockwell's classical sense of composition: the speaker stands at the apex of a pyramid drawn by the upward glances of his neighbors. The warm, light tones of the speaker's skin glow against the matte black chalkboard in the background, giving him a larger-than-life, heroic appearance. The work also exudes a sense of immediacy. A snapshot effect is achieved by the inclusion of fragmented forms at the painting's borders: the partial head of the man in the lower left and the glimpse of two faces in the right and left back corners (the one on the left is Rockwell's own). Rockwell's eye for detail (he used ordinary people as models and had scores of photographs made before beginning to paint in order to remind him of things as small as a folded collar) gives each inch of the painting a sense of the accidental and familiar.

In 1943, the four canvases were published in *The Saturday Evening Post* before being sent on a nationwide tour called the "Four Freedoms War Bond Show." More than a million people saw them in sixteen cities and over 133 million dollars in war bonds were sold. This painting — Rockwell felt it and *Freedom to Worship* were the best of the four — helped galvanize the nation to action during the war. Long after that conflict, its message continues to resonate; time has revealed that the value of the Four Freedoms series lies not simply in the ideas it presented, but in Rockwell's exceptional ability as an artist.

TEACHING ACTIVITIES

E = ELEMENTARY | M = MIDDLE | S = SECONDARY

| Encourage students to study this painting carefully.

DESCRIBE AND ANALYZE **E | M | S**

Ask students what these people are doing.

The standing man is speaking and others are looking and listening to him.

Have students find the words TOWN and REPORT.

They are located on blue paper near the lower edge.

Where might these people be?

They are attending a community meeting. Because MONT is visible on the paper, it may be a town meeting in Vermont.

Ask students to describe the expression on the speaker's face.

He seems very intent and serious. He looks up as if he is speaking to someone above him.

Ask students to describe the textures and patterns of the standing man's clothes and hands. Have them compare his hands and clothing to that of the other men. What do their hands and clothing suggest about their professions and financial status?

The speaker wears a slightly rumpled, zippered, plaid shirt and frayed jacket. The other men wear smooth, white buttoned shirts, ties, and suit jackets. The speaker's hands are darker and rougher than the lighter, smoother hand of the man on his right. The speaker is probably a manual laborer and the others, wealthier businessmen.

In what ways does this scene seem real?

The closely observed details and the composition with some faces only partially shown are almost like a photograph.

Who is attending this meeting?

We see young and old men and a woman in a black hat.

Who is the youngest man? *The speaker is.*

How do you know? *His hair is dark rather than gray and his face isn't as wrinkled as the others'.*

Describe the reaction of the other people in this scene to the speaker.

They are all listening respectfully to him.

How did Rockwell emphasize the speaker?

His light face contrasts with a plain black background. Light shines on his forehead and most of the people are looking at him.

M | S

Where is the viewer of this scene?

The viewer is seated two rows in front of the speaker, looking up at him.

How does this viewpoint influence our understanding of how Rockwell felt about this man and what he was doing?

We look up to this man, making him seem important.

INTERPRET **E | M | S**

Encourage students to imagine what the speaker might be saying. Discuss recent town meetings or hearings in your community where citizens voiced their opinions.

M | S

What is the paper in the speaker's pocket?

It is probably a town report.

Because the men in this scene have town reports, what does Rockwell assume about Americans and their form of government?

Ordinary American citizens can read and are capable of understanding complex issues concerned with government.

What inspired this painting?

Franklin D. Roosevelt's 1941 State of the Union address. Roosevelt appealed to four essential human freedoms.

Explain why this scene shows an American freedom. Why did Americans believe there was a connection between this image and World War II?

An ordinary working-class American citizen is able to voice his opinions without fear of censorship. Americans were fighting totalitarian dictatorships that did not allow this freedom of speech.

CONNECTIONS

Historical Connections: World War II; war bonds

Historical Figures: Franklin Delano Roosevelt; Dwight D. Eisenhower; Winston Churchill; Adolph Hitler

Civics: Bill of Rights; U.S. Supreme Court cases: *Whitney v. California, Stromberg v. California, Brandenburg v. Ohio,* and *New York Times Co. v. United States;* structure and function of local government

Literary Connections and Primary Documents: "Four Freedoms" speech, Franklin Delano Roosevelt (secondary); "Death of the Ball Turret Gunner," Randall Jarrell (secondary)

19b Selma-to-Montgomery March for Voting Rights in 1965, 1965

On August 7, 1965, President Lyndon Johnson signed the Voting Rights Act, one of the most important pieces of legislation in America since the era of Reconstruction. It signaled the victory of a battle that was fought five months earlier in Dallas County, Alabama. On March 25, twenty-five thousand participants — the largest civil rights gathering the South had yet seen — converged on the state capital of Montgomery, concluding a four-day march for voting rights that began in Selma, fifty-four miles away.

James Karales, a photographer for the popular biweekly magazine *Look,* was sent to illustrate an article covering the march. Titled "Turning Point for the Church," the piece focused on the involvement of the clergy in the civil rights movement — specifically, the events in Selma that followed the murder of a white minister from the North who had gone down to support voting rights for blacks. Karales's photograph of this event captured the spirit and determination of civil rights workers during those tense and dangerous times.

As in Emanuel Leutze's *Washington Crossing the Delaware* (see 4-A), the participants face human and natural obstacles that stand in the way of heroic action. Karales positioned his camera so that we look up at the train of marchers, who appear to climb some unseen path toward the low, threatening sky as they move resolutely from right to left. As though in defiance of the oncoming storm, four figures at the front of the group march in unison and set a brisk, military pace. In the center of the photograph, the American flag, a symbol of individual freedom and Constitutional rights, is carried by

invisible hands beneath a heavy, black thundercloud that appears ready to break.

In the week before Karales took this iconic picture, two unsuccessful attempts to march on the capital had already been made. On Sunday, March 5, the first activists, recorded by television cameras and still photographers, crossed the Edmund Pettus Bridge out of Selma. Horrified viewers watched as unarmed marchers, including women and children, were assaulted by Alabama state troopers using tear gas, clubs, and whips. The group turned back battered but undefeated. "Bloody Sunday," as it became known, only strengthened the movement and increased public support. Ordinary citizens, as well as priests, ministers, nuns, and rabbis who had been called to Selma by Dr. Martin Luther King Jr., flocked to join its ranks. The second attempt — "Turnaround Tuesday" — which Karales had been sent down to cover, was halted at the bridge by Dr. King before anyone was injured. Finally, six days later, the last march began after President Johnson mobilized the National Guard and delivered his voting rights legislation to Congress.

At first, Karales's photograph did not receive much exposure or recognition. He was a quiet man who let his work speak for itself. Born in 1930 to Greek-immigrant parents in Canton, Ohio, Karales trained as a photojournalist at Ohio University and then apprenticed with legendary photographer W. Eugene Smith. He worked for *Look* magazine from 1960 until the magazine folded in the early 1970s, and covered significant events of that turbulent decade such as the Vietnam War, the work of Dr. King, and the civil rights movement. Of all his photographs, it was those of this last group for which he became known, and his image of the Selma march has become an icon of the civil rights movement. It caught the attention of a broad audience when it appeared in the 1987 award-winning documentary series, *Eyes on the Prize,* which chronicled the history of the movement and acknowledged the role played by the news media in getting the story to the American public.

Karales's *Selma-to-Montgomery March for Voting Rights in 1965* reveals the strength of conviction demonstrated by hundreds of Americans seeking basic human rights. Transcending its primary function as a record of the event, it tells the story of the desire for freedom that is the shared heritage of all Americans. It is also a testament to Karales's ability to capture a timeless image from a fleeting moment — one that still haunts the American conscience.

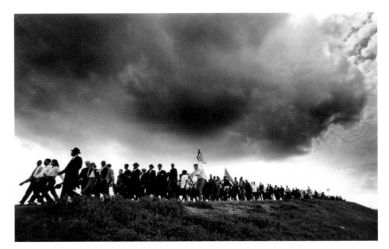

19-B James Karales (1930–2002), *Selma-to-Montgomery March for Voting Rights in 1965,* 1965. Photographic print. Located in the James Karales Collection, Rare Book, Manuscript, and Special Collections Library, Duke University. Photograph © Estate of James Karales.

TEACHING ACTIVITIES

Encourage students to carefully study this photograph and think about the kind of mood it sets.

DESCRIBE AND ANALYZE

E | M | S

Ask students to locate two flags. Why does the American flag play a prominent role in this march?

These people were marching for equal voting rights for African Americans in the United States. As citizens of the United States, African Americans wanted the same rights and opportunities as other Americans.

M | S

Encourage students to imagine where the photographer placed himself in order to take this picture.

He was slightly below the marchers, looking up at them.

Ask what is in the background behind the marchers.

A light sky with dark clouds is above the marchers.

Ask students how this viewpoint emphasizes the message and drama of the scene.

Karales makes the marchers look larger by tilting the camera up and creates drama by silhouetting the figures against the sky.

Discuss how this image might lose some of its impact if buildings and trees were included in the background.

M | S

How does the photographer suggest that there are many people participating in this march?

The camera angle exaggerates the perspective, making the line look as if it stretches into a great distance; we can't see the end of the line because it continues behind the hill.

INTERPRET

E | M | S

What do the outstretched legs and thrust-back shoulders of the three leading marchers suggest about their attitude?

They seem young, determined, and strong.

E | M | S

Call students' attention to the legs of the leading marchers. Apparently they are marching together in unison. What might they be doing to keep this same rhythm and beat?

They may have been singing and marching to the rhythm of music.

You may wish to play or have students sing "We Shall Overcome," a song popular during the civil rights movement.

E | M | S

What do the clouds overhead suggest?

There is the possibility of a storm.

M | S

Have students discuss why the publication of this photograph and others like it in magazines and newspapers helped the movement for civil rights in the United States.

CONNECTIONS

Historical Connections: Jim Crow laws; sit-ins; boycotts; civil rights movement

Historical Figures: Martin Luther King, Jr.; Rosa Parks

Geography: the shift in cultural geography that occurred as a result of the civil rights movement (integration)

Literary Sources and Primary Documents: *My Brother Martin: A Sister Remembers Growing Up with the Rev. Martin Luther King Jr.*, Christine King Farris (elementary); *Goin' Someplace Special*, Pat McKissack (elementary); *To Kill a Mockingbird*, Harper Lee (secondary); *When Justice*

Failed: The Fred Korematsu Story, Steven A. Chin (middle, secondary); "Letter from Birmingham Jail" and "I have a dream" speech, Martin Luther King, Jr. (elementary, middle)

teaching activities

Although often derided by those who embraced the native tendency toward realism, abstract painting was avidly pursued by artists after World War II. In the hands of talented painters such as Jackson Pollack, Robert Motherwell, and Richard Diebenkorn, abstract art displayed a robust energy and creative dynamism that was equal to America's emergence as the new major player on the international stage. Unlike the art produced under fascist or communist regimes, abstract art had no purpose other than being about art. Richard Diebenkorn was a painter who moved from abstraction to figurative painting and then back again. If his work has any constant theme it is one that concerns the light and atmosphere of the West Coast. As such, it touches the heart of landscape painting in America.

In Richard Diebenkorn's *Cityscape I,* the land and buildings are infused by the strong light of northern California. The artist captured the climate of San Francisco by delicately combining shades of green, brown, gray, blue, and pink, and arranging them in patches that represent the architecture and streets of his city. Unlike *The Oxbow* by Thomas Cole (see 5-A), there is no human figure in this painting. But like it, *Cityscape I* compels

us to think about man's effect on the natural world. Diebenkorn leaves us with an impression of a landscape that has been civilized — but only in part.

Cityscape I's large canvas has a composition organized by geometric planes of colored rectangles and stripes. Colorful, boxy houses run along a strip of road that divides the two sides of the painting: a man-made environment to the left, and open, presumably undeveloped, land to the right. This road, which travels almost from the bottom of the picture to the top, should allow the viewer to scan the painting quickly, but Diebenkorn has used some artistic devices to make the journey a reflective one.

On the left, the vertical climb is slowed by sunshine that pours in across a lush green lot and abruptly changes the color of the road and the open area beyond. This bold horizontal movement continues across from the road to the open field on the right by means of a thin gray line (perhaps a small trail). Just below is a golden-brown lot sectioned off in white and bordered by two white paths that form an arrowhead shape. This shape marks the contrast between shade and sun, developed and undeveloped environment. Above the slender gray line, the houses thin out and the landscape is interrupted only by small trees. More tellingly, the bird's-eye viewpoint used in the lower section of the painting shifts and slows: the dove-gray road widens, no longer appearing to narrow or recede. In fact, the whole upper portion of the painting seems flat or tilted up, like a rollercoaster track, where — at the apex of the climb — the journey momentarily stops, leaving the rider surrounded by only an intense, cloudless sky.

Diebenkorn emphasized the importance of the canvas's surface by the technique of applying color over color to construct a fluid image of a California landscape, changing his viewpoint from one part of the painting to another. He was interested in using the action and materials of painting to tell us about his subject not literally, but visually. *Cityscape* is actually a combination of a closely observed, actual location (the left half) and an invented landscape (the right). Diebenkorn wanted to recreate what he saw rather than reproduce the exact setting. He had flown over the New Mexican desert as a young man and remained fascinated by the designs of nature he saw from an airplane. The high viewpoint here allows us to move above and over parcels of land, fitting them into complex shapes that lock together like a puzzle from one end of the canvas to the other. The artist wanted us to contemplate this puzzle. A painting, he wrote, "is an attitude. It's like a sign that is hung up to be seen. It says this is the way it is according to a given sensibility."

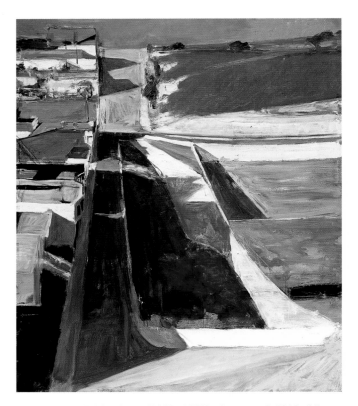

20-A Richard Diebenkorn (1922–1993), *Cityscape I,* **1963. Oil on canvas, 60¼ x 50½ in. (153.04 x 128.27 cm.). San Francisco Museum of Modern Art. Purchased with funds from Trustees and friends in memory of Hector Escobosa, Brayton Wilbur, and J. D. Zellerbach. © Estate of Richard Diebenkorn.**

TEACHING ACTIVITIES

E = ELEMENTARY | **M** = MIDDLE | **S** = SECONDARY

Allow students to look carefully at the foreground, background, and sides of this landscape.

DESCRIBE AND ANALYZE

E

Ask students to identify triangles, trapezoids, and rectangles in this cityscape. *They are in the fields, buildings, and shadows.* Have students locate trees, windows, and a flight of steps in this scene. *Trees are near the top, windows are in a white building on the left, and steps are near the lower left.*

E

Have students view a landscape from an upper story or playground climbing structure. Ask them to compare this elevated view with how the scene looks when they stand on the ground. What do they notice from the higher view that they would not see if they were lower?
Where might Diebenkorn have been when he saw the cityscape for this painting? *He could have been in a tall building, on a high hill, or in a low-flying airplane. (He was impressed with the view from a plane when he was a young man.)*

E | M | S

Ask students how the two sides of the road in Diebenkorn's painting differ. Which side is man-made and which is undeveloped? *The left side is filled with gray and white buildings while the right side is undeveloped fields of green and gold.*

E | M | S

Ask students to describe the land in this scene. *It's hilly with green fields and gold earth.*
Show students photographs of San Francisco's hills to see the landscape that inspired this painting. Notice how steep the hills are.

E | M | S

Ask how Diebenkorn created a sense of depth in this scene. *Distant shadows and buildings are lighter and higher in the composition than those close to us.*

E | M | S

Ask students if this painting is more like life (realistic) or simplified (abstract). *It is more abstract.*
Ask how the buildings and fields are different from what they might actually see. *They are basic shapes and have very few details.*
By painting this scene abstractly rather than realistically, what message has Diebenkorn shown in this painting? *He focuses our attention on interesting colors, light, and geometric shapes.*

M | S

Tell students to follow the road back into this scene. How does Diebenkorn slow their eye movement through this landscape? *Horizontal shadow and light shapes slow the visual movement.*

M | S

Have students compare Diebenkorn's *Cityscape 1* to Edward Hopper's *House by the Railroad*. How are they similar? *In both paintings light and shadow are extremely important. Both show buildings, but not people.*
How are they different? *Hopper's painting is much more detailed and realistic. Land fills most of Diebenkorn's composition. The sky and building are much more important in Hopper's. We look down on Diebenkorn's landscape from a bird's-eye viewpoint, but we look up at Hopper's.*
Compare their moods. *Because of the bright, light colors, Diebenkorn's seems more upbeat and cheerful.*

INTERPRET

E

Ask students what time of day it might be in Diebenkorn's painting. Why do they think this?
The long shadows suggest that it's early morning or late afternoon.

M | S

Ask what factors affect the color and lightness of an actual landscape.
The weather, sunlight, and humidity or pollution in the air all affect how much light shines on a scene.
Ask students to describe the weather and air quality of this scene. *It's clear and dry.*

S

Ask students why abstract painting was popular in the United States after World War II. *Abstract art, with its energy and creativity, complemented the dynamism of the United States as it became a world leader. Also, abstract art demonstrated that in a democracy artists could express themselves freely, unlike artists in totalitarian countries who had to create art supporting government ideologies.*

CONNECTIONS

Historical Connections: communism; suburbanization

Historical Figures: Senator Joseph McCarthy

Geography: urban geography

Literary Connections and Primary Documents: *The Crucible* and *Death of a Salesman*, Arthur Miller (secondary)

Arts: Abstract Expressionism; bay area figurative movement

20b Ladder for Booker T. Washington, 1996

The titles of Martin Puryear's sculptures might best be considered as metaphors that expand rather than limit the meaning of his works, which are spare, carefully crafted, evocative, and profound. Like poetry, much is lost in the interpretation. When his sculptures are titled after historic people, it is especially easy to misread them. In *Ladder for Booker T. Washington,* Puryear chose the title only after he had completed the sculpture. To think of the title as a frame for the sculpture would be backwards.

Puryear's *Ladder* reflects handcraft techniques he honed abroad while studying in West Africa and in Scandinavia. The side rails, polished strands of wood, are fashioned from a golden ash sapling that once grew on Puryear's upstate New York property; and the ladder's now sinuous, now sharp, rails, connected by round, lattice-like rungs that swell in the middle, reflect the wood's organic cycle of growth and change. Puryear says that he "forced" the perspective of the ladder. Although the rungs begin at a respectable 11¾ inches wide at the bottom, the distance between them diminishes as they climb upward thirty-six feet. Their span narrows to a dizzying 1¼ inches at the top of the ladder, giving the illusion of much greater height. Suspended about three feet above the floor and anchored to its surroundings by almost undetectable wires, *Ladder* seems to float precariously in space.

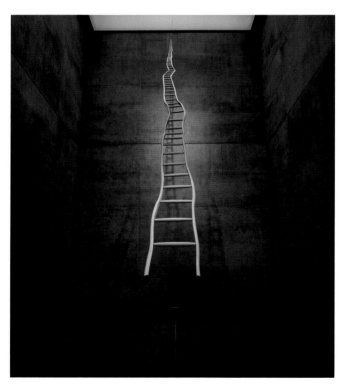

20-A Martin Puryear (1941–), *Ladder for Booker T. Washington,* 1996. Wood (ash and maple), 432 x 22¾ in., narrowing at the top to 1¼ in. x 3 in. (1097.28 x 57.785 cm., narrowing to 3.175 x 7.6 cm.). Collection of the Modern Art Museum of Fort Worth, Gift of Ruth Carter Stevenson, by Exchange.

Like Puryear's sculpture, the legacy of the man for whom it was named is open to interpretation. Booker T. Washington, an eminent but controversial leader of the African American community, was born into slavery in the Piedmont region of Virginia around 1856. At the age of twenty-five he rose to prominence as the founder and first president of Tuskegee Institute in Alabama. In the years following Reconstruction, the promised gains for African Americans were slipping away, and as an educator, Washington insisted that blacks be skilled both vocationally and intellectually: "When the student is through with his course of training, he [should go] out feeling that it is just as honorable to labor with the hands as with the head." At Tuskegee, the curriculum was founded on the tenet that work in all its manifestations was "dignified and beautiful."

Under Washington's guidance, Tuskegee became a successful and respected institution, and Washington himself was revered by many blacks and whites. However, his stand on civil rights was highly criticized by other African American leaders, such as W. E. B. DuBois, as being subservient. Washington thought that blacks need not campaign for the vote. The goal as he saw it was to establish economic independence before demanding civic equality, even if that meant using white assistance. He drew on his own life experience, recounted in his autobiography *Up from Slavery,* to exemplify his conviction that hard work would be sufficient to propel African Americans to success and acceptance. Although Washington quietly supported anti-segregation, he did not speak out openly against racism until the end of his life.

Puryear has used the concept of a ladder not easily ascended more than once — most spectacularly in an eighty-five-foot cedar and muslin spiral staircase created in a Paris church in 1998–1999; and this artistic metaphor dovetails seamlessly with the contradictions inherent in the often contentious legacy of Booker T. Washington. The association of ladders with ambition, transcendence, danger, faith, and salvation, deeply woven into the Judeo-Christian tradition, was certainly a vital part of the educational leader's life. The title of Washington's autobiography *Up from Slavery* is a direct reference to an ascent to a richer existence, both materially and psychologically. The spiritual "We Are Climbing Jacob's Ladder" was one of Washington's favorites (it was also sung by the Freedom Marchers from Selma to Birmingham, see 19-B).

Puryear's finely crafted ladder resonates with Washington's belief in the dignity of manual labor expertly accomplished. But the artist leaves the final explanation of his construction open. As critic Michael Brenson has stated, "Puryear has the ability to make sculpture that is known by the body before it is articulated by the mind."

TEACHING ACTIVITIES

E = ELEMENTARY | **M** = MIDDLE | **S** = SECONDARY

Encourage students to look carefully at this sculpture, noting where it begins and where it ends.

DESCRIBE AND ANALYZE

E | M

What is this object?
It is a ladder.
How is it different from most ladders?
It curves and gets narrower at the top.

E | M | S

Have students describe the side rails and rungs of this ladder.
The side rails are crooked, like the organic shape of the trees from which they were made. The rungs are thicker in the middle. The whole ladder is polished and assembled with fine craftsmanship.

E | M | S

What does this ladder rest on?
It does not stand on the floor. It is suspended from the ceiling and held in place by very fine wires. It seems to float about two and one-half feet above the floor.
Ask students if they can see the wires holding it in place. Notice the shadows created by the ladder.

M | S

Ask students what illusion Puryear creates by making the ladder narrower at the top than bottom.
It makes it seem even taller than it is.
Remind them of the African American spiritual "We Are Climbing Jacob's Ladder." Does this ladder seem tall enough to reach to the heavens?

INTERPRET

E | M | S

Ask students if they think the ladder would be difficult to climb and why.
It would be very difficult because it is long and curving and it gets very narrow at the top.

E | M | S

Discuss with students what ladders can symbolize. Remind them of phrases like "climbing the ladder to success" and "getting to the top." Call attention to the title of this sculpture, *Ladder for Booker T. Washington.* The title of Washington's autobiography was *Up from Slavery.* Ask why this ladder is an appropriate symbol for this title. (Students should understand that the climb from slavery to attaining equal civil rights was as difficult as it would be to climb this ladder.)

M | S

How does the fine craftsmanship of this ladder represent some of Washington's beliefs?
In addition to intellectual skills, Washington believed that students should learn manual skills, like the woodworking represented by this ladder, in order to support themselves.

M | S

Where does the ladder lead?
It leads to the light.
What might the fact that the ladder is raised off the ground symbolize?
You have to pull yourself up to the place where the ladder starts.
Have students discuss how a person might climb this ladder to success, and where it might lead.

CONNECTIONS

Historical Connections: slavery; Reconstruction; civil rights; Pan-Africanism

Historical Figures: Booker T. Washington; W. E. B. DuBois

Civics: Fifteenth Amendment; Voting Rights Act of 1965

Literary Connections and Primary Documents: *Roll of Thunder, Hear my Cry,* Mildred D. Taylor (middle); *Up from Slavery,* Booker T. Washington (secondary); *Invisible Man,* Ralph Ellison (secondary); Atlanta Address of 1895, Booker T. Washington (secondary);

Emancipation Proclamation (1863), Abraham Lincoln (elementary, middle)

Arts: abstract art

selected bibliography

GENERAL SOURCES

Baigell, Matthew. *A Concise History of American Painting and Sculpture*. New York: Harper & Row, 1984.

Brown, Milton W. *American Art to 1900: Painting, Sculpture, Architecture*. New York: Harry N. Abrams, 1977.

Brown, Milton W., Sam Hunter, John Jacobs, Naomi Rosenblum, and David M. Sokol. *American Art: Painting, Sculpture, Decorative Arts, Photography*. New York: Harry N. Abrams, 1979.

Dictionary of American Art. New York: Harper & Row, 1979.

Feest, Christian F. *Native Arts of North America*. New York: Oxford University Press, 1980.

Grove Art Online. http://www.groveart.com (accessed August 30, 2007).

Larkin, Oliver. *Art and Life in America*. Rev. ed. New York: Holt, Rinehart and Winston, 1960.

Mendelowitz, Daniel M. *A History of American Art*. 2nd ed. New York: Holt, Rinehart and Winston, 1970.

Novak, Barbara. *American Painting of the Nineteenth Century: Realism, Idealism, and the American Experience*. 2nd ed. New York: Harper and Row, 1979.

Penney, David W. *North American Indian Art*. World of Art. New York: Thames and Hudson, 2004.

Pritzker, Barry M. *Native Americans: An Encyclopedia of History, Culture, and Peoples*. 2 vols. Santa Barbara, CA: ABC-CLIO, 1998.

Stebbins, Theodore E., Carol Troyen, and Trevor J. Fairbrother. *A New World: Masterpieces of American Painting 1760–1910*. Boston: Museum of Fine Arts, 1983.

1-A POTTERY AND BASKETS: C. 1100 TO C. 1960

Berlo, Janet C., and Ruth B. Phillips. *Native North American Art*. New York: Oxford University Press, 1998.

Campbell, Emory Shaw. *Gullah Cultural Legacies*. Hilton Head, SC: Gullah Heritage Consulting Services, 2002.

Cohodas, Marvin. *Degikup: Washoe Fancy Basketry, 1895–1935*. Vancouver: Fine Arts Gallery of the University of British Columbia, 1979.

Crown, Patricia L., and W. H. Wills. "Modifying Pottery and Kivas at Chaco: Pentimento, Restoration, or Renewal?" *American Antiquity* 68, no. 3 (2003): 511–532.

Fewkes, Jesse Walter. *Designs on Prehistoric Hopi Pottery*. New York: Dover Publications, 1973.

———."The Prehistoric Culture of Tusayan." In *Selected Papers from the American Anthropologist, 1888–1920,* edited by Frederica De Laguna, 223-245. Evanston, IL: Row, Peterson, 1960.

Lee, Molly. *Baleen Basketry of the North American Eskimo*. Seattle: University of Washington Press, 1998.

Opala, Joseph A. *The Gullah: Rice, Slavery and the Sierra-Leone-American Connection*. Freetown, Sierra Leone: United States Information Service, 1987. http://yale.edu/glc/gullah/index.htm (accessed January 15, 2008).

Peterson, Susan. *The Living Tradition of María Martínez*. New ed. Tokyo and New York: Kodansha International, 1997.

Pollitzer, William S. *The Gullah People and Their African Heritage*. Athens, GA: University of Georgia Press, 1999.

Porter, Frank W., ed. *The Art of Native American Basketry: A Living Legacy*. Contributions to the Study of Anthropology 5. New York: Greenwood Press, 1990.

Reynolds, Terry R. "Maria Montoya Martinez: Crafting a Life, Transforming a Community." in *Sifters: Native American Women's Lives,* edited by Theda Perdue, 160–74. New York: Oxford University Press, 2001.

Rosengarten, Dale. *Row Upon Row: Sea Grass Baskets of the South Carolina Lowcountry*. Columbia, SC: McKissick Museum, University of South Carolina, 1986.

Stuart, David E. *Anasazi America: Seventeen Centuries on the Road from Center Place*. Albuquerque: University of New Mexico Press, 2000.

Wright, Richard B. "Style, Meaning, and the Individual Artist in Western Pueblo Polychrome Ceramics after Chaco." *Journal of the Southwest* 47, no. 2 (2005): 259–325.

1-B MISSION NUESTRA SEÑORA DE LA CONCEPCIÓN, SAN ANTONIO, TEXAS, 1755

Fisher, Lewis F. *The Spanish Missions of San Antonio*. San Antonio: Maverick Publishing, 1998.

Lee, Antoinette J. "Spanish Missions." *APT Bulletin* 22, no. 3 (1990): 42-54.

Quirarte, Jacinto. *The Art and Architecture of the Texas Missions*. Jack and Doris Smothers Series in Texas History, Life, and Culture. Austin: University of Texas Press, 2002.

Torres, Louis. *San Antonio Missions*. Tucson: Southwest Parks and Monuments Association, 1993.

2-A JOHN SINGLETON COPLEY (1738–1813),
PAUL REVERE, 1768

Barratt, Carrie Rebora. *John Singleton Copley in America.* New York: Metropolitan Museum of Art, 1995.

2-B SILVER OF THE 18TH, 19TH, & 20TH CENTURIES

Cutten, George Barton. *Silversmiths of North Carolina 1696–1860.* 2nd rev. ed. Raleigh, NC: North Carolina Department of Cultural Resources, 1984.

Davidson, Marshall. "Yankee Silversmithing." *Metropolitan Museum of Art Bulletin,* n.s., 2, no. 2 (1943): 99–101.

Dean, John Ward. "Memoir of Frederick Kidder." *The New-England Historical and Genealogical Register* 41 (1887): 129–40.

Falino, Jeannine, and Gerald W. R. Ward, eds. *New England Silver & Silversmithing 1620–1815.* Boston: Colonial Society of Massachusetts, 1984. Distributed by the University Press of Virginia.

Graham, Hood. "Silversmiths and Society in America, 1650–1850." *American Art Journal* 2, no. 1 (1970): 54–59.

Martello, Robert. "Paul Revere's Last Ride: The Road to Rolling Copper." *Journal of the Early Republic* 20, no. 2 (2000): 219–39.

Phillips, John Marshall. *American Silver.* New York: Chanticleer Press, 1949.

Quimby, Ian M. G. "1776: How America Really Looked: Silver." *American Art Journal* 7, no. 1 (1975): 68–81.

Stern, Jewel. *Modernism in American Silver: 20th-Century Design.* Edited by Kevin W. Tucker and Charles L. Venable. New Haven: Yale University Press, 2005.

Triber, Jayne E. *A True Republican: The Life of Paul Revere.* Amherst: University of Massachusetts Press, 1998.

Waters, Deborah Dependahl. "From Pure Coin: The Manufacture of American Silver Flatware 1800–1860." *Winterthur Portfolio* 12 (1977): 19–33.

3-A GRANT WOOD (1892–1942), *THE MIDNIGHT RIDE OF PAUL REVERE,* 1931

Corn, Wanda M. *Grant Wood: The Regionalist Vision.* New Haven: Published for the Minneapolis Museum of Art by Yale University Press, 1983.

3-B GILBERT STUART (1755–1828), *GEORGE WASHINGTON* (LANSDOWNE PORTRAIT), 1796

Barratt, Carrie Rebora, and Ellen G. Miles. *Gilbert Stuart.* New York: Metropolitan Museum of Art; New Haven and London: Yale University Press, 2004.

4-A EMANUEL LEUTZE (1816–1868), *WASHINGTON CROSSING THE DELAWARE,* 1851

Groseclose, Barbara. *Emanuel Leutze, 1816–1868: Freedom Is the Only King.* Washington, DC: Smithsonian Institution Press, 1976.

4-B HIRAM POWERS (1805–1873), *BENJAMIN FRANKLIN,* 1862

Hawthorne, Nathaniel. *Passages from the French and Italian Notebooks of Nathaniel Hawthorne.* 2 vols. Boston: J. R. Osgood and Co., 1871. See first volume, http://www.gutenberg.org/dirs/etext05/ frit110.txt; second volume, http://www.gutenberg.org/dirs/etext05/frit210.txt (accessed January 11, 2008).

Reynolds, Donald. "The 'Unveiled Soul,' Hiram Powers's Embodiment of the Ideal." *Art Bulletin* 59, no. 3 (1977): 394–414.

Wunder, Richard. *Hiram Powers: Vermont Sculptor, 1805–1873.* 2 vols. Newark: University of Delaware Press, 1991.

Fitz, Karsten. "Contested Space: *Washington Crossing the Delaware* as a Site of American Cultural Memory." In *Space in America: Theory, History, Culture,* edited by Klaus Benesch and Kerstin Schmidt, 557–79. Amsterdam and New York: Rodopi, 2005.

5-A THOMAS COLE (1801–1848), *VIEW FROM MOUNT HOLYOKE (THE OXBOW),* 1836

Howat, John K. *American Paradise: The World of the Hudson River School.* New York: Metropolitan Museum of Art, 1987.

Parry, Ellwood C. *The Art of Thomas Cole: Ambition and Imagination.* Newark: University of Delaware Press, 1988.

5-B N. C. WYETH (1882–1945), COVER ILLUSTRATION FOR *THE LAST OF THE MOHICANS,* 1919

Michaelis, David. *N. C. Wyeth: A Biography.* New York: Knopf, 1998.

6-A JOHN JAMES AUDUBON (1785–1851), *AMERICAN FLAMINGO,* 1838

Walker, John. *National Gallery of Art, Washington.* New York: Harry N. Abrams, 1956.

6-B GEORGE CATLIN (1796–1872), CATLIN PAINTING *THE PORTRAIT OF MAH-TO-TOH-PA — MANDAN*, 1861/1869

Catlin, George. *North American Indians.* Edited and with an introduction by Peter Matthiessen. New York: Penguin Books, 1989.

Dipper, Brian. "Green Fields and Red Men." In *George Catlin and His Indian Gallery,* edited by George Gurney and Theresa Thau Heyman, 27–61. Washington, DC: Smithsonian American Art Museum; New York: W. W. Norton, 2002 .

Hight, Kathryn S. "'Doomed to Perish': George Catlin's Depictions of the Mandan." *Art Journal* 49, no. 2 (1990): 119–124.

7-A THOMAS COLE (1801–1848) AND OTHERS, OHIO STATE CAPITOL

Cummings, Abbott Lowell. "The Ohio State Capitol Competition." *Journal of the Society of Architectural Historians* 12, no. 2 (1953): 15–18.

Hitchcock, Henry Russell. *Architecture: Nineteenth and Twentieth Centuries.* 4th ed. Baltimore: Penguin Books, 1977.

Hitchcock, Henry Russell, and William Seale. *Temples of Democracy: The State Capitols of the U.S.A.* New York: Harcourt, Brace, and Jovanovich, 1976.

O'Donnell, Thomas E. "The Greek Revival Capitol at Columbus, Ohio." *Architectural Forum* 42, no. 1 (1925): 4–8.

Parry, Ellwood C., III. *The Art of Thomas Cole, Ambition and Imagination.* Newark: University of Delaware Press, 1988.

7-B GEORGE CALEB BINGHAM (1811–1879), *THE COUNTY ELECTION*, 1852

Shapiro, Michael Edward. *George Caleb Bingham.* New York: Harry N. Abrams, 1993.

Weinberg, Jonathan. "The Artist and the Politician." *Art in America* 88 (2000): 138–83. http://findarticles.com/p/articles/mi_m1248/is_10_88/ai_66306835 (accessed January 14, 2008).

8-A ALBERT BIERSTADT (1830–1902), *LOOKING DOWN YOSEMITE VALLEY, CALIFORNIA,* 1865

Anderson, Nancy K., and Linda S. Ferber. *Albert Bierstadt: Art & Enterprise.* New York: Hudson Hills Press, in association with the Brooklyn Museum, 1990.

Brenson, Michael. "He Painted the West that America Wanted." Review of "Albert Bierstadt: Art and Industry." *New York Times,* February 8, 1991. http://query.nytimes.com/gst/fullpage.html?res=9D0CE4D7113AF93BA35751C0A967958260 (accessed January 14, 2008).

Howat, John K. *American Paradise: The World of the Hudson River School.* New York: Metropolitan Museum of Art, 1987.

8-B BLACK HAWK (C. 1832–1890), *"SANS ARC LAKOTA" LEDGER BOOK,* 1880–1881

Berlo, Janet Catherine. *Spirit Beings and Sun Dancers: Black Hawk's Vision of the Lakota World.* New York: George Braziller, 2000.

Donnelley, Robert G. *Transforming Images: The Art of Silver Horn and His Successors.* Chicago: The David and Alfred Smart Museum of Art, 2000.

Lowie, Robert H. *The Crow Indians.* New York: Farrar and Rinehart, 1935.

Szabo, Joyce M. *Howling Wolf and the History of Ledger Art.* Albuquerque: University of New Mexico Press, 1994.

9-A WINSLOW HOMER (1836–1910), *THE VETERAN IN A NEW FIELD,* 1865

Cikovski, Nicolai, and Franklin Kelly. *Winslow Homer.* Washington, DC: National Gallery of Art; New Haven: Yale University Press, 1995.

Goodrich, Lloyd. *Winslow Homer.* New York: Published for the Whitney Museum of American Art by the MacMillan Company, 1944.

Davidson, Marshall B., and Elizabeth Stillinger. *The American Wing at the Metropolitan Museum of Art.* New York: Metropolitan Museum of Art, 1985.

9-B ALEXANDER GARDNER (1821–1882), ABRAHAM LINCOLN, FEBRUARY 5, 1865

Katz, D. Mark. *Witness to an Era: The Life and Photographs of Alexander Gardner: The Civil War, Lincoln, and the West.* New York: Viking, 1991.

10-A AUGUSTUS SAINT-GAUDENS (1848–1907), ROBERT SHAW MEMORIAL, 1884–1897

Dryfhout, John H. *The Work of Augustus Saint-Gaudens.* Hanover, NH: University Press of New England, 1982.

Marcus, Lois Goldreich. "The *Shaw Memorial* by Augustus Saint-Gaudens: A History Painting in Bronze." *Winterthur Portfolio* 14, no. 1 (1979): 1–23.

Tharp, Louise Hall. *Saint-Gaudens and the Gilded Era.* Boston: Little, Brown, 1969.

Wilkinson, Burke. *Uncommon Clay: The Life and Works of Augustus Saint Gaudens.* New York: Harcourt Brace, 1985.

10-B QUILTS: 19TH THROUGH 20TH CENTURIES

Duke, Dennis, and Deborah Harding, eds. *America's Glorious Quilts*. New York: Hugh Lauter Levin Associates, 1987.

Fons, Marianne. *Fons & Porter Presents Quilts from The Henry Ford*. Urbandale, Iowa: Landauer Books, 2005.

Fry, Gladys-Marie. *Stitched From the Soul: Slave Quilts from the Ante-Bellum South*. New York: Dutton Studio Books, 2002.

Granick, Eve Wheatcroft. *The Amish Quilt*. Intercourse, PA: Good Books, 1989.

Hafter, Daryl M. "Toward a Social History of Needlework Artists." *Woman's Art Journal* 2, no. 2 (1981/1982): 25–29.

Herr, Patricia T. *Amish Quilts of Lancaster County*. Atglen, PA: Schiffer Publishing, 2004.

Hughes, Robert. *Amish: The Art of the Quilt*. New York: Wings Books, 1995.

Vlach, John Michael. *The Afro-American Tradition in Decorative Arts*. Athens, GA: University of Georgia Press, 1978.

Wahlman, Maude Southwell. "African Symbolism in Afro-American Quilts." *African Arts* 20, no. 1 (1986): 68–76, 99.

11-A THOMAS EAKINS (1844–1916), *JOHN BIGLIN IN A SINGLE SCULL*, C. 1873

Cooper, Helen A. *Thomas Eakins: The Rowing Pictures*. New Haven: Yale University Art Gallery, 1996.

Goodrich, Lloyd. *Thomas Eakins*. Cambridge, MA: Published for the National Gallery of Art by Yale University Press, 1982.

Hendricks, Gordon. *The Life and Work of Thomas Eakins*. New York: Grossman Publishers, 1974.

Homer, William Innes. *Thomas Eakins: His Life and Art*. 2nd ed. New York: Abbeville Press, 2002.

11-B JAMES MCNEILL WHISTLER (1834–1903), *THE PEACOCK ROOM*, 1876–1877

Merrill, Linda. *The Peacock Room: A Cultural Biography*. New Haven: Yale University Press, 1998.

12-A JOHN SINGER SARGENT (1856–1925), *PORTRAIT OF A BOY*, 1890

Fairbrother, Trevor J. *John Singer Sargent*. The Library of American Art. New York: Harry N. Abrams, in association with the National Museum of American Art, Smithsonian Institution, 1994.

Gallati, Barbara Dayer, Erica E. Hirschler, and Richard Ormond. *Great Expectations: John Singer Sargent Painting Children*. With contributions by Erica E. Hirshler and Richard Ormond. New York: Brooklyn Museum of Art, in association with Bulfinch Press, 2004.

12-B CHILDE HASSAM (1859–1935), *ALLIES DAY, MAY 1917*, 1917

Fort, Ilene Susan. *The Flag Paintings of Childe Hassam*. Los Angeles: Los Angeles County Museum of Art; New York: Harry N. Abrams, 1988.

Hiesinger, Ulrich W. *Childe Hassam: American Impressionist*. Munich: Prestel, 1994.

Weinberg, H. Barbara. *Childe Hassam: American Impressionist*. New York: The Metropolitan Museum of Art; New Haven: Yale University Press, 2004.

Walker, John. *National Gallery of Art, Washington*. New York: Harry N. Abrams, 1956.

13-A WALKER EVANS (1903–1975), *BROOKLYN BRIDGE, NEW YORK*, 1929

Epstein, Daniel Mark. "The Passion of Walker Evans." *The New Criterion Online* 18, no. 7 (2000). http://newcriterion.com:81/archive/18/mar00/evans.htm (accessed January 14, 2008).

Haw, Richard. *The Brooklyn Bridge: A Cultural History*. New Brunswick, NJ: Rutgers University Press, 2005.

Mellow, James R. *Walker Evans*. New York: Basic Books, 1999.

Rathbone, Belinda. *Walker Evans: A Biography*. Boston: Houghton Mifflin, 1995.

13-B LOUIS COMFORT TIFFANY (1848–1933), *AUTUMN LANDSCAPE — THE RIVER OF LIFE*, 1923–1924

Duncan, Alastair, Martin Eidelberg, and Neil Harris. *Masterworks of Louis Comfort Tiffany*. New York: Harry N. Abrams, 1989.

14-A MARY CASSATT (1844–1926), *THE BOATING PARTY*, 1893/1894

Mathews, Nancy Mowll. *Mary Cassatt: A Life*. New York: Villard Books, 1994.

Walker, John. *National Gallery of Art, Washington*. New York: Harry N. Abrams, 1956.

14-B JOSEPH STELLA (1877–1946), *BROOKLYN BRIDGE*, C. 1919–1920

Haskell, Barbara. *Joseph Stella*. New York: Whitney Museum of American Art, 1994.

Haw, Richard. *The Brooklyn Bridge: A Cultural History*. New Brunswick, NJ: Rutgers University Press, 2005.

Jaffe, Irma B. *Joseph Stella*. Cambridge, MA: Harvard University Press, 1970.

15-A CHARLES SHEELER (1883–1965), *AMERICAN LANDSCAPE*, 1930

Brock, Charles. *Charles Sheeler: Across Media*. Washington, DC: National Gallery of Art, 2006.

15-B WILLIAM VAN ALEN (1883–1954), THE CHRYSLER BUILDING, 1926–1930

Campi, Mario. *Skyscraper: An Architectural Type of Modern Urbanism*. Boston: Birkhauser, 2000.

16-A EDWARD HOPPER (1882–1967), *HOUSE BY THE RAILROAD*, 1925

Hobbs, Robert. *Edward Hopper*. New York: Harry N. Abrams, in association with the National Museum of American Art, Smithsonian Institution, 1987.

Levin, Gail. *Edward Hopper*. New York: Crown, 1995.

16-B FRANK LLOYD WRIGHT (1867–1959), *FALLINGWATER*, 1935–1939

Huxtable, Ada Louise. "Masterpiece: A Marriage of Nature and Art." *Wall Street Journal*, March 18, 2006.

17-A JACOB LAWRENCE (1917–2000), *THE MIGRATION SERIES, NO. 57*, 1940–1941

Hills, Patricia. "Jacob Lawrence's *Migration* Series: Weavings of Picture and Texts." In *Jacob Lawrence: The Migration Series*, 144–53.

Lorenson, Jutta. "Between Image and Word, Color and Time: Jacob Lawrence's *The Migration Series*." *African American Review* 40, no. 3 (2006): 571–87.

Turner, Elizabeth Hutton, ed. *Jacob Lawrence: The Migration Series*. Urbana, VA: Rappahanock Press in association with The Phillips Collection, Washington, DC, 1993.

17-B ROMARE BEARDEN (C. 1911–1988) *THE DOVE*, 1964

Fine, Ruth, ed. *The Art of Romare Bearden*. Washington, DC: National Gallery of Art, 2003.

Gelburd, Gail, and Thelma Golden. *Romare Bearden in Black and White*. New York: Whitney Museum of American Art, 1997.

Glazer, Lee Stephens. "Signifying Identity: Art and Race in Romare Bearden's Projections." *Art Bulletin* 76, no. 3 (1994): 411–26.

18-A THOMAS HART BENTON (1889–1975), *THE SOURCES OF COUNTRY MUSIC*, 1975

Adams, Henry. *Thomas Hart Benton: An American Original*. New York: Knopf, 1989.

Benton, Thomas Hart. *An Artist in America*. 4th rev. ed. Columbia: University of Missouri Press, 1983.

18-B DOROTHEA LANGE (1895–1965), *MIGRANT MOTHER*, 1936

Heyman, Therese Thau. *Celebrating a Collection: The Work of Dorothea Lange*. Oakland, CA: Oakland Museum, 1978.

Meltzer, Milton. *Dorothea Lange: A Photographer's Life*. New York: Farrar Straus Giroux, 1978.

Ohrn, Karin Becker. *Dorothea Lange and the Documentary Tradition*. Baton Rouge: Louisiana State University Press, 1980.

Partridge, Elizabeth. *Restless Spirit: The Life and Work of Dorothea Lange*. New York: Viking, 1998.

19-A NORMAN ROCKWELL (1894–1978), *FREEDOM OF SPEECH, THE SATURDAY EVENING POST*, 1943

Claridge, Laura P. *Norman Rockwell: A Life*. New York: Random House, 2001.

Hennessey, Maureen Hart, and Anne Knutson. *Norman Rockwell: Pictures for the American People*. Atlanta: High Museum of Art; Stockbridge, MA: Norman Rockwell Museum; New York: Harry N. Abrams, 1999.

Marling, Karal Ann. *Norman Rockwell*. New York: Harry N. Abrams, 1997.

19-B JAMES KARALES (1930–2002), *SELMA-TO-MONTGOMERY MARCH FOR VOTING RIGHTS IN 1965*, 1965

Friedland, Michael B. "Giving a Shout for Freedom, Part II." Paper presented at the "Sixties Generations Conference: From Montgomery to Viet Nam," March 4–6, 1993, Fairfax, VA. In *Viet Nam Generation: A Journal of Recent History and Contemporary Issues.* Special Issue: *Nobody Gets Off the Bus: The Viet Nam Generation Big Book*, 5, no. 4. http://www3.iath.virginia.edu/sixties/HTML_docs/Texts/Scholarly/Friedland_Boyd_02.html (accessed January 11, 2008).

Kasher, Steven. *The Civil Rights Movement: A Photographic History, 1954–68.* Forward by Myrlie Evers-Williams. New York: Abbeville Press, 1996.

Loke, Margarett. "James Karales, Photographer of Social Upheaval, Dies at 71." *New York Times,* April 5, 2002. http://query.nytimes.com/gst/fullpage.html?res=9F02E5DD163DF936A35757C0A9649C8B63 (accessed January 14, 2008).

Wren, Christopher. "Turning Point for the Church." *Look* 29 (May 18, 1965): 31.

20-A RICHARD DIEBENKORN (1922–1993), *CITYSCAPE I*, 1963

Glueck, Grace. "A Painter Unafraid to Change Styles," *New York Times,* October 10, 1997. http://query.nytimes.com/gst/fullpage.html?res=9D0DE7DE153CF933A25753C1A961958260 (accessed January 14, 208).

Kuspit, Donald. "East Coast, West Coast: Robert Rauschenberg, Richard Diebenkorn." *Art New England* (February/March, 1998): 15 ff.

Livingston, Jane. *The Art of Richard Diebenkorn.* New York: Whitney Museum of Art; Berkeley: University of California Press, 1977.

Pops, Martin. "Diebenkorn in the Age of Rauschenberg." *Salmagundi* 88, no. 120 (1991): 27–44.

20-B MARTIN PURYEAR (1941–), *LADDER FOR BOOKER T. WASHINGTON*, 1996

Benezra, Neal. *Martin Puryear.* With an essay by Robert Storr. Chicago: Art Institute of Chicago; New York: Thames and Hudson, 1993.

Crutchfield, Margo A. *Martin Puryear.* Richmond: Virginia Museum of Fine Arts, 2001.

Washington, Booker T. *Up from Slavery: An Autobiography.* Garden City, New York: Doubleday and Company. 1901. See 1991 ed. at *Documenting the American South* http://docsouth.unc.edu/fpn/washington/menu.html (accessed January 29, 2008).

art index

history and other indexes

HISTORY

TIME PERIODS, CULTURES, AND EVENTS:

PEOPLE:

Hughes, Langston: 17-A, 17-B
Hurston, Zora Neal: 17-A, 17-B
Indigenous Peoples: Cliff Dwellers (Anasazi), Hopi, Inupiat,
 Pueblo, Sikyákti, and Washoe: 1-A; Coahuilticans: 1-B;
 Mohicans: 5-A, 5-B; Mandan: 6-B; Sans Arc Lakota: 8-B
Jackson, Andrew: 1-B, 6-B, 7-B, 8-B
Jackson, Stonewall: 9-A, 9-B, 10-A
Jay, John: 3-B
Jefferson, Thomas: 2-B, 6-B, 7-A
Johnson, Lyndon B.: 7-B, 19-B
King George III: 2-A, 2-B, 3-A
King, Martin Luther: 19-B
Lafayette, Marquis de: 3-B
Lee, Robert E.: 9-A, 9-B, 10-A
Leyland, Frederick Richards: 11-B
Lewis, Meriwether: 6-B
Lincoln, Abraham: 9-A, 9-B, 10-A
Massachusetts Fifty-fourth Regiment: 10-A
McCarthy, Senator Joseph: 20-A
Mott, Lucretia: 7-B
Muir, John: 8-A
Parks, Rosa: 19-B
Perry, Commodore Matthew Calbraith: 11-B
Petty, William, First Marquis of Lansdowne: 3-B
Polk, James K.: 1-B
Popé: 1-B
Puritans: 5-A
Revere, Paul: 2-A, 2-B, 3-A
Rockefeller, John D.: 12-A
Roebling, John and Washington: 13-A, 14-B
Roosevelt, Eleanor: 19-A
Roosevelt, Franklin Delano: 19-A
Roosevelt, Theodore: 8-A
Sacajawea: 6-B
Shaw, Robert Gould: 10-A
Sherman, George McClellan: 9-A, 9-B, 10-A
Sojourner Truth: 9-B, 10-A, 14-A
Sons of Liberty: 2-A, 2-B
Stanton, Elizabeth Cady: 7-B, 14-A
Taylor, Zachary: 1-B
Tecumseh: 8-B
Thoreau, Henry David: 5-A
Toomer, Jean: 17-B
Towle, Loren Delbert: 13-B
Tubman, Harriet: 10-A
Warren, Mary Otis: 4-A
Washington, Booker T.: 17-A, 20-B
Washington, George: 3-B, 4-A
Wright, Richard: 17-B

PRESIDENCY:
Jackson, Andrew: 6-B
Johnson, Lyndon Baines: 19-B
Lincoln, Abraham: 9-A, 9-B
Roosevelt, Franklin Delano: 18-B, 19-A; "Four Freedoms"
 speech: 19-A
Washington, George: 3-B, 4-A
Wilson, Woodrow: 12-B

THEMES AND TOPICS:
African American: 4-A, 7-B, 10-A, 10-B, 17-A, 17-B,
 18-A, 19-B, 20-B
American frontier: 5-A, 5-B, 6-B, 8-A, 8-B
American Indian: 1-A, 1-B, 5-B, 6-B, 8-B
Animals: 6-A, 11-B, 15-B, 17-B
City on a Hill: 5-A
Communism and totalitarianism: 20-A
Conservation movement: 8-A
Currency: 2-A, 3-B
Egyptomania: 15-B
Ellis Island: 13-A, 14-B
Entrepreneurship: 2-B, 15-A, 15-B
Electoral process: 7-B
Founding Fathers: 3-B, 4-A, 4-B
Government: 3-B, 7-A, 7-B, 12-B, 18-B, 19-B
Heroism: 3-A, 4-A, 10-A, 19-B
Immigration: 14-B
Industrialism: 12-A, 15-A; 15-B, 17-A
Integration: 19-B
Japonisme: 11-B, 14-A
League of Nations: 12-B
Missions, Spanish: 1-B
Pan-Africanism: 20-B
Physiognomy: 3-B
Railroads: 8-A, 15-A, 16-A, 17-A, 18-A
Recreation: 11-A, 14-A
Skyscrapers: 15-B
Slavery: 1-A, 10-A, 10-B
Statehood: 7-A
Suburbanization: 20-A
Texas history: 1-B
Voting: see Electoral process

CIVICS

American flag: 4-A, 12-B, 19-B
Bill of Rights: 19-A
Brandenburg v. Ohio: 19-A
Declaration of Independence: 4-A, 4-B
Electoral process: 7-B
Founding Fathers: 3-B, 4-A, 4-B
Fourteenth and Fifteenth Amendments: 7-B, 20-B

Katz, Bobbie, *George Washington's Birthday: Wondering* (elementary): 3-B

Kay, Vera, *Homespun Sarah* (elementary): 10-B

Kundhardt, Edith, *Honest Abe* (elementary): 9-B

Lee, Harper, *To Kill a Mockingbird* (secondary): 19-B

London, Jack, *Call of the Wild*; *White Fang* (elementary, middle): 1-A

Lyons, Mary, *Stitching Stars: The Story Quilts of Harriet Powers* (middle): 10-B

Malcolm X, *The Ballot or the Bullet* (secondary): 7-B

McGovern, Ann, *The Secret Soldier: The Story of Deborah Sampson* (elementary): 3-B

McKissack, Patricia, *Frederick Douglass: The Black Lion* (elementary): 10-A; *Goin' Someplace Special* (elementary): 19-B

Melville, Herman, *Moby Dick* (secondary): 1-A

Muir, John, *A Thousand-Mile Walk to the Gulf* (middle, secondary): 8-A

Peacock, Louise, *Crossing the Delaware: A History in Many Voices* (elementary): 3-B

Pinkney, Andrea Davis, *Duke Ellington: The Piano Prince and His Orchestra* (elementary): 17-B

Rowland, Della, *The Story of Sacajawea: Guide to Lewis and Clark* (elementary): 6-B

Scollard, Clinton, "The Ride of Tench Tilghman" (middle, secondary): 2-B, 3-A

Sinclair, Upton, *The Jungle* (secondary): 15-A

Steinbeck, John, *Grapes of Wrath*; *Of Mice and Men* (secondary): 18-B

Stowe, Harriet Beecher, *Uncle Tom's Cabin* (middle, secondary): 1-A, 9-B, 10-A, 10-B, 20-B

Tan, Amy, *The Joy Luck Club* (secondary): 14-B

Taylor, Debbie A., *A Music in Sweet Harlem* (elementary): 17-B

Taylor, Mildred D., *Roll of Thunder, Hear My Cry* (elementary): 20-B

Toomer, Jean, *Cane* (secondary): 17-B

Twain, Mark (Samuel Clemens), *The Adventures of Huckleberry Finn* (secondary); *Tom Sawyer* (middle): 11-A

Wilder, Laura Ingalls, *Little House in the Big Woods* (elementary): 8-B

Wright, Richard, *Black Boy*; *Native Son* (secondary): 17-A

Yezierska, Anzia, *The Breadgivers* (middle): 14-B

POETRY AND PLAYS

Berryman, John, "Boston Common": 10-A

Bruchac, Joseph, *Four Ancestors: Stories, Songs, and Poems from Native North America* (middle): 8-B

Chief Joseph, "I Will Fight No More Forever" (elementary): 6-B

Crane, Hart, *Brooklyn Bridge* (middle, secondary): 13-A, 14-B

Dunbar, Paul Lawrence, "Frederick Douglass," "Harriet Beecher Stowe" (middle): 10-A

Eliot, T. S., *The Waste Land* (secondary): 12-B

Emerson, Ralph Waldo, "The Concord Hymn" (middle): 2-B

Freneau, Phillip, "Occasioned by General Washington's Arrival in Philadelphia, On His Way to His Residence in Virginia" (middle, secondary): 3-B; *Poems of Phillip Freneau, Poet · of the American Revolution* (middle, secondary): 4-A

Hughes, Langston, "Theme for English B" (secondary): 17-A

Jarrell, Randall, "Death of a Ball Turret Gunner" (secondary): 19-A

Kang, Younghill, *East Goes West* (secondary): 14-B

Lazarus, Emma, "The New Colossus" (secondary): 14-B

Longfellow, Henry Wadsworth, "Hiawatha" (middle): 5-B; "Paul Revere's Ride" (elementary): 2-A, 3-A

Lowell, Robert, "For the Union Dead": 10-A

Miller, Arthur, *The Crucible*; *Death of a Salesman* (secondary): 20-A

Mayakovsky, Vladimir, "Brooklyn Bridge": 13-A, 14-B

Moody, William Vaughn, "An Ode in Time of Hesitation": 10-A

Moore, Marianne, "Granite and Steel", 13-A, 14-B

Sandburg, Carl, "Chicago" (secondary): 15-A

Wheatley, Phyllis, *poetry of* (secondary): 1-A, 2-A, 3-B, 4-A, 4-B, 10-A, 10-B, 20-B

Wilder, Thornton, *Our Town* (middle): 16-A

Whitman, Walt, "Come Up from the Fields, Father" (middle, secondary): 9-A; "Crossing Brooklyn Ferry" (written before the Brooklyn Bridge was built):13-A, 14-B; "O Captain, My Captain!" (secondary): 9-B; "When Lilacs Last in the Dooryard Bloom'd" (secondary): 9-B

FOLKLORE AND LEGENDS

Cohn, Amy, *From Sea to Shining Sea: A Treasury of American Folklore and Folk Songs* (elementary): 10-B

Weems, Parson, *The Life of George Washington; With Curious Anecdotes, Equally Honorable to Himself and Exemplary to His Young Countrymen* (1800)*: 3-B, 4-A

SLAVE NARRATIVES

Ferris, Jeri, *Walking the Road to Freedom: A Story about Sojourner Truth* (elementary): 10-A

Washington, Booker T., *Up From Slavery* (secondary): 20-B

MATHEMATICS

General: 3-A, 10-B, 20-B

Geometry: 3-A, 10-B, 16-B

MUSIC

"Battle Hymn of the Republic": 9-A

Bluegrass, Country, Traditional: 10-B, 18-A

Blues: 17-B

"Dixie": 9-A

Gospel: 18-A

Historical instruments: 18-A

Inspirational: 19-B

Jazz: 17-B

Spirituals, *general*: 18-A, 20-B; "We Are Climbing Jacob's Ladder": 20-B

"Star Spangled Banner": 12-B

"We Shall Overcome": 19-B. 20-B

SCIENCE

PRIMARY DOCUMENTS AND HISTORICAL WRITINGS

*No suggested grade band